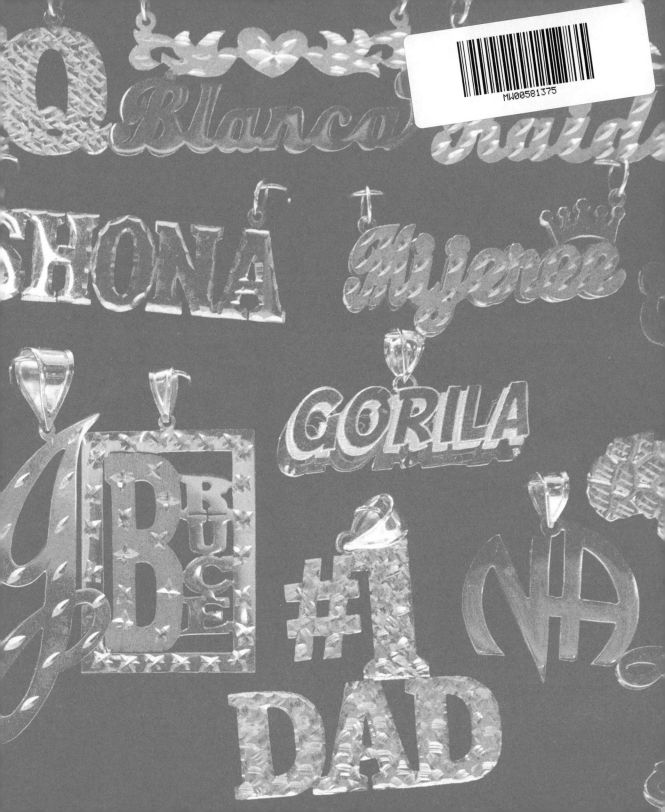

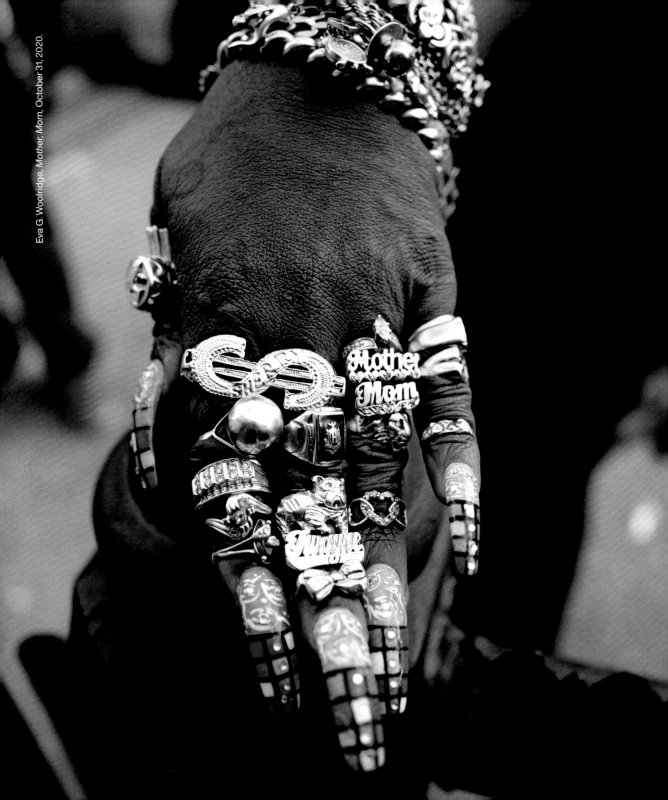

THE NAMEPLATE

JEWELRY, CULTURE, AND IDENTITY

Isabel
Attyah Flower

Marcel
Rosa-Salas

Clarkson Potter/Publishers

New York

Published in the United States by Clarkson Potter/
Publishers, an imprint of Random House, a division
of Penguin Random House LLC, New York.
clarksonpotter.com

CLARKSON POTTER is a trademark and POTTER with
colophon is a registered trademark of Penguin Random
House LLC.

ISBN 978-0-593-23529-4
Ebook ISBN 978-0-593-23530-0

Printed in China

Design by Kyle Richardson and Robert Diaz

Cover photograph: Proprietary nameplate designs from
Bargain Bazaar on Fulton Street in Downtown Brooklyn.
Endpaper photograph: Arlene Mejorado

10 9 8 7 6 5 4 3 2 1

First Edition

Opposite: Emily Manwaring, *When I'm in Your Arms,* 2021,
mixed media on paper.

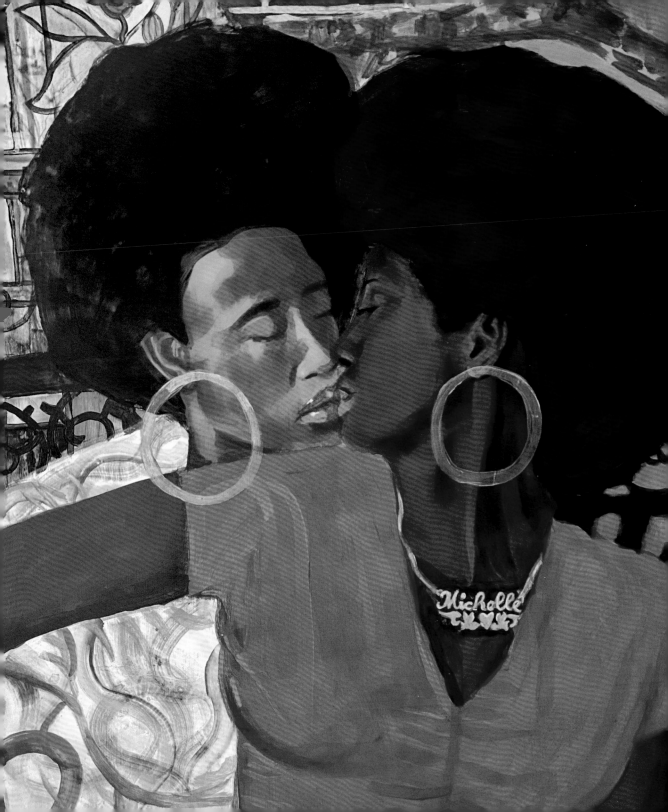

Contents

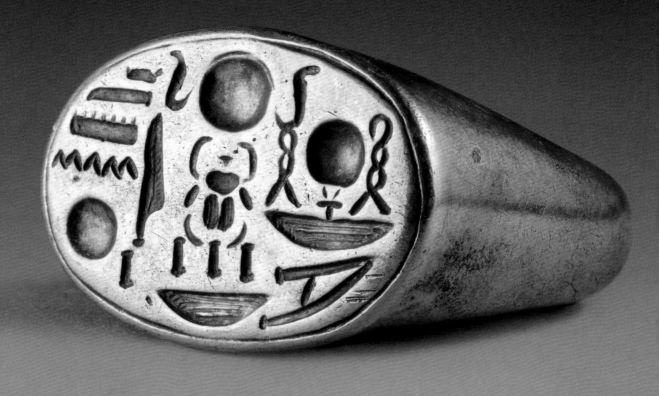

Signet Ring with Tutankhamun's Throne Name. ca. 1336–1327 B.C.
Courtesy of The Metropolitan Museum of Art, New York, Gift of
Edward S. Harkness, 1922.

Introduction

Before the big-money developers descended upon downtown Brooklyn in the early 2000s to scrub away the patina of urban grit for the sanitized monotony of mass chain retail, Fulton Street was an eclectic commercial destination, bustling with the kinds of shops where you could buy a new pair of Jordans (shrink wrapped in plastic, of course), a mixtape, and a gold chain, all at the same establishment.

With pens, notebooks, and a voice recorder in hand, we spent a drizzly November Saturday in 2015 walking up and down what is known by many as Fulton Mall, which, even in the wake of gentrification, is still home to one of New York's busiest shopping districts and, historically, one of the world's foremost meccas for Hip Hop fashion. This research outing was in preparation for a podcast we were starting, the first episode of which would be about an accessory particularly meaningful to both of us—nameplates. While we wandered, we kept our eyes peeled for the surviving jewelry stores of an erstwhile era—the type with Jesus pieces, diamond-encrusted Mickey Mouse pendants, and three-finger rings glimmering in window displays.

Though the number of shops that specialize in this jewelry has dwindled in the past two decades, nameplates remain coveted accessories for many. Little did we know that our excursion that day would mark the beginning of a journey that would continue to evolve over the next five years and open up countless new relationships, unearth understudied historical connections, and result in this book.

WHAT IS A NAMEPLATE?

Nameplates are a style of jewelry in which names, or other significant words, are sculpted from precious and base metals and worn as necklaces, earrings, rings, belt buckles, and bracelets. Like most expressions of culture, nameplates have no singular origin.

Adornment in the form of language is as old as writing itself, and there has been, throughout history, an inherent and undeniable power in decorating one's body with one's own name. As the nameplate traversed an array of locales across the globe, it flourished into myriad syncretic design traditions that illuminate the many ways people use fashion to make statements about their individual identities and cultivate a sense of community. Nameplate jewelry's origins can be traced as far back as ancient Egypt. Pharaohs and members of the upper classes dipped gold signet rings engraved with hieroglyphic writing into wax as a way of signing official documents. From the Victorian-era mourning jewelry worn in English and Judaic traditions to family heirlooms crafted in Hawaii and Panama to coming-of-age objects for numerous different cultural groups, the nameplate's historical lineage spans a vast range of contexts. The 1987 excavation of the RMS *Titanic* revealed an early-twentieth-century nameplate bracelet; the name Amy, forged in diamond-encrusted silver script, was set in a rose gold curb link chain.

Nameplates have been pivotal sartorial items for pop cultural figures both real and fictional, including Hip Hop pioneers Grandmaster Flash, Big Daddy Kane, LL Cool J, and MC Lyte. Renowned *bachatero* Antony Santos sported nameplate necklaces on two of his album covers; one featured his first name, the other his full first and last on two lines, and both were rendered in bold block capitals. Bayamón, Puerto Rico–born boxing champion Héctor Camacho wore his signature MACHO pendant with pride—the oversized, single-plated Chinese lettering (also known as "Kung Fu") nodded to the influence of the era's B-boys and B-girls.

Nameplates have also been requisite to the wardrobes of famed television and movie characters like Spike Lee's Mars Blackmon in the 1986 film *She's Gotta Have It* and Radio Raheem in 1989's *Do the Right Thing.*

The latter's matching four-finger "LOVE" and "HATE" rings were crucial props in one of the film's most memorable scenes. Likewise, Dolly Parton's Doralee Rhodes in the 1980 blockbuster *9 to 5,* Sarah Jessica Parker's Carrie Bradshaw in *Sex and the City*, and Drea de Matteo's Adriana La Cerva in *The Sopranos* all rocked nameplates of note.

Yet while the nameplate has multiple, overlapping progenitors, we—and many of the people we spoke to while making this book—became familiar with this jewelry through the specific styles, contexts, and cultural traditions that make up the manifold phenomenon that is American Hip Hop. Individual style and the ability to showcase oneself in a unique way were requisites of Hip Hop's four founding pillars: DJing, MCing, breaking, and writing graffiti. Each medium cultivated expertise by way of personalization, whether a particular way of mixing and transitioning beats, a singular rapping flow, a never-before-seen dance move, or an eccentric hand style. The intent of these creative endeavors was to develop a persona that was distinct and highly recognizable, and artists often created a moniker to accompany their craft. These names, alter egos of sorts, are an essential part of Hip Hop's particular brand of autonomous self-expression. Many of these monikers were displayed to the world through jewelry items, and their sartorial influence spread through nightlife and other key occasions of social gathering and intersection. It is, in many ways, through the influence of Hip Hop that the nameplate has become a contemporary, mainstream, and global sensation.

We are what we wear. But style—as a site of self-declaration—is also a vector of power. Embedded in practices of self-presentation are also heftier matters, such as the political and cultural contours of race, ethnicity, socioeconomic class, and gender, which inevitably inform not only who wears what, but how fashion choices are perceived and even policed in the public sphere. Hip Hop's emergence and rise to popularity also coincided with periods of extreme and targeted political disinvestment, poverty, and oppression, especially in New York City, from arson rampant in the Bronx in the 1970s to Reagan-era austerity measures in the early 1980s and the violence that accompanied the concurrent arrival of crack cocaine. As cultural historian Jeff Chang has noted, the Hip Hop generation has often been characterized as "invisible," which, in retrospect, seems unthinkable given the profound impact of their creative production on the rest of the world in the decades that followed. But the revolutionary attitudes and aesthetics of these children of New York City were deeply connected to that position of marginalization and disenfranchisement. Particularly in the United States, where consumerism is tethered to cultural citizenship and social belonging, dress and self-fashioning took on a valence of agency, even if in small ways. Nameplate jewelry tells a story about the inextricable intersections between style and society, in which wearing one's name for others to see is also a symbolic site of struggle over selfhood, sovereignty, and social belonging.

A foundational motivation for this book was encountering the lack of recorded and published history addressing this style of jewelry or its wearers. We reached out to jewelry historians and experts, inviting them to weigh in on their understanding of where nameplates came from. Several told us that nameplates did not have a history because, as some expressed, nameplates are not "fine jewelry"—a technical category for objects of adornment made from precious metals and gemstones that also serves as a euphemism for jewelry that is deemed significant due to the perceived value of the artistic or cultural tradition from which it comes. The complicated and stigmatized associations that nameplates sometimes contain are the central reason that their history has not yet been written, as many of the people who have created and worn them have long been denied respect, memorialization, and care.

The release of our podcast resulted in an invitation to write the first-ever academic article about nameplate jewelry, which was published in a special, fashion-focused issue of *QED: A Journal in GLBTQ*

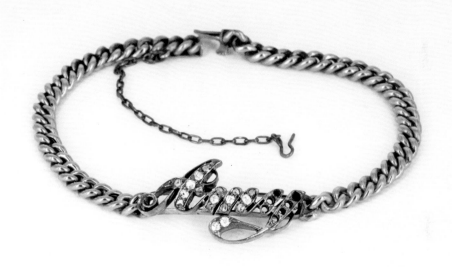

A name bracelet—constructed from 15-karat rose gold and
diamonds, with an overlay of almost-pure silver—recovered
in 1987 from the wreck of the RMS *Titanic*, which sank in 1912.
©2017 RMS Titanic, Inc.

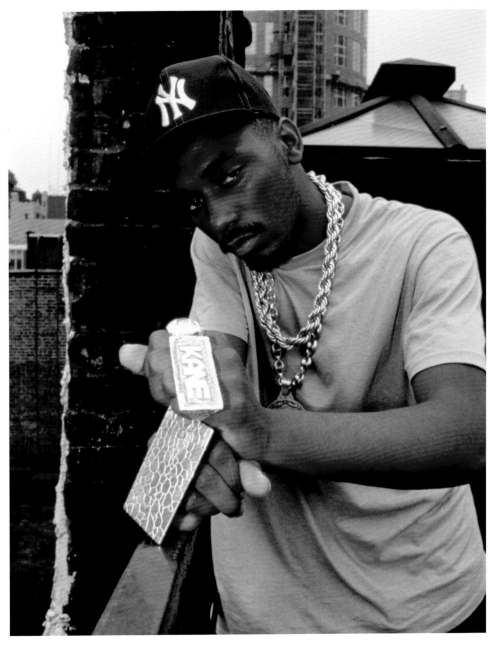

THE NAMEPLATE

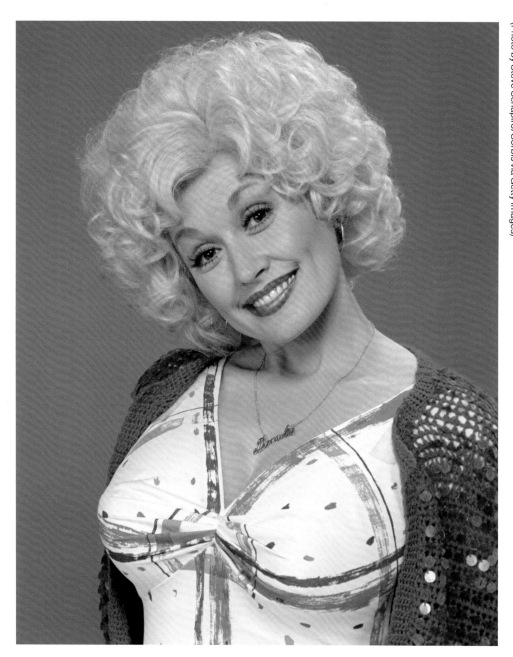

INTRODUCTION

Worldmaking in 2017. But the process of researching and writing a long-form article for a scholarly outlet with a limited audience led us to realize that this subject warranted a more visual documentation than was possible with a podcast or an essay and, most important, a deeper, more personal exploration of why people find nameplates to be meaningful. We had learned so much from our interviews; what might be uncovered if the conversation was opened up to people from around the world?

DOCUMENTING A CULTURAL PHENOMENON

In 2017, we began work on this book. Around the same time, we met Kyle Richardson—a designer whose work and personal style we automatically gravitated to—and invited her to join the project as our designer. We use photography and first-person storytelling to produce a collective and visual tribute to this style, while also claiming nameplates' equitable place in history. Like every person, every nameplate has a story. By adopting a participatory open format, we gathered content in two ways: at live events we hosted and via online submissions. Our approach to prioritizing the voices and experiences of all our participants is modeled after Chicanx historian Maria Cotera's notion of archiving as an *encuentro,* or an encounter with the past. In her words, "It is in the intimate spaces of memory exchange where the present and the past meet and that the sense of building knowledge together is most profoundly activated." This is the type of mutual discovery and collaboration that we sought during every interaction that has comprised this project.

From 2017 to 2019, we hosted nine live events in New York City, Houston, and Los Angeles. For every event, we partnered with a different photographer whose work aligned with the project—including Naima Green, Azikiwe Mohammed, Gogy Esparza, Destiny Mata, Nahomi Rizzo, Mia Penaloza, Troy Montes, Arlene Mejorado, Nichelle Dailey, and Laura Ciriaco, along with Adria Marin and Celeste Umaña, students from the Los Angeles nonprofit organization Las Fotos

Project. These events took the form of free parties, which we hosted everywhere from community centers to galleries and cafés. Attendees had their portraits taken with their nameplate jewelry and wrote their reflections about its significance on note cards. We had a flatbed scanner on-site so that we could gather digitized, close-up images of varying nameplate designs and offer an archiving option for anyone who might not want to be photographed. Other participants from all over the world submitted images and narratives to us through an email submission form on our website or by sending us a message on our Instagram. In addition to the narratives we gathered, we also curated images, essays, and interviews from artists, photographers, and thinkers whose critical perspectives and experiences helped deepen our understanding of nameplates' history and significance.

The images and narratives presented in this book offer a glimpse into the active cultural life of nameplate jewelry that will continue to unfold well after the book's publication. This project is not intended to be a definitive archive of nameplate jewelry, nor could it be. We hope that this will be the first of many inquiries into the cultural life of nameplate jewelry and its wearers, and a contribution to the necessary reimagination of our past and present.

Following pages: Catalog excerpts, shop displays, design drafts, and a brushed gold sample encountered during our research at shops in Lower Manhattan, Brooklyn, and Staten Island in New York, and in Houston, Texas.

Varie[ty]
sizes

BRIAN
BNP1

JOHN
BNP2

ROB
BNP3

Linda
BNP4

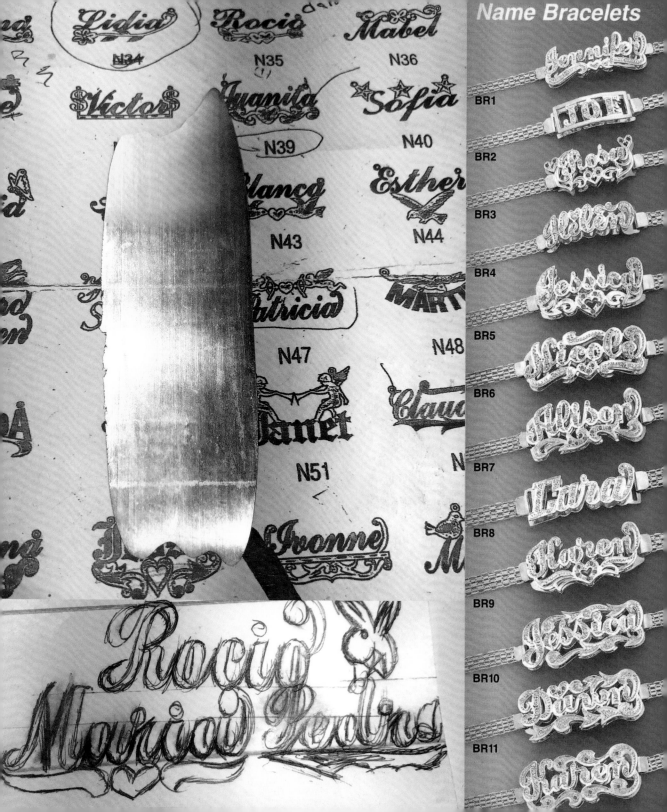

Making a Nameplate

The artists who make nameplates can be found at jewelry storefronts, mall booths, and other small businesses—many of which have been around for decades. Nameplates are now also available online from artisans and retailers.

We began at a shop close to our homes and hearts: Bargain Bazaar Jewelers on Fulton Street in Brooklyn. The artists have been designing and hand-fabricating nameplates for twenty-five years, and the shop is one of the last-remaining and best-known storefronts in this epicenter of Hip Hop fashion.

Our research also brought us to storefronts on Canal Street and in Harlem and the Bronx, as well as to malls and swap meets in Houston and Los Angeles, where we encountered vendors who showcased unique and often localized styles and techniques. This glimpse into the world from which these objects emerge highlights the tremendous knowledge, skill, and creativity that their makers bring to the tradition.

[1] When a customer decides on the details for their nameplate design, Oswaldo mocks it up on the computer, prints it out on a sheet of adhesive paper, and pastes it on top of a sheet of metal (gold, white gold, or silver).

[2] He uses a motorized tool called a flex shaft, along with a saw, to carve out the nameplate design from the sheet of metal.

[3] Using a tool called a bur, Oswaldo carves in any etching details.

[4] When the pendant is being carved, he wipes it with a special alcohol to protect it from being burned by the torch he uses to solder and clean the metal.

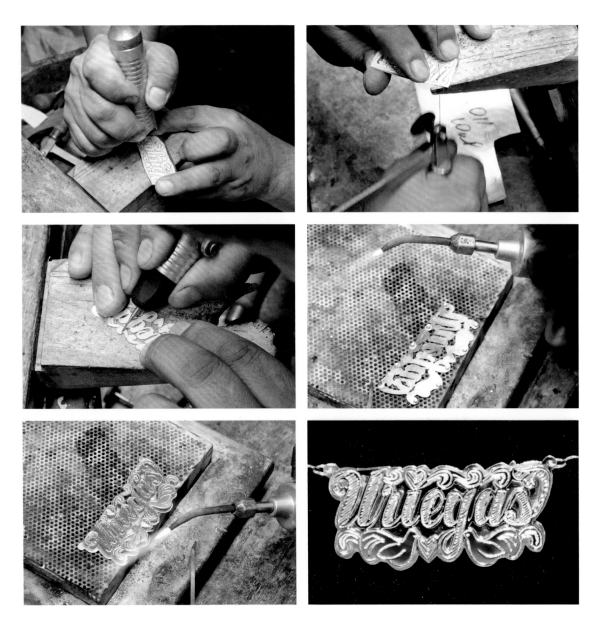

Nameplates by artist Oswaldo Serrano.
Photographs by Kyle Richardson.

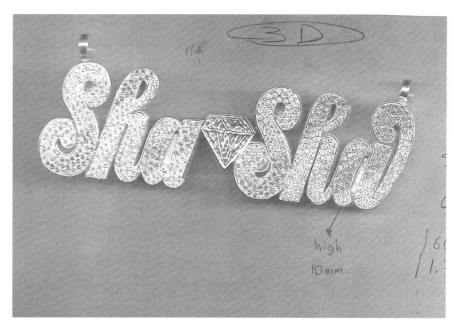

Orders for custom nameplate designs from Bargain Bazaar's archives, housed at their store in Brooklyn.

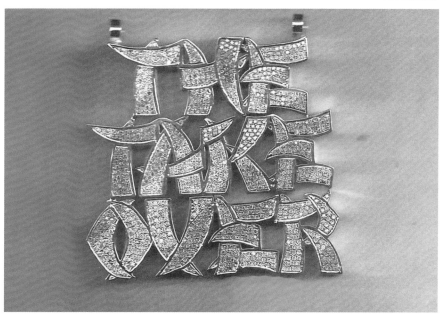

THE NAMEPLATE

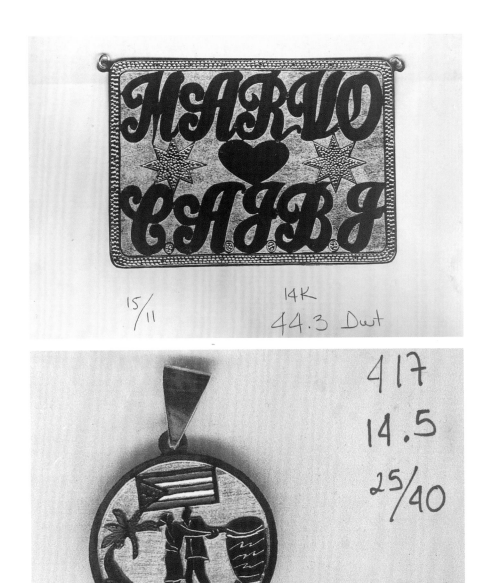

15/11

14K
44.3 Dwt

417
14.5
25/40

MAKING A NAMEPLATE

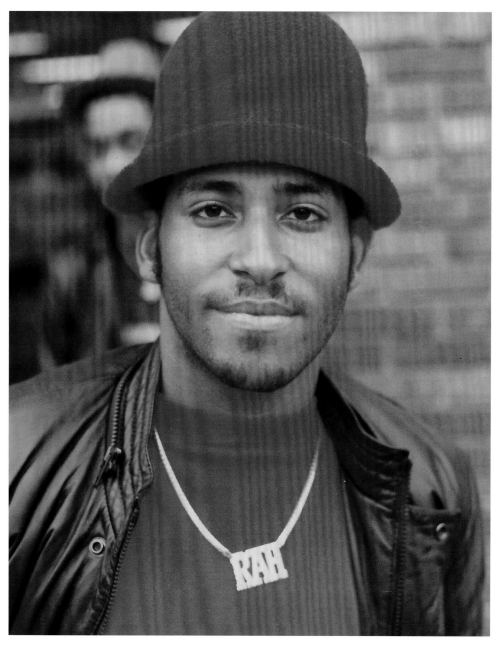

Photographs by Jamel Shabazz. *Rah*, Flatbush, Brooklyn, 1984.

THE NAMEPLATE

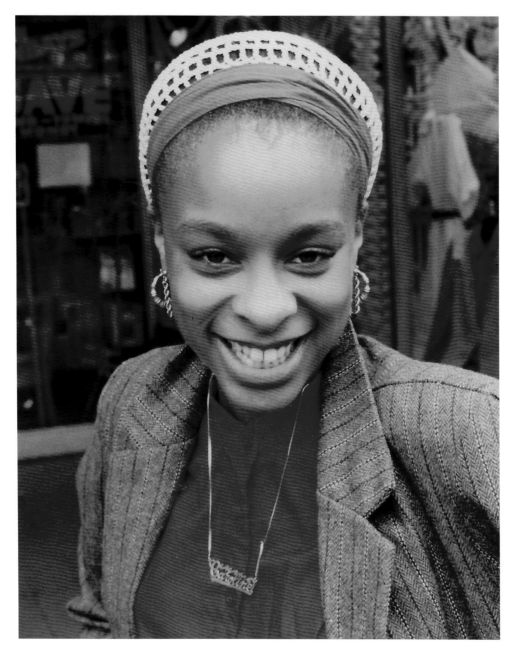

23 MAKING A NAMEPLATE

Notes on Nameplate Typography

Tasheka Arceneaux-Sutton

TASHEKA ARCENEAUX-SUTTON is an educator, graphic designer, image-maker, and writer. She is an Associate Professor of Design and Creative Technologies at the University of Texas–Austin and faculty in the M.F.A. program in Graphic Design at Vermont College of Fine Arts. She is the founder of Blacvoice Design, a studio specializing in branding, electronic media, identity, illustration, and publication design.

Nameplates come in various typographic styles—such as serif, sans serif, or slab serif—and scripts. The most popular type style used for nameplate jewelry in the United States is script, which comprises several different typefaces: formal, calligraphic, black letter, and casual. Script typefaces have been around since the mid-sixteenth century and were traditionally considered "feminine," classic, and elegant. They were initially created to mimic cursive handwriting, in which letters were conjoined to make writing faster. In calligraphic scripts, some letters are connected and some are not (you can see this variation in the catalogue templates on the following pages such as "Erica," "Joann," "Maria," "Carol," and "Valerie"), and most appear to have been written with a flat-tipped writing tool. Black letter, another popular script also known as Old English or Gothic (see "Robert" and "Michelle"), is the typographic style used for the Gutenberg Bible, which marked the invention of movable type in the West. Black letter typefaces appear in mastheads of popular newspapers including *The New York Times* and logos such as for Corona beer and Disneyland. Today, black letter fonts are associated with beer labels, heavy metal bands, West Coast rap, and Chicanx cultural aesthetics. Casual script type styles were designed to suggest informality, as if they were written quickly. These often appear to have been drawn with a brush, and in most cases, the character strokes connect one letter to the next.

Serif typefaces (see "Dennis") have been around since the fifteenth century and are named as such because of their little "feet." Serifs are typically used for lengthier texts because they are considered easier to read. *Vogue* and *Elle* magazines, for example, both use a serif typeface for their mastheads. Sans serif typefaces literally mean without serifs; they became popular during the late nineteenth century. Sans serif typefaces (see "Susan," "Willie," and "Scott") are generally used in logos and headlines. Helvetica, which is probably the most popular typeface in the world, is a sans serif. Slab serif (also known as Egyptian) type styles utilize heavy square or rectangular serifs and were frequently used in "wanted" posters and advertisements during the Industrial Revolution.

The most popular lettering style for nameplates is formal script, which appears in most of the designs on the catalogue page. Formal scripts are typically thin with minimal contrast in stroke weight—the type of font you might see on a wedding invitation. But the formal scripts used in most nameplates don't have as much contrast in stroke weight as traditional scripts; nameplate type styles are usually quite bold compared to the much thinner, traditional formal scripts. I call these contemporary style scripts. Formal and contemporary scripts tend to have swashes, which make the letterforms more exuberant, and accent most of the designs shown here. Swash characters are decorative letters with a flourish or an extended stroke, terminal, or serif, usually at the beginning or end of a letterform.

NOTES ON NAMEPLATE TYPOGRAPHY

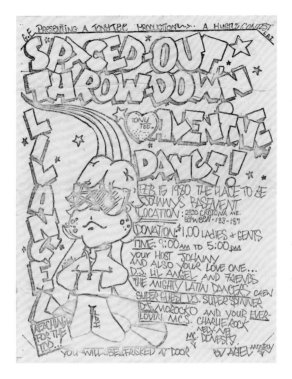

Flyer for a Valentine's Day dance party at Johnny's Basement, Bronx, New York. February 15, 1980. Johan Kugelberg Hip Hop collection, #8021. Division of Rare and Manuscript Collections, Cornell University Library.

These tend to be calligraphic in style and add an elegant touch to an otherwise normal letterform. Most swashes fall into three categories: capitals, beginning and ending characters, and stylistic swashes. Historically, swash capitals were used at the beginning of a sentence; today, they often bring a reader's attention to the first letter to begin a chapter, article, or paragraph. Beginning and ending swash characters are capitals or lowercase characters whose flourishes extend horizontally, adding an ornamental element to the type. Stylistic swashes include anything from a simple stroke extension to an extravagant descender (see "Christina," "Kristen," "Cindy," "Jennifer," and "Donna")—the bigger, the better.

As script fonts were created to mimic the connectivity of handwriting, it makes sense that this type style is the most popular for nameplates both visually and practically, as the names themselves tend to be cut from a single piece of flat metal. It is also likely more difficult for jewelers to create very thin letterforms. Another reason for the heavier versions of script fonts used in nameplates could be a relationship to graffiti letterforms, such as bubbles and straight letters, especially as nameplates became popular during the beginning of the Hip Hop era in the 1970s and '80s, at which time Hip Hop flyers were also popular examples of individualized expression. These flyers combined hand lettering, Letraset, photomontages (usually including pictures taken at previous dance parties), and illustrations. This mixing and matching of styles and media was appropriate for a time when sampling was foundational to Hip Hop music. Nameplates were a part of the Hip Hop subculture and continue to encompass many of the qualities associated with Hip Hop, such as self-expression and the merger of various styles and genres.

THE NAMEPLATE

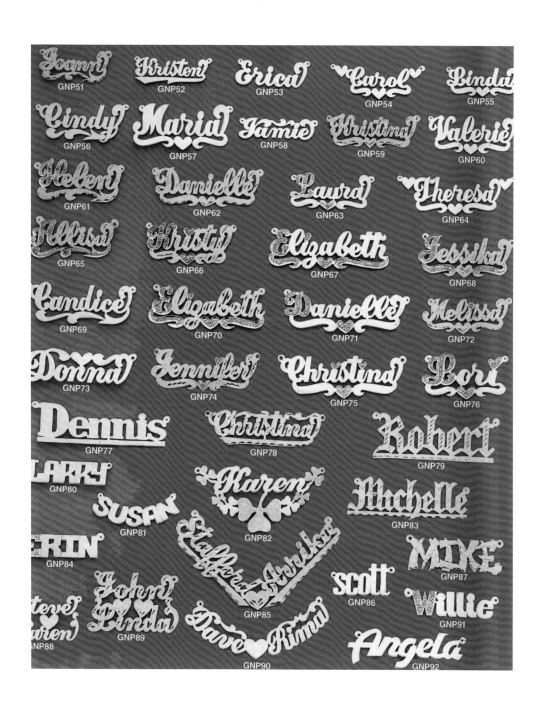

GNP51 GNP52 GNP53 GNP54 GNP55
GNP56 GNP57 GNP58 GNP59 GNP60
GNP61 GNP62 GNP63 GNP64
GNP65 GNP66 GNP67 GNP68
GNP69 GNP70 GNP71 GNP72
GNP73 GNP74 GNP75 GNP76
GNP77 GNP78 GNP79
GNP80 GNP83
GNP81 GNP82 GNP87
GNP84 GNP86
GNP88 GNP89 GNP85 GNP91
GNP90 GNP92

27

NOTES ON NAMEPLATE TYPOGRAPHY

THE NAMEPLATE

Left: Jessica LeBron and her baby daughter Sammi Gay at Norman Thomas High School in Manhattan, 1994.

Opposite: Photographs taken in the mid-1990s through the early 2000s by Ilya Shaulov at Rainbow Shoe Repair on Delancey Street in the Lower East Side.

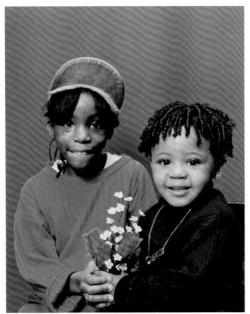
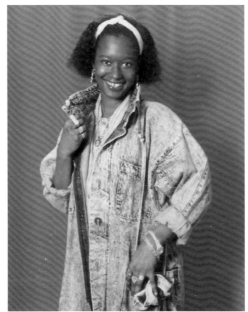
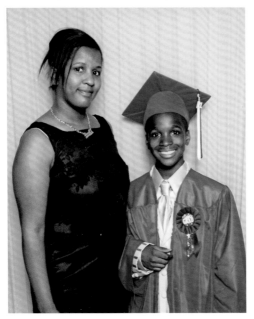
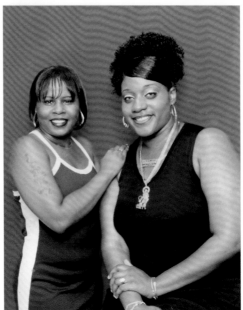

NOTES ON NAMEPLATE TYPOGRAPHY

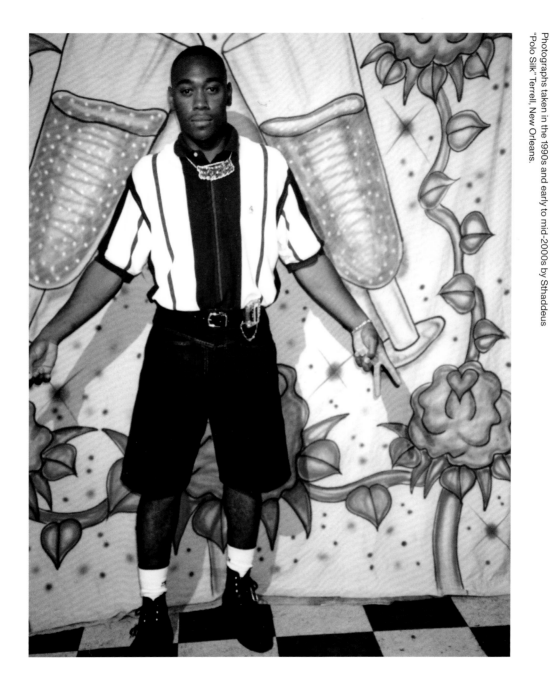

Photographs taken in the 1990s and early to mid-2000s by Sthaddeus "Polo Silk" Terrell, New Orleans.

THE NAMEPLATE

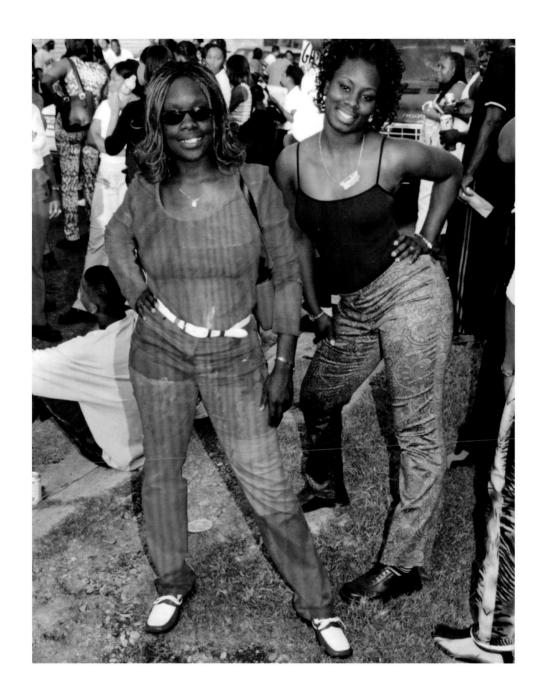

NOTES ON NAMEPLATE TYPOGRAPHY

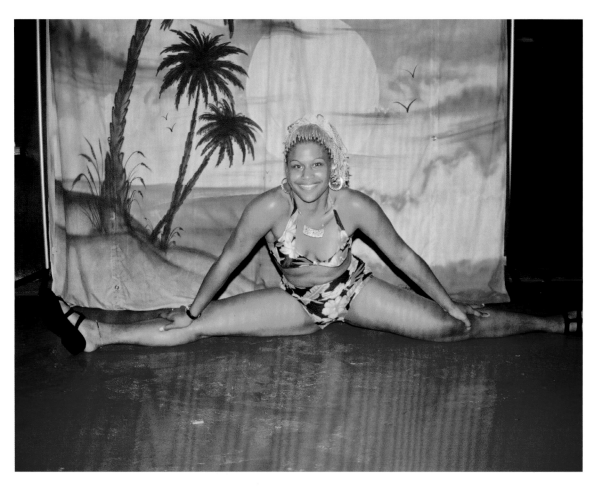

Photographs taken in the 1990s and early to mid-2000s
by Sthaddeus "Polo Silk" Terrell, New Orleans.

THE NAMEPLATE

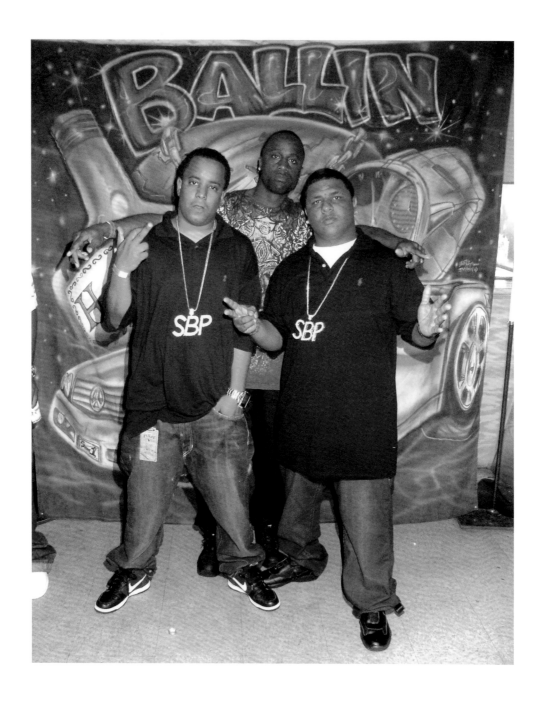

NOTES ON NAMEPLATE TYPOGRAPHY

What's in a Name?

*Rawiya
Kameir*

RAWIYA KAMEIR is a Sudanese-Canadian writer, editor, and producer living in Syracuse, New York. She is a contributing editor at Pitchfork and an assistant professor at the S.I. Newhouse School of Public Communications at Syracuse University.

HOT TIP FOR FELLOW JOURNALISTS:
Begin your interviews by asking someone whether they know how and why they got their name and behold all kinds of meaningful insight about intergenerational ambitions, family lore, and sibling relationships. And it's not only unique or culturally specific names that reveal untold stories. Even names as common as Michael or Mary can excavate fascinating details: a parent's erstwhile radical politics, say, or a clandestine love affair memorialized in the form of a middle initial. Even when the answers don't make it into the story, the conversations tend to take on new dimensions in their wake. It isn't just an interview technique either. Ask a friend how they got their name and I promise you will unlock a deeper connection.

Names don't just tell stories; often, they *are* stories—personal, social, cultural, political. Mine was never one you could find on a key chain at Claire's or on a vanity license plate at a gift shop. But I didn't much mind; my name was my identity and I was fine not sharing it with a whole bunch of people. Growing up Sudanese at an international school in Côte d'Ivoire, most of my friends didn't have key-chain names either. They were dense with consonants and vowel orders that made teachers pause at roll call. Some of them had "house" names—that is, a formal first name for school and work, and a playful one that rang out at home. Some of them were named, as in various West African traditions, after the day of the week on which they were born. My honorary Baoulé name, bestowed upon me by our housekeeper, is Ahou, or "girl born on a Thursday." But I much preferred Rawiya, Arabic for "storyteller." Even when I felt alienated by aspects of my family's culture, I always felt a strong connection to my name and grateful to my parents for choosing it.

I was in middle school when my aunt gave me my first nameplate, a silver necklace with dense Arabic calligraphy. My preteen rebellion had manifested as an objection to the yellow gold popular among the women in my family; I preferred silver, which I believed felt less gendered, less bourgeois, and yet somehow closer to the platinum jewelry worn by the rappers I idolized. By this point, I'd already developed some minor guilt about not knowing how to read and write in my parents' mother tongue. I knew the alphabet and could phonetically sound out words on billboards and storefronts, but not much more. My name, however, I knew intimately. And so I loved tracing the nameplate with my finger: the gentle arc of the ر, the strong-backed ا, the loopty-loop of the و, the dramatic curvature of the ية.

The necklace must have come from one of the tourist-trap shops that dotted my grandparents' street in Cairo, where we would spend the summers and red-faced Americans and Brits would eagerly overspend on tacky trinkets. Every year I'd ask my mom to buy me ankh pendants and rings jeweled with scarabs molted in amber, but eventually I would add more nameplates to my collection: "Rawiya" in hieroglyphics on a vertical slab à la the Rosetta stone; "Ahou" etched onto a misshapen heart; "A2O," the blocky initials of a record label I thought I'd one day help my cousins run. At the

WHAT'S IN A NAME?

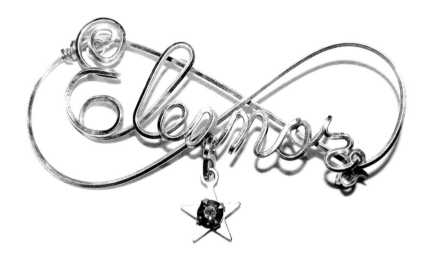

Wire name brooch ca. 1930s–40s.

end of each summer, I'd pile up gifts for my friends, each in its own jewel-toned velvet pouch: delicate silver nameplate necklaces for the girls, bracelets with engravings for the boys.

Over the years, I've often said a quiet prayer of gratitude for my name, which looks pretty on a pendant but, more important, has long given me a sense of purpose. You can imagine my dismay when, well into my thirties, my parents casually shattered all that self-mythology. In doing some research for this essay, I asked them to walk me through their memories of my naming, what they had in mind for my life in selecting it. They both stared at me blankly. "Well," my mom began. "I once knew someone named Rawiya. I always thought it sounded nice." My dad shrugged and listed some of the other names that were in contention and that sounded equally nice. When I presented my firmly held theory, that I would have been a different person had I been named Maaza or Sara, he laughed dismissively: "Don't be ridiculous. You are who you are. A name is just a name."

Running parallel to this revelation is the imminent arrival of my brother's baby, our family's first grandchild. Hovering over every name suggestion is an acute awareness of its potential accessibility to the white people who will likely be the baby's neighbors, teachers, and classmates. It's okay, my dad insists, because in our culture, first names are either familial, religious, or else purely aesthetic. We are not like Ethiopians, he says, with a mix of reverence and playful ribbing, for whom every single name must have deep significance. I've been humbled to think that perhaps he is right, perhaps a name is just a name. But I know that whoever my niece is, this aunt will buy her first nameplate.

THE NAMEPLATE

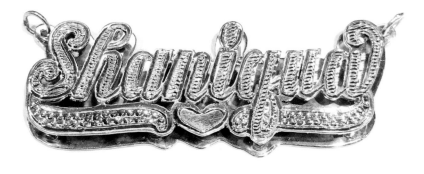

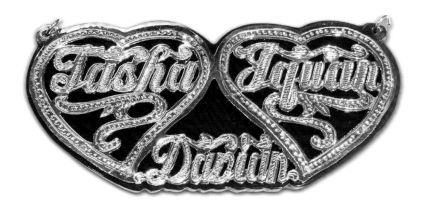

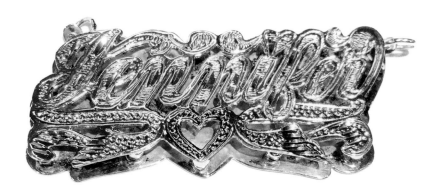

WHAT'S IN A NAME?

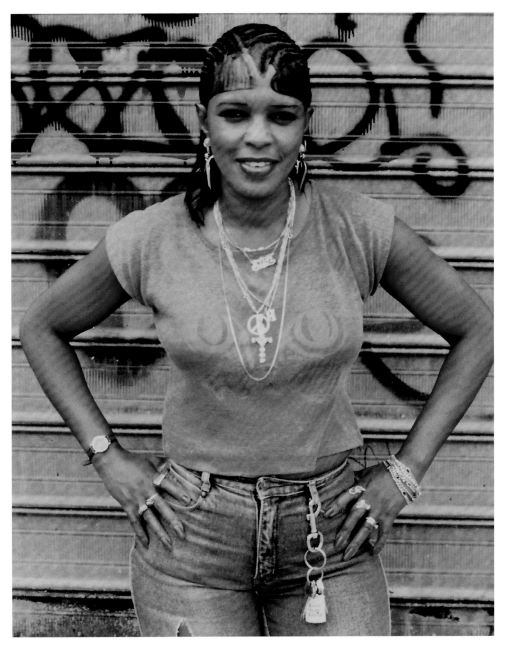

Photographs by Jamel Shabazz. Wavy, Flatbush, Brooklyn, 1988.

THE NAMEPLATE

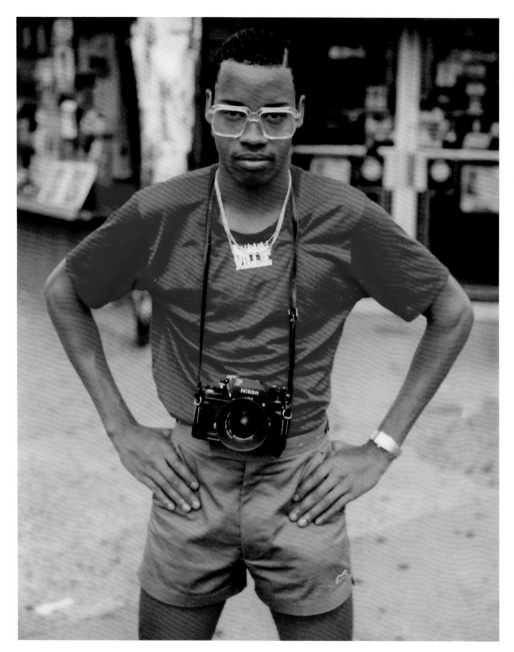

WHAT'S IN A NAME?

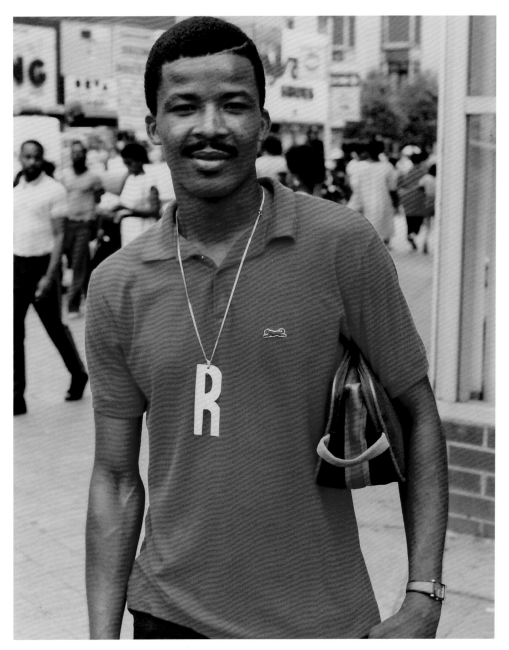

Photographs by Jamel Shabazz. *Big Ron, Downtown Brooklyn, 1988.*

THE NAMEPLATE

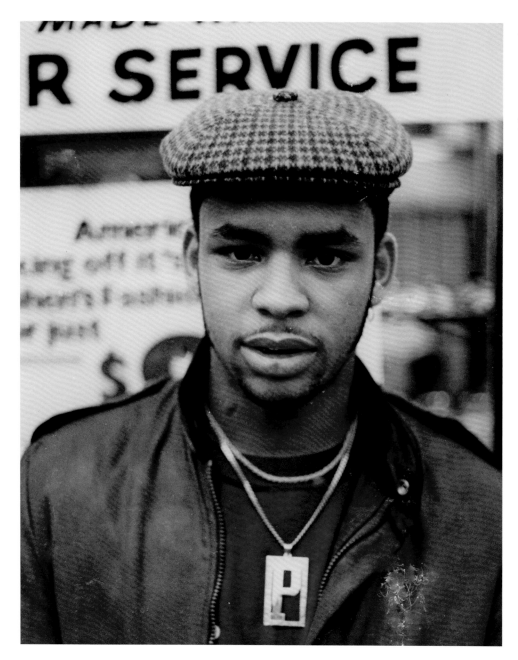

41 WHAT'S IN A NAME?

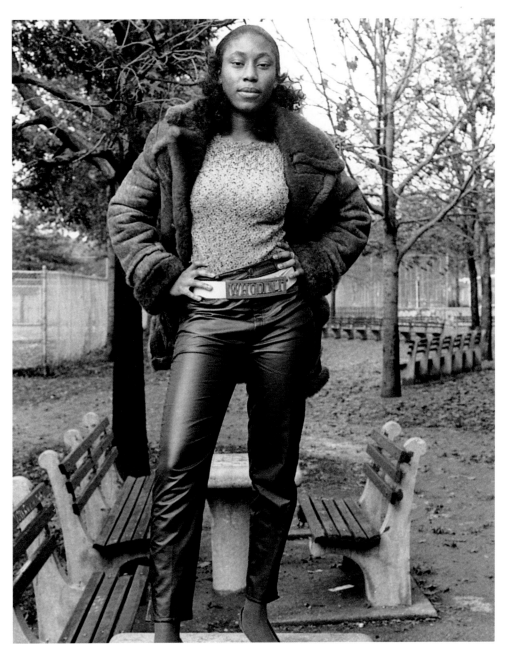

Photographs by Jamel Shabazz. *Fly Girl*, Flatbush, Brooklyn, 1982.

THE NAMEPLATE

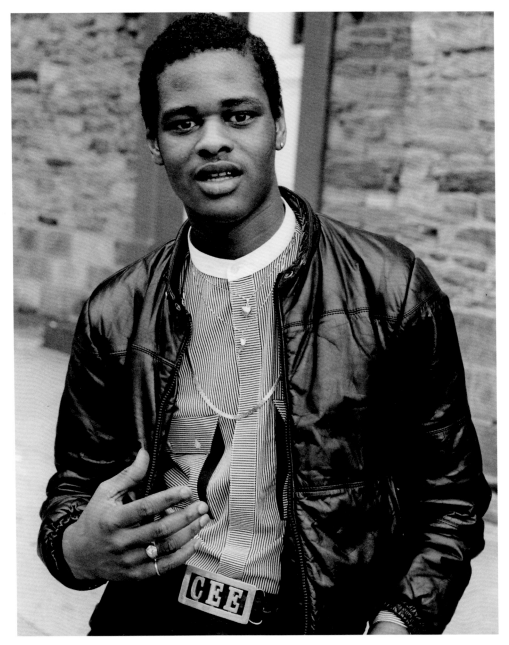

WHAT'S IN A NAME?

Set the Scene:
Albee Square Mall

Professor
Q

—As told to <u>Isabel Attyah Flower</u> and <u>Marcel Rosa-Salas</u>, Brooklyn, NY, 2019

PROFESSOR Q is a Brooklyn-born historian and archivist who runs the Instagram page @albeesquare87.

DOCUMENTING THE NAMEPLATE: What does Albee Square Mall mean to you? Paint a picture of its significance in the development of Hip Hop fashion.

PROFESSOR Q: Albee Square Mall was the backdrop for the moments in Brooklyn history that truly celebrated the full expression of the youth. In the early 1980s, it became a hangout for high school girls from St. Joseph's and George Westinghouse. It was always a bunch of girls hanging out with a few guys. We're talking like '82, '83—just a couple knuckleheads from Fort Greene and the high school right up the block, posted up, surveying the area. Nothing too crazy. By the end of '84, early '85, that's when freebase started kicking off and baby kingpins were out there getting the money. This marked the transition out of the innocent high school interactions, the sweethearts, the New Edition popcorn love era—I call those the pastel days. The Jordache and Sasson jeans. It was *Thriller,* you know what I mean? But by '84, '85, the real street element was being turned up a notch.

The mall went from an empty public space to being totally consumed with the rawest of raw. The game room was in the back of the first floor. That shit was like gladiator school. The who's who of knuckleheads from the entire borough started gathering in there. They had their thing—digging pockets—and they would run up behind someone, put them in a choke hold, pull their pockets, punch somebody, then kick them out of the room. The game room became the epicenter of all mayhem.

That started spilling out onto the main floor. That's where the jewelers were kicking off. I remember K&I Jewelers and Treny and Ali were the first jewelry stores where all the young hustlers would go to get little rings and small pieces. This is like '85, right? By now, outside the mall in the square itself, it had gone from fly girls posted after school to folks pulling up with cars, mopeds, and MB5s. Now you're getting in that real B-boy, kind of dangerous, *Wild Style* movie energy, and it was like, "Yo! What's going on here?" The apex of the baby hustlers was in '85, '86 and that's when the style ramped up from the traditional ropes and nugget rings to customized pieces—to "I want my name on that." Now the rappers are like, "Wow. Albee Square is the place to be. This shit is popping." If you weren't on 125th in Harlem then you were down there.

Big Daddy Kane and Biz Markie were like the first real rappers. Before they were big, they were at the mall every day—Full Force from Flatbush, every day, the Real Roxanne, every day, all of the Brooklyn dudes, every day, posted up on the first floor or outside, getting into all kinds of shit. The real 50 Cent from Fort Greene—he was there every day. All of the Decepticons, Megatron and Rumble. You had the Wolfpack. You had Lo Lifes. You had neighborhood crews that would just roll up to the mall, twenty, thirty deep. If you were unknown, even if you were a Brooklyn rapper, and you came through that block with any kind of jewelry or sneakers or anything, you were getting robbed if you didn't get commissioned. Any rapper you could name from that time who wasn't certified walking in that main door, by the time they were coming out, they got *got.* Even with hits

on the radio. I don't want to put it on blast, but I know from experience.

By '86, '87, it was unlike anywhere else in the city, even 125th, which was like our Hollywood Boulevard. At the mall, you knew something was going to happen, but you'd still go. You knew there was a 90 percent chance you might get robbed or shot at or stabbed or slashed. But you'd still go. In Queens, The Colosseum was popping, too, but nowhere close to what was going on in Albee Square. The rise of the crack era enabled baby kingpins from the hood to be out there like, "I get money. I'm going to buy a chain every day. I'm going to park my car right here. I'm going to blast tunes and take pictures with the girls."

In '88, Biz made a song called "Albee Square Mall." He was like, "If I'm not in the studio, you're going to find me at the payphone on the top floor of Albee Square Mall with my beeper and my chain, probably eating cookies." Everyone was like, "Yo, this dude really stamped this shit." I think '88 was the most flamboyant year. That's when over-the-top jewelry reached its peak: nameplates, dookie ropes, huge truck jewelry pieces, dinner plates, Nefertitis, Santa Barbaras, Virgin Marys. The Jesus piece was popular, but it wasn't yet what it would be in the nineties, and nobody was doing diamonds like that unless you were cream of the crop. But the real big-time people, they would hang out at Albee and on Canal, but they weren't buying jewelry there. To be honest, if you were part of the premier, getting money dudes or females at that time, you were on 47th in the Diamond District with the Mike Tysons, the cream-of-the-crop drug dealers, actresses, and models. But for the hood couture, nothing was beating Albee Square Mall and Third Avenue in the Bronx for fat ropes, nuggets, three- and four-finger rings, and gold teeth.

The nameplates at that time were the huge, flat, rectangular B-boy style; they were four or five inches long and maybe two inches high. I remember Master Don had a big one. He was one of the first rappers from Harlem who was also like a style guru. He was a ladies' man and he had a huge, two-line nameplate, like the one in *She's Gotta Have It*. Those flat rectangles had a big

moment in '85, '86, '87, and '88. The B-boys wore them with the Adidas Gazelles. That was happening at Albee, but I think it was really an uptown thing first that then spread through the city.

DTN: Could you talk more about your perspective on how these styles became popular, and the differences in jewelry and nameplates coming from different parts of the city?

Q: I've spoken to a few folks I've known for a long time about this, and we all agreed that we first saw this jewelry style in the seventies on stars like Teddy Pendergrass and Barry White. At the same time, in Harlem, we had a lot of the real fly people getting pinky rings with their names and chains with their initial. People like Pee Wee Kirkland, who was a basketball player and a hustler at the time, had encrusted bangles and bracelets. He had the chain with the big K with diamonds in it. That was all the influence of rock stars like Rick James.

Pimp culture also took it to another level. They were doing high-rise rings with their names in script before any kind of B-boy influence. The pimp was like a ghetto rock star. Take Don Juan; he was from Chicago and among the most popular pimps of the early to mid-seventies. He had "Magic Juan" spread across two rings. He was everywhere, and he only drove green Rolls-Royces. In any city he pulled up, he'd have a green Rolls-Royce ready.

Many of the original rappers, like Jam Master Jay, would attest to getting a lot of their style, especially in regard to jewelry, from the pimps of the late seventies and early eighties. The pimps were trailblazers. You would see them on 42nd Street with a thousand tiny chains that all had little emblems on them. The B-boy thing evolved from that, and it was in the Bronx that you'd first see the simple, original rectangles with just a name. Then they started doing what were called the Chinese letters, because, at that time, Kung Fu flicks were the shit and you could go see them on 42nd Street. That cinema was a huge part of the foundation of B-boy culture, even before Wu-Tang and RZA put the

THE NAMEPLATE

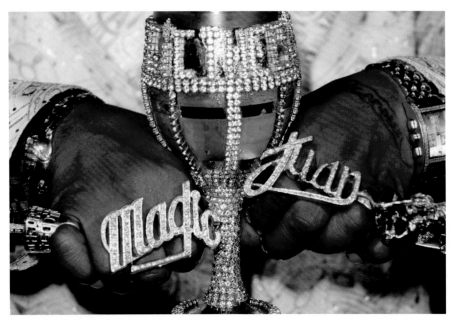

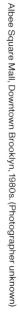

SET THE SCENE

THE NAMEPLATE

spotlight on it. If you had one of the Chinese font nameplates at that time, no one could tell you shit.

DTN: Did you ever have a nameplate?

Q: I had a small gold ring. And I'm going to keep it real—I wanted mine to look like Richard Porter's, the hustler from Harlem whose story was depicted in *Paid in Full.* He had his name set in script and diamonds, with calligraphic squiggly lines on the bottom. It looked classy and clean. There were a couple dudes in Brooklyn with similar ones. I was like, "If I can't get it like that, I ain't even wasting my time." I had the two-finger ring with my name and a Nefertiti I would wear with it. That was the look. I also had a tall, three-finger high-rise that I got from Bargain Bazaar on Fulton Street around '91. It says, "BK'S MOST"—BK apostrophe S MOST.

DTN: Working with Bargain Bazaar has been a huge part of this project because they were one of the first and few spots that let us interview them in depth for our first podcast about nameplates in 2015. Last week I was in there getting my friend a nameplate, and I asked, "Do you guys do apostrophes?" and they were like, "We specialize in apostrophes. We've been doing apostrophes since the nineties when you couldn't get apostrophes nowhere."

Q: It's true! Bargain Bazaar had like twenty-five booths doing jewelry, plus the airbrush spot in the back. They had a top level with clothes, and they had mixtapes. It was a sight to see. Bargain Bazaar brings back some crazy memories. You can't find someone over forty who hung out there who doesn't have a raw story. Some are good memories; some are bad. There were other popular spots, too. On 125th, there was Zodiac's and another place right next to it. As I mentioned before, there was Third Avenue in the Bronx—too many spots to name, just like Fordham Road. On Fordham, Lucky Jewelry was the go-to spot. Everyone was looking for the jewelers who would be willing to make anything.

DTN: In the time we've been doing this project, we've often been asked to get specific about who innovated nameplates first. Some people feel that the influence of gold jewelry and nameplates can be attributed to various Caribbean cultures, while others have spoken to us about the influence of Italian American and African American crossover in Harlem.

Q: I'm from Flatbush. When we talk about the Caribbean influence, we have to speak on the first wave of immigrants that came from Jamaica in the early seventies. The second wave was in the late seventies and early eighties. I've heard that they came up with a lot of gold because, at the time, the government was making it hard for them to pull their money. Since they couldn't transfer their money across borders, they were converting it into gold and wearing it instead. When they got to wherever they were going, their whole life savings were on their bodies. People thought it was them flossing, but it was really a way to transport currency. Then they might pawn it just to get started. Think about Slick Rick—he was born in England to Jamaican parents. He was taking inspiration from the culture at that time, from Jamaican and Guyanese immigrants, as well as from real West Indian gangsters. It became a look and it evolved into a style.

DTN: Fashion designer Dapper Dan has also commented that the period of pimp chains and rings was influenced by Italian immigrants in Harlem who brought Figaro, Gucci, and all these other chain styles from Sicily and southern Italy. When they interacted and did business with other gangsters in the area, there was a natural cultural exchange.

Q: That is 100 percent true. I could attest to specific kingpins I know personally who adopted what the British at that time called casual style or tennis attire— Ellesse, FILA, Sergio Tacchini. I know for a fact that the influence of that type of sportswear in Hip Hop came from specific kingpins who were emulating the Italians they were doing business with.

Let's get something straight. Italians brought drugs to the community first. They funneled it through guys in the hood and on the street. It wasn't until crack that they cut out the middleman and went straight to the plugs, who were the Dominicans and the Colombians. Before the early to mid-eighties, you had to go through the mob if you were trying to be a drug dealer in the city. The neighborhood kingpins were seeing the Figaro chains and the FILA velour tracksuits because when they went to do deals, the mob didn't respect them enough to put on their suits. They would wear their leisure clothes. They'd be out here at 3 p.m. in Fort Greene like, "Meet me, Tony. We'll go have a cappuccino." But when it was time for real raw deals, they're putting on their suits; they're sharp, hair slicked back, clean as a whistle, pulling up in their Cadillacs. Still, for a young man from the projects—a B-boy going to do a deal with a Mafia don—the Figaro chain and the Fila velour with a fat pinky ring was leaving an impression. He took that back to the projects and said, "Yo, I'm going to dress like the plug. I'm going to have my own style that no one else has."

DTN: We've been fascinated by the origins of specific chain styles. Our nameplates are set on curb chains, also known as Miami Cubans.

Q: Those are based in Sicilian and Italian influence. But the rope? Everyone was wearing the rope forever, but no one in their right mind would have thought of making a 40mm rope before the crack era. That wasn't even a thing. The first dookie rope might've been mid-'87, and it might've been a 14mm, which is about the size of your thumb. But with money coming in, dudes were going to their jewelers like, "Can I get a 25mm?" and the jewelers were like, "Are you sure? Solid? Okay." That might've been about $9,500 back then, but today, you're talking more like $40,000. In 1990, you might've been able to swing like $23 a gram.

The explosion of these trends always came down to individuals pushing the envelope. When someone pushed the envelope with a 25mm, I remember it like yesterday. And I don't want to say names, but I remember that first time we saw a 30mm. People were like, "Yo, what the fuck? How could you literally be walking around with a 30mm rope?" And then somebody said, "I'm going to do a 35." Rakim and Kane were the only rappers at that time pushing it with a 35. That was unheard of. It's like the size of your wrist. It was literally uncomfortable. The Italians on the other hand? They never wore truck stuff. They wouldn't wear anything more than a 4 or 5mm.

DTN: We've been amazed by the span of people from different times and places who have shared their jewelry stories with us—take, for example, a Jewish woman, also from Brooklyn, who got her nameplate for her Bat Mitzvah in 1973. We're trying to piece together the effects of exposure and mutual inspiration while also accepting that it would be possible to assign a linear timeline.

Q: To the point about exposure, what was also going on at that time was disco. The disco was where all of these different cultures collided in one physical space. Disco is the foundation of New York City fashion, and to this day, nightlife is still where people of all walks of life come together and see each other dressed their best.

New York City nightlife in the seventies was a movie in itself. That shit was another level. People would come from all over the world just to get a taste of places like Studio 54. What was going on was a real mash-up between rock 'n' roll, punk, reggae, and early Hip Hop. I think the nameplate resonated in these spaces because it signified a coming of age that everyone was experiencing in their own way, whether via Bay Ridge, Coney Island, the South Bronx, or Yonkers. And it was part of immigrant culture, whether Italian, Jewish, Caribbean, or Latin. This conversation is pushing me to tell y'all—y'all might have a bigger project than you might actually realize. What you're describing is bigger than just nameplates.

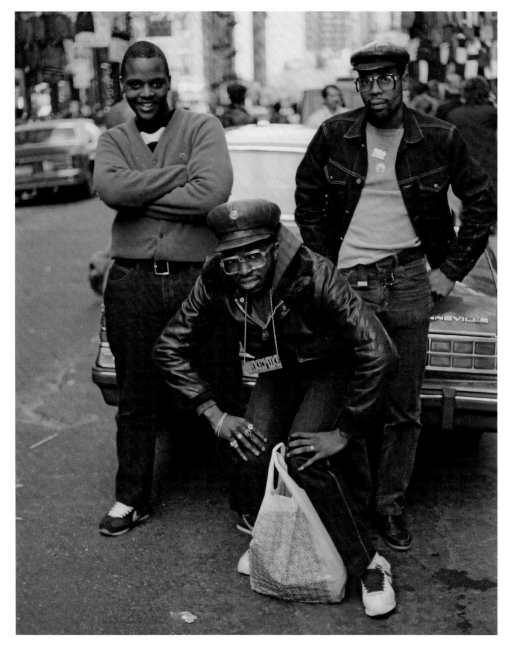

51 SET THE SCENE

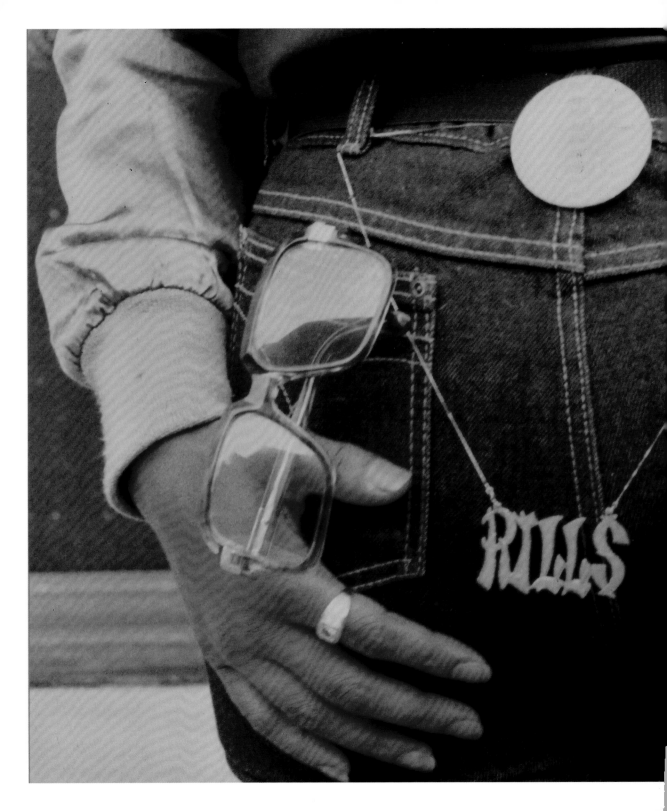

Photograph by Jamel Shabazz. *The Magic Touch,*
Downtown Brooklyn, 1982.

Nameplate Stories

The methodology of this project hinges on a participatory, open-call strategy for collecting images, information, and stories about nameplate jewelry. Though we greatly valued the ability to connect with our participants at our events, not everyone who wished to share their story was able to attend in person. The ability to crowdsource online expanded the breadth and variety of this work in ways that proved to be essential. The images we received range from selfies to archival photographs to close-ups of the jewelry items. The stories of how people got their pieces, the relevance of the word(s) or name(s) emblazoned on them, and their significance, also vary dramatically. While recurring themes and motifs serve to bind together a global community of nameplate wearers, at the same time, the divergences are imperative to capturing the intricacies of cultural experiences and meanings. Let us introduce you to some of the individuals who took the time to share their stories.

Opposite: Maria Yolanda Liebana, *Am I Latinx Enough?*, 2019, epoxy clay, paper mâché, imitation gold leaf, gold spray paint, plastic column, and rhinestones.

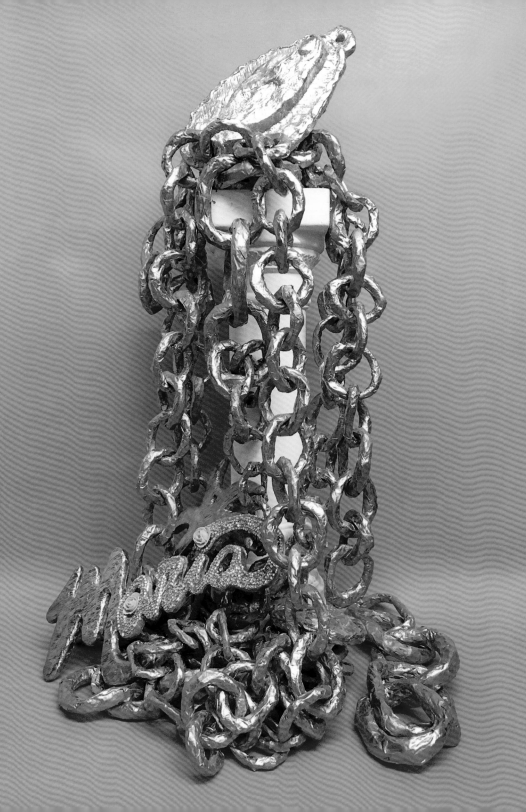

A & B

I'm a North Philly born and raised Boricua kid of '80s freestyle parents. Since I was little I've always talked about name jewelry as a rite of passage. The privilege to save up enough to get your set was worth more to me than any quince or sweet sixteen.

I remember the Christmas of my 6th grade year my friends and I all asked for our name earrings. Some of us already had pieces here and there. A bracelet, rings, or even a necklace. But nothing compared to the shiny gold of some fresh bamboo hoops with your unique stamp on it. I couldn't wait!

When we got back after winter break that year, everyone showed off their new gear. I remember initially being made fun of because mine weren't as big or had the link twists that were standard. It didn't stop me from wearing them though. Fast-forward over twenty years later, almost everyone I know has retired their name jewelry and I'm still here repping everywhere I go. No matter if at an Ivy League job interview or at my grad school commencement, I never forget what feels most beautiful about where I'm from and wear a nameplate everywhere I go!

C

When I was in elementary school, all the older girls had theirs and even looking back at pictures of my aunt in the '90s, she had 'Gloria' written in gold with two doves carrying it across her chest with the Aqua Net hair. It was last year, I was 15, me and my mom were in downtown LA and she was like "pues quieres ir a comprar tus letras?" Bihhh. I was so excited. We went into a spot where they had big doorknockers in the window so we walked in. It was a dream being in there with all the lights and gold hoops, Guadalupes, and nameplates glistening at me. The lady gave me papers with all the designs and I picked the "smile now cry later" faces with a cursive script. It was a Sunday and the lady said it would be done by the next day but during the weekdays I knew my parents weren't gonna be down to take me. So I waited a whole-ass week having dreams and nightmares about it breaking or losing it but every day, I was so excited that I was going to have my first piece that I bought for myself.

D

My name chain was a birthday gift from my mother. I must've begged for it for at least a year. It was a simple, single-plated chain with no gimmicks but it was so incredibly special to me. I must have been 13 or 14 when she gifted it to me, and once I put it on the first time, I can't remember taking it off. I slept with it on, showered with it on, I even tried to hide it beneath my basketball jerseys on game days so I could keep it on (since we had to take off all our jewelry before the games). It's the most important piece of jewelry I had growing up, and I think it became even more important once I went to boarding school. Only a few of the black and brown girls at my school had name chains (and that was a total of maybe three of us), so in a sense, our nameplates linked us both to each other and also back to our hoods and culture.

E

My dad and I visiting family in Puerto Rico. My first nameplate was a gift from my father when I was around 8 years old and definitely my favorite gift. My name is Ineabelle and growing up I could never find my name on a keychain, diary, or anything that would have a name already on it. Not even my initial, which is "i." Having my name in a gold chain was a part of my identity. My name has a story and it sparked conversation when people looked at it. I still wear it today. I am now a teacher and I have conversations with my students about my nameplate, where it came from, and what my name means. Although I was never able to find the definition of my name, someone once told me it means "inner beauty" and I'll take that, because inner beauty lasts a lifetime. In junior high school my brother gifted me the double-plate necklace. Today I still have them both. My dad's no longer with us so this nameplate means much more now.

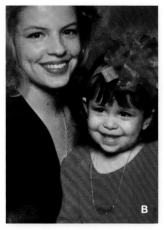

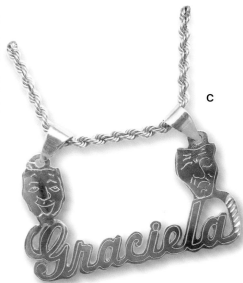

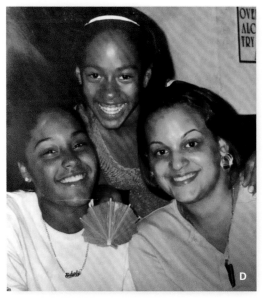

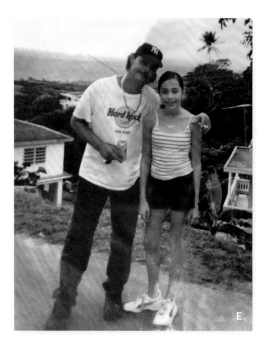

NAMEPLATE STORIES

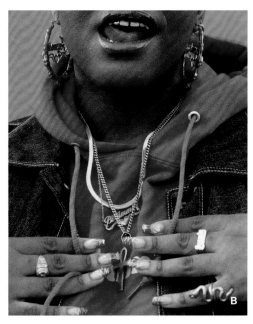

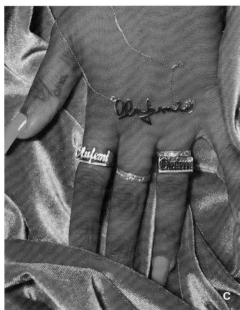

THE NAMEPLATE

A

My mother is Puerto Rican and spent half her childhood growing up between the Bronx and PR. She always emphasized to me the importance and relationship a Latin woman should have with her gold jewelry. When I was 11 years old, she bought me my first piece of jewelry, which is my gold nameplate necklace. My mother is a single mother of two kids. She spent the entirety of her Christmas bonus from her second job to be able to afford my nameplate necklace. My nameplate is so important to me. It reminds me of who I am and it reminds me of my mother, the strongest woman I know. I feel so proud to wear it that I almost never take it off.

B

It was always the gold nameplates and hoops for me. Even as a jit. I always wore uniforms so it was a way to remind the kiddos who was the flyest in the classroom lol. Recently a mentor of mine asked specifically why I wear a gold tooth and that she didn't like it. I understand, she's older and more traditional, but to me it's like our ancestors wore gold from the top of their crowns to the crevices of their tombs. Why shouldn't I?

C

My name means "God loves me." When I wear it, I proclaim it.

D

The nameplate necklace shows up a lot in my work. Sometimes on purpose and other times unconsciously. When I see someone rocking their nameplate, whether on a necklace or belt, etc., I feel a sense of connection with them. (Photo by Amanda Lopez)

A

Growing up I always coveted the nameplate jewelry of my older cousins and neighborhood friends. To me, it represented a rite of passage and an essential part of making sure your outfit was jiggy. Over the years, as I grew older, I eventually became the owner of a double-plated name chain, laced with diamonds and the earrings to match. Eventually I lost the earrings and had the chain snatched off of my neck BUT the simplest item in the set, gifted to me separately by my grandmother, is still with me to this day: my name ring. Back in Harlem, name jewelry felt like a status symbol, or a marker of swag and prestige, but as I grew older and began to occupy spaces in "mixed company," like that of corporate offices, name jewelry attracted the sort of attention and judgment that made me feel insecure and nearly made me question the pride I had in where I'm from and how we do things. Years later, I found my name ring back in my old high school bedroom in my mom's home, and it immediately took its place back in rotation as my greatest treasure. Now that I was back to wearing it proudly and unapologetically, I noticed that everywhere I went people were complimenting it and asking where I got it and how. I used every opportunity I was given to mention that my grandmother got it for me with love, that I've had it for years and how near and dear it is to me. So now I wear it on the middle finger of my left hand as sort of a big "fuck you" to those who made me feel less than or other when they saw me wear it. It's a reminder to myself that this piece of jewelry is worth more than just its weight in gold. It's a reminder that I am loved, that I come from a community rich in culture and generosity, and that we've "been on" since before the appropriation of our personal brand of hood couture. I plan on keeping this ring for as long as it will have me and maybe stocking up on replicas for my future children someday, too. (Photo by Francis Montoya)

B

This is my father after he came home from his fourth and last bid. He's originally from Spanish Harlem but grew up in Queens. He went away for four years about two months after I was born.

C

My father, Ira, aka King Cobra, from the Westside of Los Angeles, was the man in his day. The best jeweler in Los Angeles. No one had better jewelry than him. This picture was in 1984. He passed his love of nameplates down to me. He inspired me to start my own jewelry company.

D

My first intro to nameplates was an ID bracelet gifted to me when I was born. On my 13th birthday, my mom gave me my first nameplate necklace. It was right before I started at the largest Catholic school in Queens, where jewelry and other accessories were an important signifier of one's interests, culture, and personality in a sea of thousands of students wearing the same thing. During those years, I got my first job on the Colosseum block. I used the money I earned to buy a plain nameplate belt from across the street. The more money I earned, the more blinged out my belt became until every letter was studded in shiny rhinestones. That gift from my mom planted the seed for my interest in jewelry and, later, my love for making it. More importantly, it was a marker of my growth.

E

My name is Noelle C. Artist/Stylist/Creator of FineTuned Inc. in Sacramento, CA. My nameplate(s) stories start off with my name, Noelle . . . I got my first nameplate when I was 19 years old. I wanted one ever since I was younger. I was born in 1980, so I have lived in the era of hip hop, the culture and the fashion. Used to watch *Breakin', Beat Street,* and *Krush Groove* A LOT!! Read a lot of *Word Up!* and *Right On!* magazines . . . saw a nameplate necklace and it was love at first sight.

Fast forward 19 years later and I was FINALLY able to get my very own necklace since I got a job. I got my shit right before it became the "Carrie" necklace bullshit (what a coincidence). My second nameplate is very special. It's a gold bar with my children's nicknames, "Nas, Nami, Nai." My nameplate overlaps the bar . . . kind of like me protecting them. I got my name done cause it was all about me at one point in my life, but now it's all about them.

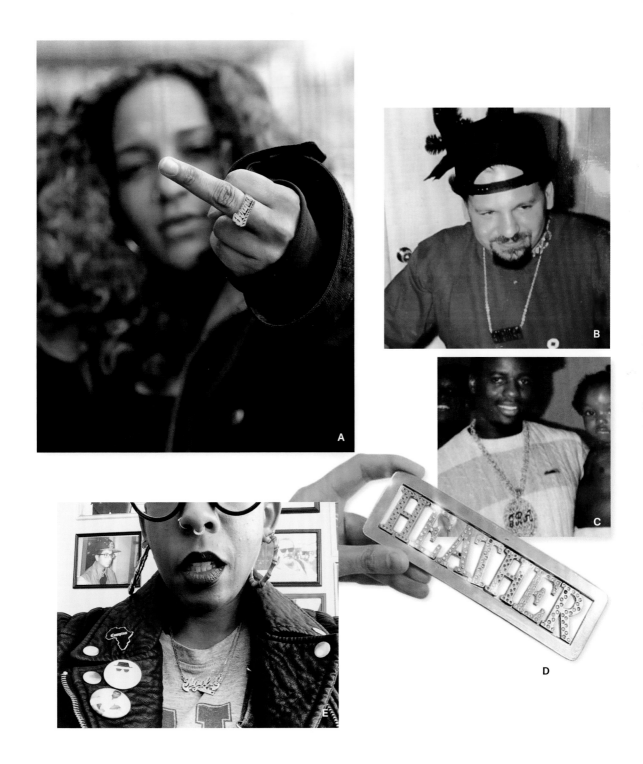

NAMEPLATE STORIES

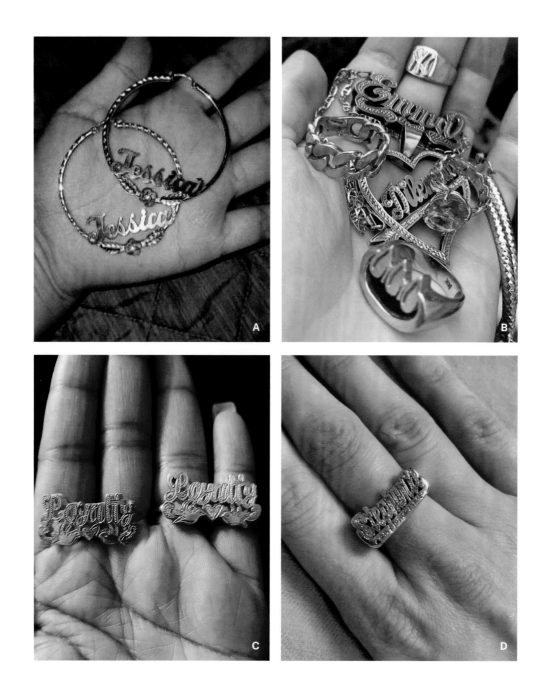

THE NAMEPLATE

A

When I was growing up my mom worked at a laundromat and would find a lot of lost little pieces of gold no one ever came back to claim. After years she had enough to get me and my brother custom pieces done. I had been wanting big hoops de oro for years, but it wasn't financially possible. I got my hoops made with the gold melted that my mom found, and with what I saved up working part-time in high school I paid for the labor. These were made on Lake St. in Minneapolis. When I dropped off the gold to be melted I told the woman working the counter the design I had dreamed of, and a week later when I went to pick it up they were not like that at all! The jeweler free-styled and I did not like it. After having worked so hard at a $6 minimum wage I told them no, that wasn't what I paid for and that it needed to be fixed. That was my first time asserting my wants.

B

Growing up in NYC, a nameplate is a must have. All my friends had one and I used to beg my parents for one but they didn't get it. I mean how will anyone know you're anybody if you don't have a nameplate? My boyfriend in high school bought me one and I never took it off. As I got older, I wanted something a little bit more flashy, so I pimped out my nickname—"Dilemma." It was my 21st birthday present to myself. When I wear the two of them together it makes me feel 21 again.

C

I grew up in a Seventh-Day Adventist Church until junior high school. During that time I saw my friends and classmates get christened with nameplate belts, earrings, and necklaces. I was so mad I missed the belt trend! But better late than never. My husband gifted me my first nameplate earrings as a college graduation gift. And later for my birthday, he copped me a necklace. He's the real mvp.

D

I got my ring for my communion at age 7. I've worn it since and I'm now 26. Some diamonds are missing and it's dented a bit—even my left ring finger is morphed because I refused to ever take it off. It means a lot to me and I'm glad I can share it!

A & D

These rings belong to my Tia. Her name was Raquel Ontiveros, and she was the oldest of nine siblings. She was the matriarch of our family. She was my mom's oldest sister and they all were born and raised in Chicago. At a very young age, she figured out that she could sing, but their mother passed away when they were all very young. Because she needed to work she always maintained a job, and as her side hustle she was a singer. She was the vocalist for the very first mariachi to ever form in Chicago in the '40s. She was also a dancer and performed with a folklórico group during the '40s, '50s and '60s. When she passed away, my mom and her sister went to my auntie's apartment to clear everything out. We all knew she had a lot of jewelry but I don't think we really realized the extent to which she had jewelry. We sorted through stuff and picked the things that we wanted to remember her by, and when I saw those rings I just about died because I remember seeing her wear those when I was a kid, and I was just obsessed with them. My aunt used to go to Acapulco a lot to perform. There was a jeweler in Acapulco that my whole family used to go to to have things made, and she had these two rings made with this jeweler. I don't know what material they are, but they definitely stain my finger every time I wear them. They're not super expensive because she didn't have a lot of money, but she still figured out a way to make things uniquely her. I think they're copper. One of them is "Raquel," her name, and the other her initials, "R M O," because everybody's middle name is Maria. I really did have to fight with one of my cousins over getting those two rings, but ultimately I won the battle.

B

Family heirlooms: When I turned 18, I was gifted the bracelet from my father. Later on I inherited the pinky ring. The name ring was something I always wanted, not really having had the confidence to rock a chain.

C

Nola (on my middle finger) is my daughter who passed away in 2018. My wife gifted me that ring on my birthday as a remembrance to her. Gee (on my index finger) is my father. I have been wearing this ring since high school after I found it in his jewelry collection and I haven't stopped wearing it. Nancy (name chain) is my grandma. She just passed away last year. I was thinking of ways I wanted to honor her so I figured I would get her name around my neck.

THE NAMEPLATE

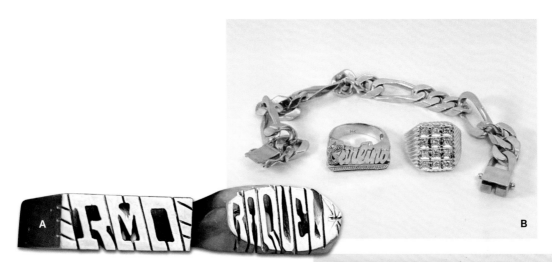

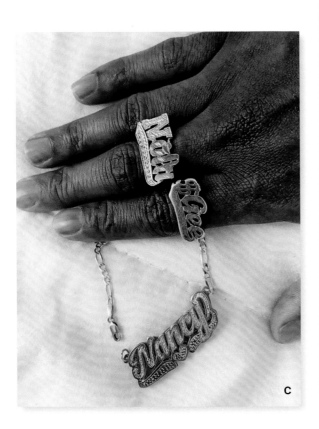

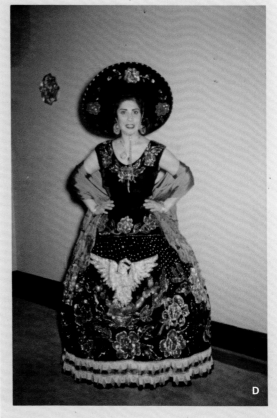

65 NAMEPLATE STORIES

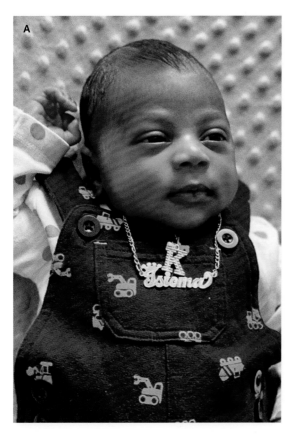

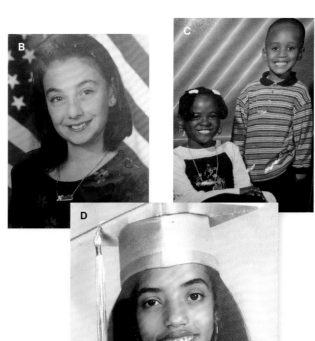

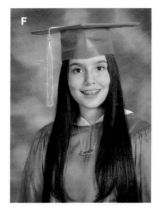

THE NAMEPLATE

A

I had my first name necklace when I was 3 months old. My mother back in the '90s was one of those decked-out ladies, so of course me and my sister had to have some gold jewelry too. Unfortunately my father wasn't the best of men so when he left he took my mother's jewlery and also mine and my sister's. My mother's best friend stepped up as a father figure for me and my sister. He made sure we were taken care of even when my mother was on the verge of giving up. He was always there to give out a helping hand. Years later, I ended up getting married to his son, and just before I could have had my child he passed away. While I was pregnant, I had a dream where he was going out and when I tried stopping him he said I shouldn't worry, he was coming back real soon. When my son was born it was only natural to name him after his grandfather "Isioma," which means "good luck" in my language.

B

1999 for my school photo at Our Lady of Pompeii. It's 20 years old and I still have it.

C

Me and my sister in the '90s.

D

Back when I thought straight hair meant getting dolled and dressed up. Back when I rocked my gold name chain and hoops. Back when I outlined my lips. Back when I believed in my genius until boarding school, where I was the "only one" for the first time and started to doubt myself. Back when you couldn't tell me anything. Back when I was 14. You can take a girl out of the Bronx, but you can't take the Bronx out of the girl.

E

Like any coming-of-age discourse, there's always a tangible memory that kept you close to a place in time. My first nameplate necklace was a reflection of that moment in my life. I'm originally from Harlem but spent my high school years in North Philadelphia. There was no such thing as being a 16-year-old girl in Philly without getting your jewelry from one of the shops on Olney. My necklace was my first fine custom piece (the first of many). It was the "name brand" jewelry I donned with pride that represented who I was

and where I came from. Sindy, my name in a gold double plate with a diamond in the i's tittle, symbolizing my story growing up in Harlem and my anecdotes living in Philly. My nameplate carried the melting pot of cultures that made me who I am; it was my most prized possession.

Due to a series of unfortunate events, I lost a vast majority of my jewelry throughout my adult years. Almost ten years after these consecutive losses, my partner felt it was only right to gift an upgrade of the necklace I cherished the most. As an adult, I always told myself I didn't want to have the simple script nameplate that Sarah Jessica Parker made popular. I didn't want to copy what the popular trend was at the moment. I wanted to stay true to who I was. Christmas 2019, I received my new nameplate, Sindy, cast in gold bubble letters, with a diamond in the i's tittle and a few more diamonds to spare. It was the perfect reflection of who I've grown to become as an adult.

F & G

An Unintentional Family Tradition: My grandma had an initial gold ring. My mom had two nameplates and a name ring growing up. My grandma gifted her the first nameplate necklace and ring. My first nameplate was a birthday gift from my mom. I believe it was for my 10th birthday. Before a birthday or Christmas, sometimes my mom would do this thing where she would hint at what she was going to get me as a gift to make sure it was something I would like. We were in the bathroom together. I was using the sink while she was on the toilet flipping through the latest *Cosmopolitan*. I remember her asking me something along the lines of "Do you like this nameplate?" And when she turned the magazine to me, she pointed to a photo of Carrie Bradshaw from *Sex and the City* wearing a single-plated "Carrie" necklace. Not thinking anything of it, I told her that I liked the necklace. Soon after that was my birthday and she gifted me my first nameplate. I was so excited because it was my ideal nameplate (definitely better than Carrie Bradshaw's). The necklace was gold and double-plated, with tiny diamonds and a heart line underneath. My nameplate necklace was a staple for every picture day from that moment on.

A

My Irish-Cuban mom's nameplate and charms from her '70s Bay Ridge/Sunset Park upbringing.

B

My name is Nakeisha, I was born and raised in the Bronx. Growing up in the hood, all you had was your name. We didn't own cars or have money but your name was YOURS, so we looked for ways to display that. As a kid displaying my name came in the form of writing it all over the walls of my childhood home (my mom used to kick my ass for writing on her walls). I never really knew what a nameplate was. My older sister and her friends all had one but I never really wanted one until middle school. In middle school when everyone started dating and having crushes, people would wear their man's or girl's nameplate—it was like tattooing your boyfriend's or girlfriend's name without the ink and needle, so when that started my twin sister and I begged our parents for name jewelry. My parents gifted both my sister and me a pair of name earrings and a name chain they had brought from a store on Fordham Road in the Bronx. The very first thing I did was give my chain to my boyfriend Kenny as a status symbol of our relationship, which he lost after about a month and my father refused to replace it lol. I think the best part of my name jewelry was that my name earrings were spelled wrong, instead of saying "Nakeisha" they read "Kakeisha," which I took on as sort of a nickname once we realized the mistake. I never took my name earrings off. I am proud of my name and proud of who I am and wearing my name jewelry was a way for me to affirm that, no matter where I went or who I was around.

In 2010, at the start of my sophomore year in college, I attended an off-campus party with some school friends. At the party a shooting occurred and I was shot in my arm and in the jaw. My friend and roommate was shot in the head and killed. That night in the hospital ER they took everything covered in blood. This included my name earrings. For the first time in my life I remember feeling extremely vulnerable. Not only had I been victimized and traumatized by the shooting and death of my friend, but my earrings always made me feel confident and complete. Without them I felt sort of naked. Four years after the shooting our case had ended and I remember begging the detectives to return my earrings. However, because of the amount of blood on my clothing and other items, they became a biohazard and could not be returned. Seeing how upset I was, my father went back to that same shop on Fordham Road and got

me a new set of name earrings (this time with my name spelled correctly).

Today, I live in Virginia where nameplates aren't very common. Although the name earrings I wear now are not my beloved "Kakeisha" earrings, it has become even more important to me than before to wear them. As a person of color in predominantly white spaces here in VA, wearing my name earrings still helps me to affirm the pride I have in my name and my identity, and I love meeting someone who has never seen a nameplate and telling them all about them.

C

My husband gave me this when we first started dating. It's his nickname. I had to sell it when we fell on hard times and I regret it every day. Sure I can get a new one, but this one was made with the energy and fire behind a new relationship. I feel like that part of me has died in a sense. DON'T SELL YOUR GOLD!

THE NAMEPLATE

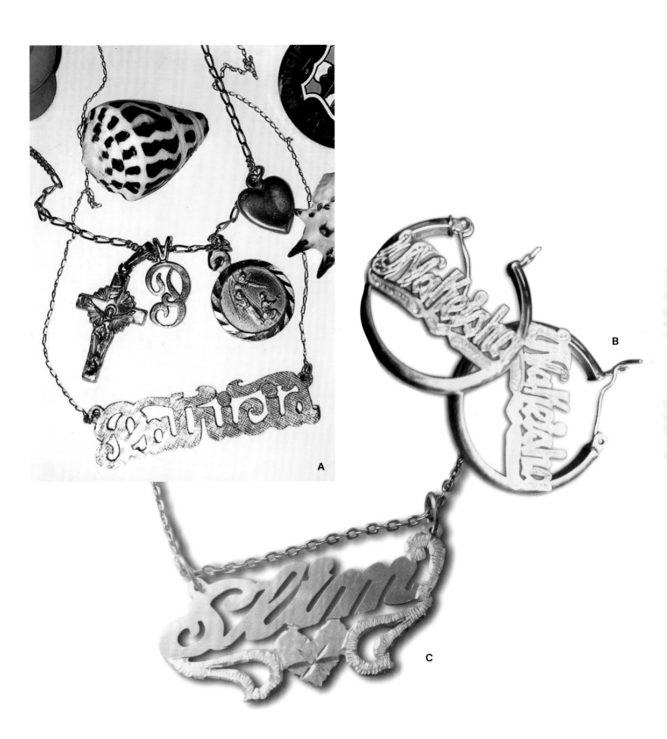

NAMEPLATE STORIES

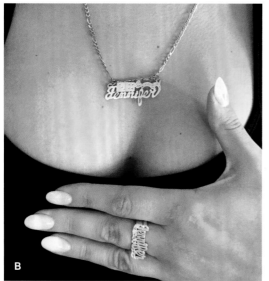

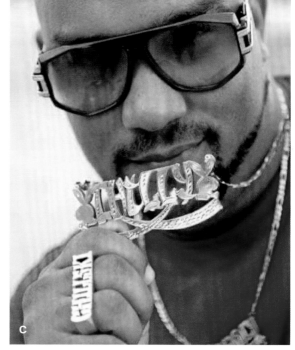

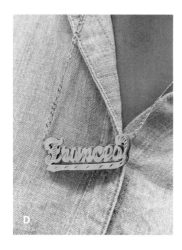

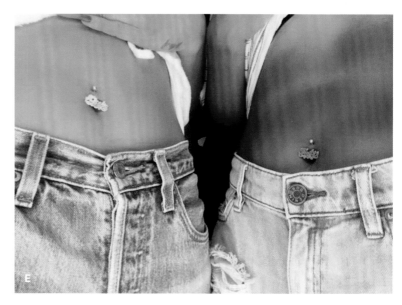

A

It was a gift from a friend (or possibly a group of friends chipped in) when I had my bat mitzvah in 1978. It has moved so many times I'm truly amazed I still have it. I do remember that back in 1978 it was a hot commodity, a really popular gift for bat mitzvahs, and I loved it.

B

My Abuela was married and divorced twice before I was born. Her name was Carmen Lucia. Over the years an old boyfriend of hers from Puerto Rico would come around, and one time he brought back a nameplate that said her name, Lucy, sitting pretty beneath a domino. I used to play dominoes with my uncles and loved it so much, the next time he came and brought me one. She got me my name ring, which has "from Abuela" engraved inside.

C

Salute To All the Fly Gold & Silver Name Plate Rockin' B Boys From the '80s Like Myself, Yours Truly CHILLY WILLY aka ALMIGHTY CHILLSKI … A Key Piece to Every Fly B Boy Way Back When, The Gold Name Plates Accented Your Fly Gear & Put You Above The Average Dressed Ones. In School The Thing To Do Was Rock Not Only Your Plate But Also Your Girl's Or Homegirls' Plates Or Vice Versa. Albeit, You Also Had To Have Juice & Be A Hardrock Cut Otherwise Your Joints Might Get Snatched.

D

Frances is the name that I was given by my godmother, Aunt Frances, once my existence was known in the womb.

What makes my name special is knowing that it represents everything in a woman that I admire.

Frances embodies the strength, class, intelligence, thoughtfulness, love, and so much more that my aunt Frances has taught me.

They ask, What's in a name? Generations & Legacy is in my name!

E

Growing up in Miami suburbs, my older sister and I were rambunctious and wild—talk about teenage angst. We both have a nickel allergy where fake gold or silver gives us skin rashes and infections. Our grandmother Martha used to sell solid gold jewelry as a side hustle in El Salvador—she was the ultimate entrepreneur & self-made Woman.

For my sister's quinceañera and my 13th birthday (we are both July babies), my mother gifted us both with 14K solid gold nameplate belly rings. We still wear them to this day; it keeps us connected even while living on opposite coasts during our adulthood. (She lives in LA and I'm in NY.)

A

This necklace is a gift from my grandmother. She tells me they aren't uncommon in jewelry shops in Tehran, but that she decided to have this one custom made. She found that the default pieces looked more like Arabic script, spelled the same way but with the characters pushed closer together than they might be when written in Persian. She asked a friend with nice handwriting to write out my name and for the jeweler to use it as a model to cut the piece.

B

Etta is my great grandmother's. I'm named after her in the Jewish tradition, using the first letter of a deceased family member's name.

C

Most times we get them to celebrate milestones. This one was for my 5th wedding anniversary, so they usually signify or commemorate special things and times in our lives—not always but often that's the case. A lot of the time they have a very special and sentimental value to us. It could be a graduation, a wedding, a birth, some even get them in remembrance of a loved one that has passed on. They are very special and traditional in our culture.

D

When I was five years old, I asked my mom, "Why didn't you name me Sarah?" She was bewildered at the question. Today, I am just as bewildered that I asked the question too!

People always made fun of my name or just simply couldn't say it right. As I began developing into a young, conscious woman I began to appreciate my name and its uniqueness. It means "My crown is a blessing" in Yoruba. I began to wear my crown proudly in my junior year of high school (2011). I decided that I would no longer allow people to conveniently call me "Bukky" (the shortened, pet version of my name). I decided that everyone I came across would have to go through the strenuous process of saying my name.

For my seventeenth birthday, I purchased a nameplate earring, three-finger ring, and chain to get all my friends with the program. Call me Adebukola, or call me nothing at all!

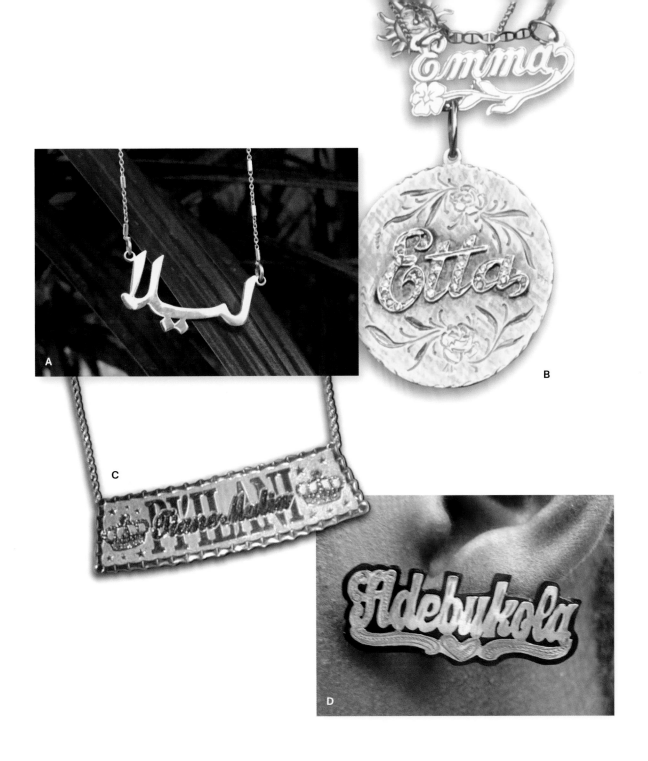

A

B

C

D

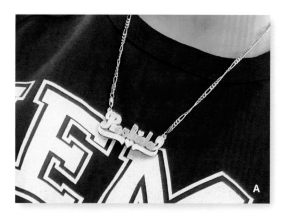

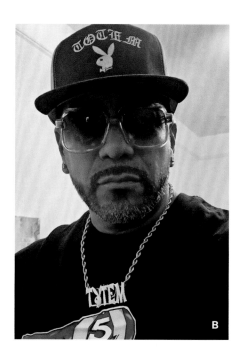

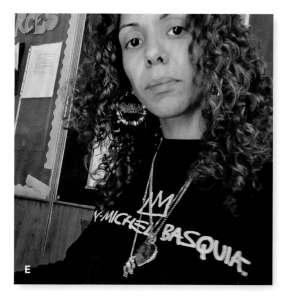

THE NAMEPLATE

A

My story probably isn't much different from most gals', but I have always loved my nameplate. I remember being in middle school and seeing all the fly girls rocking their nameplate jewelry (earrings, necklaces, rings, bracelets, and even belts!). Naturally, I wanted one as well but there was no way my West Indian mother was going to spend that kind of money on something I'd "dash weh" in a few months. So I did what any other kid would do (no, I didn't get a job: I waited until either my birthday or Christmas to ask for it. Three Christmases and four birthdays later my aunt FINALLY obliged and bought it for me for my 16th birthday. That was almost 13 years ago and I still proudly wear my nameplate around my neck and I doubt I'll stop anytime soon :).

B

The history cost more than the gold itself.

C

I gained appreciation for name jewels when girls in P.S. 138 wore the double-plated pendants attatched to the 'x and o' links. There's something so elegant about the script font on the chains. The print font on the ring tho … it's more of a bold look. My ring gives me a sense of commitment. Dedication to my cartoon character and his journey. More importantly, I love how flee and glossed up this one ring makes my whole hand look.

D

My mom was born and raised in Brooklyn, and her parents came over from Sicily in the '50s. I was born in Brooklyn, but we moved to Virginia when I was 3. My daughter (who is now 8) is wearing my mom's nameplate (who she's named after) in this photo, but she also has her own now. It's like a rite of passage! I wear mine everyday and now so does she.

E

I always had name chains or bracelets growing up. My parents never got me hoop earrings with my name, they felt it looked "too ghetto." I bought my first pair when I was 21 and have had to get them replaced 2x now. I am a teacher and I wear them to work, because I feel it shows my students that people who look like us can be successful. I am very much aware of the stigma of my earrings being "too ghetto" for work but I don't care. Definitely my favorite accessory, being in my bamboo earring with my name I feel a sense of pride because not only is it fashionable, but rocking my name earrings empowers me. I know I look fly with them on and can't anyone tell me anything.

A

Valeria. That's my middle name and what everyone called me when I was a child in Peru. When I moved to NY people started calling me by my first name because American culture defaults to first names and rarely uses middle names. When teachers called me for attendance they went straight to my first name. They also couldn't pronounce Valeria properly. I never got used to people calling me by my first name, and in some way it felt as if my middle name was ripped away from my identity. And Valeria with the American accent sounds so gross. I had to hide it so people wouldn't mess it up. I had to protect it, you might say. So as an adult I decided to give myself a nameplate necklace, to remember my roots. When people say Valeria correctly I feel so much love. I love my middle name, I love where I came from, I love my culture and that's why I also had it made in Peru, with my people's precious gold, 18K.

B

a little more about my necklaces and i—firstly, i'm a miami cuban, we're our own breed, haha. so my nameplate is actually of my last name, because i had it made later on as an adult (my mom has more toned down taste but i always remember seeing nameplate stands in the super cuban mall, westland mall, in hialeah). i admired all the designs that they had and the matching hoops. i wanted my own nameplate so bad, so now that i'm old enough i finally got my own. i went with my last name because i've opened my line under that name, and i've always loved my last name. the lizard bc my dad calls me lagartija. la caridad because she's the patrona de cuba, y mi santa. and of course my mom gave me the eye for mal de ojo.

C

I told myself a few years ago that I would get myself a gold nameplate when I got my first full-time job, which I got a little over a year ago. I was originally supposed to get a heart for the dot above the "i" but I ended up going with tropical flowers cause I'm from the tropics, plus it's a unique design.

D

The jeweler that I've been working with is actually my parents' jeweler from before I was even born! His name is Eddie and HE is responsible for my name chain. The figa hand, or "azabache" as we call it in Dominican culture, that's on my chain is from my baby bracelet which sadly broke but I kept the hand because it's super symbolic in my culture and still is used to ward off the evil eye or "mal de ojo." He also is responsible for giving my parents my baby bracelet and he still has them available which is rare nowadays! A few people have been seeking them and I'm so happy to be able to help the tradition continue.

THE NAMEPLATE

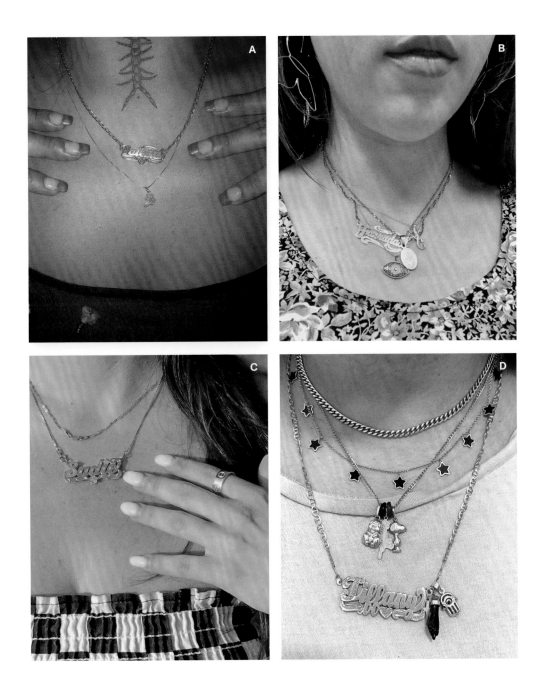

NAMEPLATE STORIES

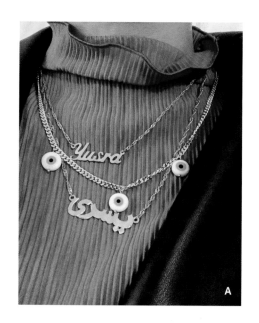

A

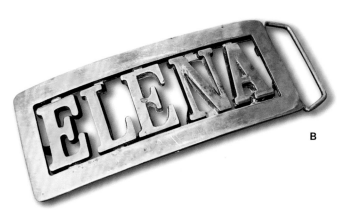

B

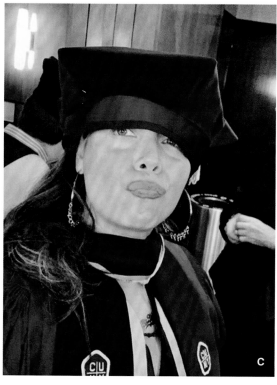

C

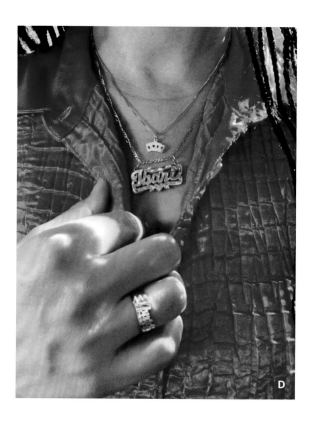

D

THE NAMEPLATE

A

When I was younger, I would often snoop through my mom's jewelry box. It's a tradition in Pakistani culture to receive gold once you get married, and while most things were kept away in a safe, she kept a few at home that I often admired, one being a gold necklace with her and my dad's name set in a simple script. I remember being 11 at the time and asking my mom for a necklace with my name on it, and sure enough, she had one stored away for me that was made after I was born. Now, I'm 22 and the necklace still remains on my neck. I know it may seem frivolous to some, but carrying my name—one that I have often purposely butchered for others to pronounce easier—gave me a firm grasp on it. It wasn't till I saw my four-year-old niece prance around proudly saying her name, and tell me how it upset her when people mispronounced it, that I understood how much someone's name plays a significant role in their identity, especially when their identity is one that is often questioned or misunderstood in society.

B

One of my few Hip Hop artifacts (besides my jewelry) from my childhood: a customized brass buckle nameplate from the '80s made in Sunset Park, Brooklyn, where I was born and raised. By the way, the nameplate buckle was worn on a top grain "oil tan" leather belt back then. That first belt in the '80s was anywhere from 26 to 30 inches long. When I got older, I replaced that belt with a 38 inch belt because I went from wearing fitted, colored Lee jeans to oversized/baggy Cross Colours jeans in the mid-'90s.

C

My nickname is ShirLo. I got it many years ago, when I dated a guy who got a kick out of the fact that I grew up in Castle Hill like JLo. So he was like, "you're ShirLo!" And the name stuck. I even had my professors call me ShirLo. Now that I'm a PhD I am Dr. ShirLo! I sign my emails as Dr. ShirLo (but only in subsequent emails in an exchange or to folks who know me) and I even make the conference badge makers put Dr. ShirLo on my name badge. All my social media handles are Dr. ShirLo. When I defended my dissertation (in 2016) my friend gave me this nameplate as my gift: DR. SHIRLO. I wear it proudly every day. I wear it to let the world know I'm changing the game: academia is not a space that welcomes folks who come from where I come from or speak how I speak, or who look like me or rock the hoop earrings like me. I am proud to be part of a growing cohort of PhDs who are changing that! I am a member of the social media campaign #thisiswhataprofessorlookslike and I use the hashtag #fromthepjstophd often. This is what I'm known for: my hoop earrings and my nickname (oh and my blue eyeliner haha).

D

On holiday as a kid, I'd frantically search through gift shops for anything with my name on it. I couldn't understand that having an Igbo name meant it was highly unlikely to be among the I's of the keychains, magnets, and other gift shop paraphernalia. On my 16th birthday, I received a gold-plated name necklace, and it eclipsed all the generic name things I had ever seen. About a year ago, the plated gold wore off, so I decided to buy myself this solid gold one (and a nameplate ring to top it off). Ibarinze, my name in its entirety, means "house of the chief," or more simply, "royalty." For me, my nameplate jewelry embodies the richness of my name, the history, and the meaning behind it.

A

Growing up I never really had gold because my mother couldn't afford it. When I started making my own money is when I got my first gold nameplate. I got King Sun because it is my righteous name, the name I am most proud of, and reflects my righteous path. Peace.

B

PiC custom buckles and earring. Partners in Crime from London. Started out as a rap duo and then progressed into graffiti writers to promote the band. The buckles were made in London in 1986. The earring was made at Goldmine on Fulton Street, NYC, in 2004. The middle buckle snapped and an attempted weld fix failed. The duo's rap career fizzled out in late '86 due to work commitments, however the writing's still on the wall.

C

Something I've always loved about the nameplate while growing up in the city is that despite having friends from different parts of the diaspora, it was something almost all of us shared. Nameplate bracelets are often the first pieces of jewelry given to children in West African cultures, and thus remind me of my family every time I wear one. My grandfather would take me to his jeweler in The Gambia to get a new one each summer I visited, and when he passed I melted some of the silver down to make a new one.

D

White tall tees were flowing in the wind, summer of 2003 in the South Bronx. A siren hollers, "We buy gold," and lured us toward a display window showcasing hood culture. Accompanied by my mother and younger sister, I stepped into a jewelry store for my little nameplate to adorn my wrist and ears. The bracelet featured Minnie Mouse kissing over the name "Mirna" (the name my father wanted for me), meanwhile the earrings showcased a heart in white gold. I was hyped. However, I lost one of the earrings after getting kicked in the ear by my good friend during a capoeira session. The "Carmen" ring came later on as a birthday gift and I dare not lose it.

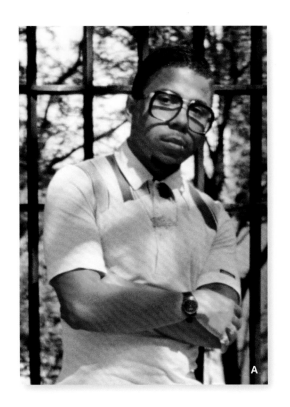

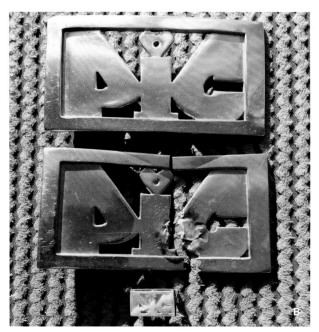

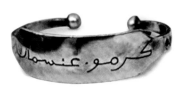

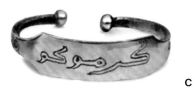

C

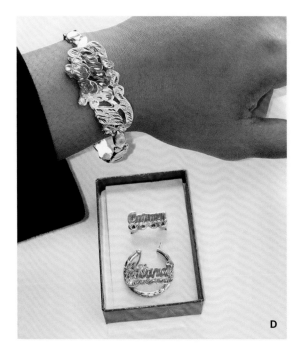

D

NAMEPLATE STORIES

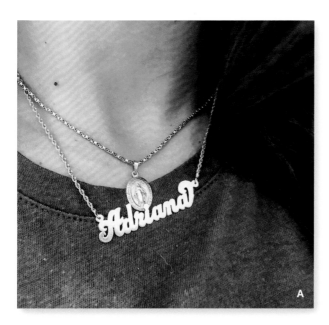
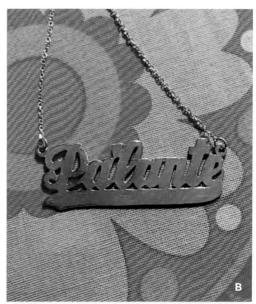
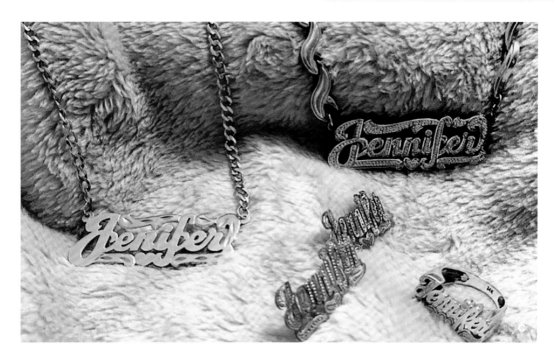

THE NAMEPLATE

A

I got my nameplate when I was about 7. My little sister got hers 2 years later. She stopped wearing hers when it was lost in our toy chest, but I stopped wearing mine when I got the idea that it made me look less serious/mature/sophisticated. At Boston College, I got the J-Crew-ified version (my monogram in swirly gold letters). But that didn't encourage me to get the OG back in rotation. Wasn't until I started working on a streetwear brand that I felt a kinship with mine. "I'm a serious business lady" and "I wear a nameplate" were no longer mutually exclusive. I wanted mine back, and I wanted people to know I was an early adopter. I wanted people to know I wear it because I'm the daughter of Brooklyn Italians. I wanted people to know that I'm proud now, even if I didn't used to be. It's pictured here with the Mary necklace I got when I was born. It won't be long before Hypebaes are wearing those with Balenciagas, but remember you saw it here first.

B

I wear my Pa'lante necklace every day, especially whenever I need an extra boost of confidence. It was gifted by Marcel, the first Nuyorican student I ever worked with at NYU anthropology after she finished her Ph.D. This is a discipline frustratingly white dominant, and Marcel's graduation in the summer of BLM protests over the death of George Floyd, demanding anti-racist police reform, made it more prescient and significant. I am pretty sure the necklace has superpowers. I say "Pa'lante" to my students, to friends, and pretty much to anyone. Pa'lante is the Puerto Rican national cheerleading chant. It is the title of the Young Lords's bilingual newspaper and also the words we tell each other to instill optimism in charged and difficult times. It is a confidence boost greeting that says: you must go forward no matter what, because you have to, and because it is so historic and politically urgent that no other option is worth considering. Onwards always, and never step back, even for a boost: "Pa'lante, siempre. Pa'tras ni pa'coger impulso"—I photographed the necklace on top of a colorful and groovy fabric patterned pillow to match the joy of this precious gift and the hopeful optimism at the heart of Pa'lante.

C

My mom always gifted me jewelry for special occasions. Being Dominican and born in the early '80s, having jewelry was considered part of the culture. Though I have lost a few pieces and was robbed at one point, I thankfully have been able to keep a few of them. The nameplate with a basic Cuban link chain my mom got me when I was 10. She gifted it after I lost my first nameplate chain in school. I was devastated. The nameplate earrings I bought myself in high school and I really thought that I was so fly and of course had the nameplate belt to match. The ring my mom bought for me when I was around 14 and, last but not least, the name chain with the waves links I got for Christmas in '06 with the bracelet to match. Though I no longer wear them they bring me nostalgia and memories of simpler times.

A

Throughout my life, I have received gifts of gold jewelry from loved ones. I received my first pair of gold earrings as an infant and my nameplate bracelet as a young child. I was gifted my first and only nameplate necklace for my quinceañera, along with this ring. As a child, I wore my jewelry with so much pride. I remember how beautiful my gold jewelry made me feel then. As a first generation Mexican American teenager growing up in a predominantly white suburb, it was uncomfortable wearing my quince nameplate to high school. Today, I am relieved to have reclaimed my love for the gifts that have been shared with me throughout my life. My quince nameplate reminds me of the community of people who raised me and have showed up to support and love me, and how they have taught me to be proud of myself. My quince nameplate was gifted to me by special man named José. During the summers, he would come to Chicago from Mexico to panhandle outside my parents' grocery store that they ran together from 1993-2007 in Humboldt Park. It's an honor to have been gifted this necklace by José and to be loved by a community who respects my parents and family.

B

Growing up, I remember watching music videos on BET, VH1 and MTV, reading *Word Up!* and *Right On!* magazines, and being mesmerized by all that encompassed hip-hop culture; specifically the stylings of Salt-N-Pepa. I wanted in! But, of course, I was too young and my parents were not having it. Plus, Minnesota (at the time) did not supply the various accoutrements for such looks. Folks that did have it got it from their Chicago or St. Louis cousins. The first time I visited NYC as an adult, I stumbled upon the jewelry stores on Bowery. I vowed to get my hands on the coveted nameplate. Fast forward to 2005, I used part of my college graduation funds to make my way back to NYC and over to Starlight (I think that was the name) Jewelers. I wanted a simple design, which confused the associate—haha! Six weeks later, it arrived and my inner b-girl's heart was full.

C

Growing up, my Titi (aunty) who I love dearly would always gift me jewelry for several occasions like Navidad or mi cumpleaños. This nameplate ring was my birthday gift when I turned nine or ten years old. I'm in my early 30s. This is definitely one of my favorite gifts. Nameplate jewelry is very big in Dominican culture. The reason why my aunt got me the ring is because back in the '80s, when she used to travel back and forth between New York and the Dominican Republic, she noticed everyone had nameplate jewelry. She eventually got a nameplate ring for herself, then one for me. I love how thoughtful she was, as she got the ring a bit larger so I can grow into it. Even though I have nicer rings in my collection, this one always gets compliments and inquiries on where to get one. Love telling people I had it over 20 years. It's definitely an heirloom piece that I will pass on.

D

I don't remember exactly when I got it, but I believe I've had it since I was 5 years old, which is why it's so small on my neck (I still wear it, though). It has my first name on the front, and my last name on the back. In Hawaii, this type of jewelry and text is known as heritage/legacy/heirloom jewelry. You can find these types of necklaces and bracelets all over HI, from swap meets to companies like Honolulu Jewelry Company, Na Hoku, etc. They will typically have text with the person's name on it, "ohana," "kuuipo" (meaning sweetheart), etc. During the late 1800s, Queen Liliuokalani wore this type of jewelry, as it had become fashionable in England. Hawaiian heritage jewelry is a symbol of the Hawaiian monarchy. Typically, only women wear heritage jewelry, and you'll find people of all ages wearing this jewelry, even baby girls. I wear it because it was a gift from my parents and it signifies who I am and where I come from. I also have a similar necklace with my father's name on it, however I don't really wear it often, I think my mom prefers to wear it.

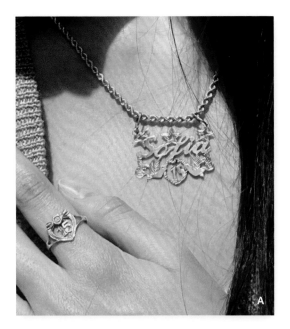

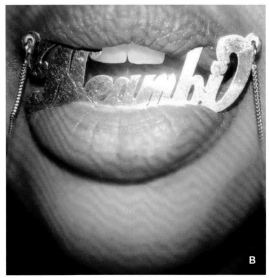

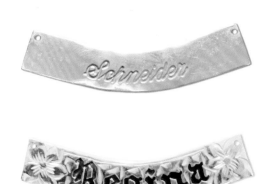

NAMEPLATE STORIES

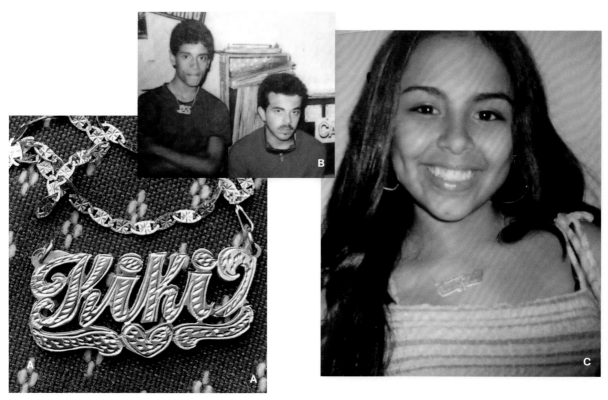

THE NAMEPLATE

A

Ever since I was in the 3rd grade I wanted a nameplate necklace like Kelis, Honey Daniels & my neighborhood friends. My parents couldn't afford to buy me one, raising five girls and putting us through private school. Having a nameplate jewelry piece was my childhood dream. It's very nostalgic to me—growing up in NYC in the 2000s I remember seeing everybody and their mother with a nameplate piece from rings, bracelets with inscription, earrings, and necklaces. The design of your piece is very personal, another reason why I've always wanted one. My double plated beauty is diamond-cut satin finish, I think. Kiki is my family nickname. People have asked me "where does Kiki come from when your name is Victoria?" Well, my niece couldn't say Vicki when she was little. The V is difficult and pretty much impossible for a toddler to say, so she just started calling me "Kiki" and thank God it stuck. I loathe the nickname "Vicki"—it just doesn't suit my character. From then on everyone in my family called me Kiki. Really funny my parents don't call me by my birth name a lot, it's Kiki. Close friends call me Kiki too, sometimes. It took me a while to figure out what name I wanted to use for the piece. Kiki just feels right and I think about my family. I wear it with pride. It's a piece I've always wanted, I worked hard for, and reminds me that I am loved.

B

P3 was my tag when I used to write graffiti in Jersey City. I went and had it custom made.

C

My mother came to the US from Peru at 16 years old. It was the peak of the '90s—baggy jeans, thin eyebrows, dark lips and nameplates. On my 12th birthday she gifted me a white gold and single-plated necklace with my name on it. I loved it because it was so me. A lot of the girls growing up had 24k gold, double-plated with designs on it. Mine was different: it was thin, dainty, and sadly it broke. I plan on reviving it once I find the person who can do it exactly like I had it. The necklace represented my identity and my style just as all the other girls did growing up. It was a New York thing, a rite of passage.

D

When I was growing up, all my older siblings, and later my friends, got nameplate belt buckles and bike tags, etc. They had more common names than me, but not by much, lol #blacknames. But there was never a "Majora" and we were too poor for some custom job. Now mass specialization fabrication makes it easier. For our first anniversary, my husband—remembering me telling him how I never got a name belt—went out and got me this one. It's silly, I was in my 40s when he gave it to me, but it made me cry. It made me love my name even more, to make up for all those younger years when I wished I was just called Mary or Jenny.

E

My nameplate is the name my parents have always called me, Lena, in Cyrillic. I wanted a nameplate for as long as I can remember and love being able to honor my culture (as a Russian American and Brooklyn bred—since coming here from Russia at 3 years old).

A

In my middle school days, if you didn't have a nameplate, you were definitely not one of the 'cool' girls. I remember going home and begging my father to please get me one, knowing that as his only little girl he would comply. We definitely were never wealthy, just a normal middle-class family, and looking back now I realize how much more he must have had to work in order to buy this for me. I'm so glad that he was able to buy it for me though because 20 years later, I still own it and it represents so much more to me now than it did then. Now it symbolizes an heirloom that I will always treasure because it will always and forever remind me of my father and the sacrifices that he had to make to appease my desire to simply fit in at school. Yesterday, I sent a picture of it to him and I said, "Look dad, I still have the nameplate you got me in middle school" and he said, "Wow, that filled my heart with happiness. Please make sure you continue to keep it safe so it will be a great memory for you once I'm no longer here." And just like that, with tears running down my face, that piece of gold jewelry meant so much more to me and I was even more grateful for my father.

B

My first nameplate was given to me when I was born, many years ago. My second nameplate, the one I still wear today, was given to me in the early '80s by my boyfriend, now my husband. It's my favorite piece of jewelry. It says Robert <3 Elisa. At the time his parents owned Personalized Boutique, Inc. They made personalized jewelry. Now we are the owners and we are still making the same style nameplate today.

C

Just wanted to say I love your page lol. Throws me back to growing up in the Bronx when my mom had me and my sister all up with nameplate jewelry. Earrings, necklace, and at some point a ring. I got made fun of cus none of my classmates believed that I was Puerto Rican, so I used to hate wearing them (I got picked on a lot bc of it) but looking back it was a really fun look and I miss those pieces. She had to pawn 'em when my dad left us and we were poor.

D

A little story about my nameplate: I used to wear it all the time in middle school. One day my family's apartment got robbed (not that we had much to steal) and the only piece of real jewelry that survived was this necklace because I happened to be wearing it that day. I can't exactly remember why I stopped wearing it. Perhaps out of fear of having it taken away, or because I didn't think it was "cool" anymore or mainstream enough; too much of a marker of a bi-cultural identity I've always had difficulty with. In 2011, times got tough and I had to sell the chain. I've had just the nameplate in this tiny ziplock bag in Chicago until now. I got a chain again, and am so proud to wear it. Thanks to @documentingthenameplate, and everyone who wears their nameplates for encouraging me to do the same. Also go support El Dorado Jewelry on 3425 W. Lawerence Ave. in Chicago!

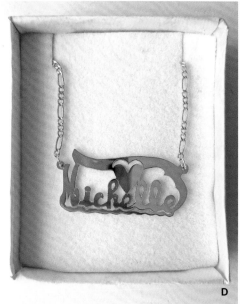

NAMEPLATE STORIES

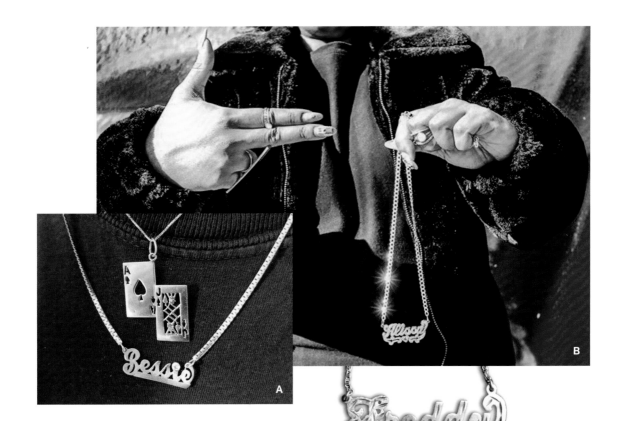

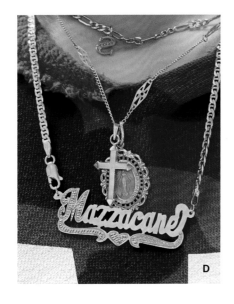

THE NAMEPLATE

A

I grew up in the '90s in a middle-class suburb outside of Philadelphia that had a large Jewish population. When I was born, I was given a nameplate bracelet—just my name engraved on a thin gold bar—a common gift to give babies in Jewish culture.

By the time I got to middle school I was going to Bar or Bat Mitzvahs (a coming-of-age ceremony for 13-year-old boys and girls) almost every weekend and I noticed that many girls received nameplate necklaces as gifts, always in gold and cursive. It was around this time that I discovered my grandmother's nameplate necklace in my parents' dresser, where they kept family photos and other heirlooms like my dad's kippah from the 1930s. I never fully understood my family history, so rummaging through these objects was a way to find connection and meaning.

I recently learned that, although my grandmother was born in the late 1800s in South Philly, she wasn't given a nameplate until the 1960s. Hers was a chunky gold rope chain with a double-plated "Bessie," written in cursive with a diamond above the "i." Depending on which family member you ask, this necklace was either given to her by "Morton the doctor" or by her cousin's husband, who owned a store on South 8th Street in Philly (Jeweler's Row) called Kanell Jewelers, which I believe still exists.

Bessie died when I was 3, so I don't have memories of her, just the nameplate with its diamond-dotted "I." I used to wear it all the time until one day I took it off and I haven't found it since. I actually think about it constantly and I hope it magically appears one day.

B

I've had this nameplate since High School . . . It wasn't until years later I noticed the attention to detail my mother took when creating this. My family is from Guyana . . . jewelry is one of the highest forms of a gift. She could have went to the Colosseum Block on Jamaica Ave in Queens but instead she went to Chinatown in Manhattan. She wanted it to last so she had it double-plated. She wanted it to stand out so she got it with the diamond-cut style. And most importantly, she wanted it to be uniquely me so she added my birthstone to the heart. I'd cry if it ever went missing.

C

My Titi's necklace when she was dating my uncle. They've been happily married since 2001.

D

This is my last name. The origin is Moroccan, then when they migrated to Italy it became the Italian version. I grew up disliking my last name but I grew to love and embrace my heritage so about a year ago I decided to get a nameplate chain of it.

E

My first "boyfriend" and now husband, Frank, gifted me this necklace for my 12th birthday. He was also 12 at the time so you can imagine how long it took him to save up to buy this. It's one of my favorite pieces of jewelry. Ten years after he gave it to me I wore it to my bridal shower. A true Brooklyn kids' love story.

[Editor's note] The above story was first submitted in 2017. In 2021, Bessie's nameplate was found.

NAMEPLATE STORIES

A

My first nameplate, I guess you can say, was my engraved baby bracelet, a staple for Nuyorican infants. In fourth grade, after moving from Far Rockaway to Puerto Rico to Orlando, my mom saved enough money to get me a birthday gift I had begged for: a silver nameplate necklace. Come sixth grade, I preferred gold over silver and got a gold nameplate necklace as well, often wearing the two together—the original 2 Chainz. That was the same year I got my first nameplate gold hoops, which I no longer have. A year later, when mami got me my classic nameplate bamboo earrings, which I've rocked on a regular basis for the last 15 years, she took my old joints and replaced my name with hers, wearing them still today. In high school, about freshman year, I got my gold nameplate ring, another piece of jewelry I've rarely taken off since then. These nameplates mean so much to me. They at once represent my identity as a NuyoFloRican chonga from East Orlando (551, what's poppin'?), my mami's hustle to make her baby girl's dreams come true, and my figurative "FU" to respectability politics in the workplace, where they prove hood shorties of color are brilliant, talented, fine, and worthy of attention and respect, just as they are.

B

I have been obsessed with hip hop/fly girl fashion since falling in love with underground hip hop culture in 1990. Unfortunately, in Australia, back then (before the days of online shopping) we could barely get a pair of Puma suedes or Adidas shelltoes, let alone a nameplate necklace or bamboo nameplate earrings. So when I finally traveled to NYC in 2002, the first thing I did was go on to Canal Street to get a pair of gold bamboo earrings made with Natasha in running writing. These earrings are still my favorite to date and I have heaps of nameplate accessories now. Another favorite is my nameplate necklace my partner bought me as my 'push present' gifted to me as I was going into labor 10 years ago. I'd also like to note that it used to really piss me off in the early '00s when white women would be like 'ah, just like Carrie Bradshaw' or compare me to J.Lo. To this day, most people who aren't from NYC still don't get it, but as long as I wear and paint my name proudly, I KNOW I AM SOMEBODY.

C

I'm from Malaysia and to be honest I don't think nameplate jewelry is a huge cultural thing here. If it is, it doesn't get talked about enough. But in my family, it was a tradition. I have a gold necklace with my name on it made by my tok che (great-grandpa). He had it made for his great-granddaughters when they were born. However, my little sister didn't get one. He was still around when she was born in 1996, but he got brain cancer around that time and passed away in 1998. I remember my mother telling me that before he was diagnosed he was extremely forgetful about things, like he would drive the motorcycle and not remember the way home. So I think maybe the reason why my sister didn't get one was because he forgot, or at least I'm trying to think of it that way.

My mother told me that my name necklace had to be made twice because my tok che got my name wrong lol. So my family is originally from Kelantan which is a state on the east coast and we have our own dialect and a lot of the spelling and pronunciation can be very different from the original word. He spelt my name as Nodiah (which is not a real name!) and my mother was furious lol. But he got it changed so all is well.

D

So, in my home at 13 years old you received a rite of passage—a nameplate, being a NYC kid. Been happening WAY before #sexandthecity. Here's my daughters' and my own . . . a ring, and then an old boyfriend who was a graffiti artist, KEL1ST from the 1980s.

E

My nameplate was a gift from my dad who passed away in 2005. I got it for my 13th birthday and had it for my entire life. I am 51 now. It just got stolen in a home invasion so all I have is pictures and memories. The photo is from SUNY Cortland in 1987.

THE NAMEPLATE

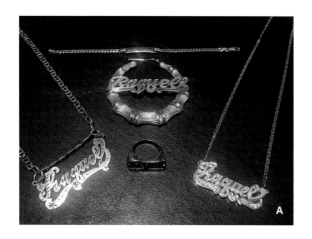

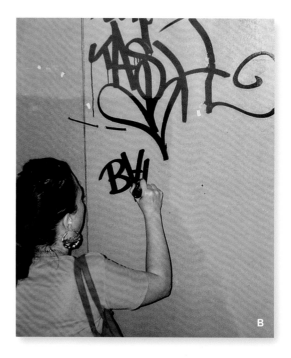

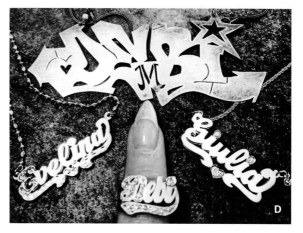

NAMEPLATE STORIES

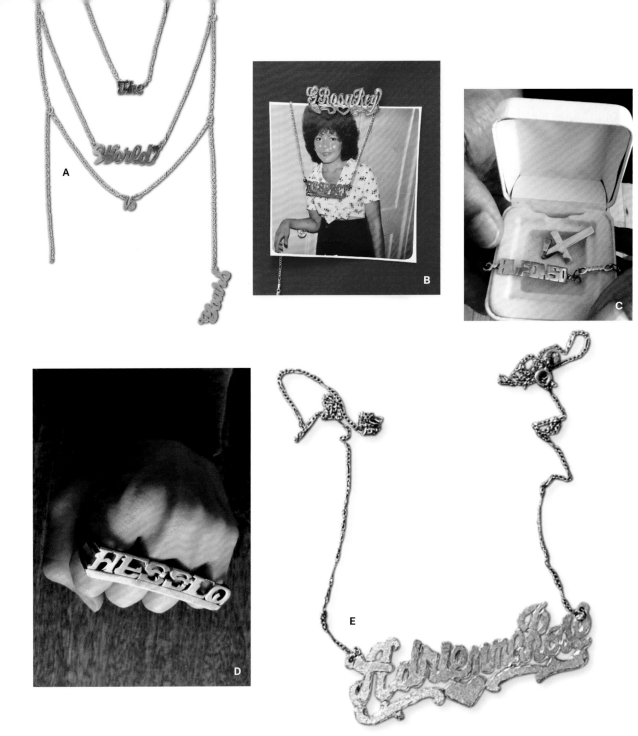

THE NAMEPLATE

A

I was always obsessed with my big sister's and cousins' nameplate necklaces. ALL the Cubanitas in Miami had one. My mom wouldn't let me get one in elementary school because she thought it was "de chusma." As a roquerita in middle school, I totally rebelled against them then. As a multimedia artist, I cull my childhood for inspiration and have made multiple pieces about the movie *Scarface*. An immigrant rags-to-riches story, it is a hyperbolic farce on the American Dream, and I became really obsessed with the tagline "The World Is Yours." I made a mirrored (a visual pun) jewelry case to house a nameplate necklace that reads the line, but the "Yours" hangs on one chain, as a commentary on the falsity that is upward mobility for immigrants who land in the US with so much hope.

B

Coming of age Hartford, Connecticut, early 1970s.

C

Alfonso means "ready, willing, and brave." I received this from my father before he passed away in 2021.

D

My four-finger gold ring was purchased in 2008. It reads HESS-LO, which was my alias back in my New York City public school days. For context, the moniker HESS, created by an older cousin of mine, is a simplified version of my name in Spanish, with a nod to the Hess Corporation back in the '90s: Heraldo, Heddy, Hess. It then became my tag and a name that only close family and friends knew me by; my mother still calls me Hess. "LO" is for my affiliation with the Brooklyn-based subculture of Lo Lifes.

I was always inspired by Hip Hop jewelry of the late '80s (read: Rakim and Kool G Rap), and wanted to own a piece of that era but add my own twist to it. The typography of the ring was directly inspired by Raekwon's logo, specifically from the album art for *Only Built 4 Cuban Linx*. At a first glance, the letters of his logo appear distorted, but when you look closely you will realize that the letters are conjoined by an uppercase and lowercase letter. I'm unsure who designed Raekwon's logo, but I was immediately inspired to create my own, only this time, I had to back-solve for the letters that weren't available for me to reference: H, S, and L. I tapped my cousin Junior for this task and we figured it out. The ring was fabricated at a jewelry store in Corona, Queens.

Two years after I purchased the ring, I lost it alongside a bag of my other belongings (including other jewelry and electronics) at Rockaway Beach. Someone had been plotting on me taking off all of my jewelry before hopping in the water, and had sneakily grabbed it while I wasn't looking. I came back with no bag in sight and negative $8,000. My cousins who were with me encouraged me to file a police report, and so we did exactly that before departing the then-ruined summer day at the beach. Three months later, I received a call from the 100th Precinct in Rockaway with news that someone tried to pawn my four-finger ring and the owner of the shop had reported it to the precinct because the ring was so unique and distinctive.

Although I never got back my other belongings, I was reunited with my four-finger ring. A moment in time and a piece of jewelry that will never leave my possession, at any price.

E

I got my first nameplate from my mother on my 16th birthday. It was beautiful and had an emerald in the dot of the "i" but sadly it went missing. A few years later my father took me to the Swap Shop and let me pick out the new one you see in this picture. I still have and wear it on occasion till this day. It was a tradition for girls in our family and in the neighborhood to have a nameplate necklace. I still wish I had the first one because it was different yet somewhat more elegant and unique than this one, but I still love the sentiment of this one too.

A

I am no stranger to the art of giving and receiving gold. As a Pakistani, we are given a gold chain with an 'Allah' pendant on it before we can walk, our mothers have special pieces waiting for holidays and we are taught that the one thing there is value in, is gold. Since a child, I've gone to my fair share of traditional Pakistani weddings. The bride wears red and is draped in very heavy gold from head to toe—I never understood why they were gifted such big pieces of jewelry that were kept away in a safe and no functional jewelry they could wear every day. I later learned that on their wedding day, the couple is given gold of extreme value and as time progresses, the value goes up. If the couple ever sees financial hardship in the future, they can sell the wedding gold for the money in the time of need. Growing up in a culture where gold meant different things allowed me to form a complex relationship with it. When I'd buy sneakers, my mom would do (incorrect) math and conclude that instead of buying sneakers, I could've saved up and invested it in a piece of gold jewelry . . . but mom, these are white AF 1s and buying them is my civic duty as a New Yorker. As a bushy-eyebrowed preteen, I'd walk around the house secretly wearing my brother's herringbone chain and often pleaded with my mom to let me wear her rope chain; she refused everytime (except on birthdays) because my late grandmother (her mother-in-law) gifted her that chain and it was special to her.

I decided I wanted a special chain, and because I was an NY kid down to my bones, this chain had to be a nameplate. I called my uncle in Pakistan and asked if he could send me a chain that had my name on it. Weeks later, I was gifted a chain that said "Rimsha," the name my family calls me. Although this was the most valuable item I had, I remember feeling a sense of disappointment. I was Rimsha, but this isn't the name everyone called me. I was 11 years old and still growing into my identity as a Pakistani-American and the last thing I wanted was one more thing that made me different from others. Nevertheless, I decided to wear my chain to school, a place where people knew me as "Ramshah." I forgot that an NYC public school is a battleground, and for the first few days I wore my chain there was a lot of speculation from classmates. In the midst of science class, my friend turned to me and said, 'they spelled your name wrong on your chain.' I was exhausted by this act of explaining another part of me and lacked the courage that allowed me to take ownership of my tri-lingual identity—I just wanted proximity to be as American as possible. I stored my chain back in its case. Late in 2018, someone asked me the proper way to pronounce my name. I explained that although my name is

Ramshah, my family called me Rimsha, and began talking about the chain I got over a decade ago. I realized that I had to make peace with my identity, before I could share it. I forgave myself for burying my identity because I wasn't ready to answer these questions in 7th grade or explain how the most special people in my life call me Rimsha, but I am now. Gradually, this chain became vital to me understanding my identity and wearing it became an act of rebellion to my 11-year-old self, who thought I'd needed to be as American as possible. I began thinking about the different ways gold has meaning in my life and the chains my friends wear—whether it be a nameplate, a chain given to them by someone special or in memory of someone they lost. Wearing these chains is a way for us to make peace with ourselves or preserve an event that happened in our life. Storing my chain away was me running from my identity cause others didn't understand it, and wearing my chain again was me embracing my identity because I finally understand it. (Photo by Ramshah Kanwal)

B

My Georgia nameplate was my 16th birthday gift. I was given a choice of the necklace or a party. I made the right decision. The bracelet says Athena in Greek. It was made in Greece as a gift to my sister when she was born in '76. I wear hers as a little reminder of my sister since we live farther apart now.

C

A memoir.

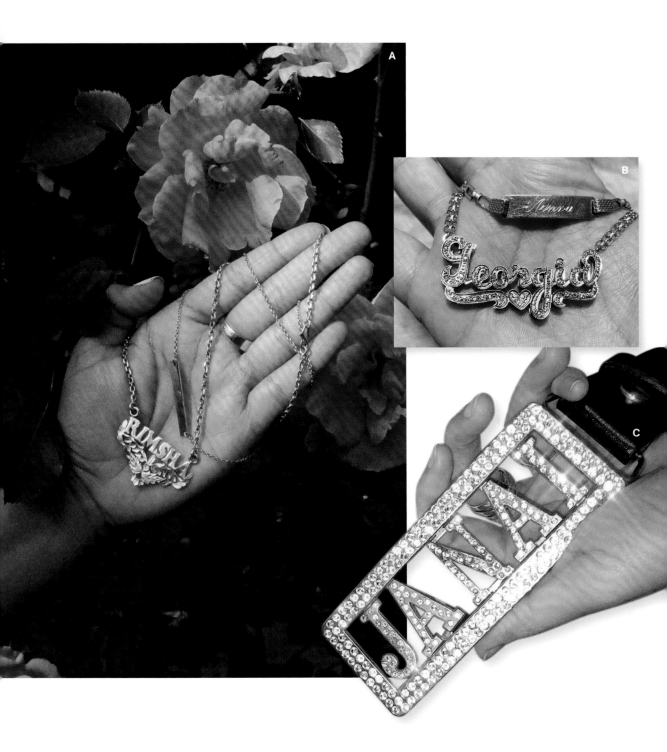

A

B

C

NAMEPLATE STORIES

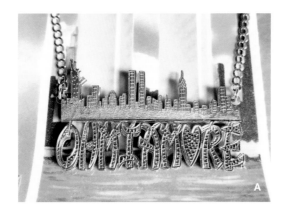

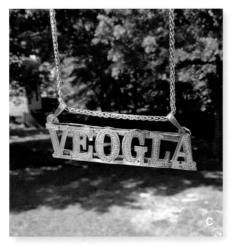

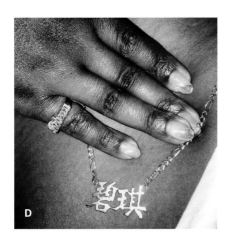

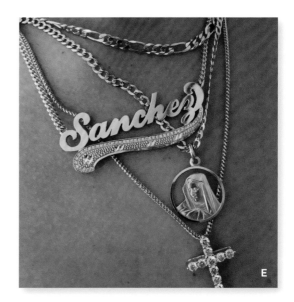

THE NAMEPLATE

A

I prefer my name in all caps because I like my presence known. OHMIAMORE is technically my artist name but my art has intertwined with my personal life so it's just me. It's a play on words: oh, mia more, or oh mi amor(e). When my lovely best friend Isabel gave me a nameplate of my choice for my 31st birthday, I already knew I wanted the NYC skyline. There would not be an OHMIAMORE if NY hadn't raised me.

B

My mom gifted me my chain when I turned 15. She couldn't afford throwing me a quinceañera so instead she got me a nameplate chain. She did a monthly payment for it. When I turned 16, she got me stud earrings with my name on them. I wear my chain every day, it's a part of me. I feel naked without it and it made me love my name more. I could never find my name in key chains at gas stations so when I got my necklace with my name on it and it was double plated with a heart, I was hype. Most recently my mom got me a new chain with an "E" pendant for my middle name Elizabeth, which is also her name. I love how she understands why nameplate jewelry is important to me.

C

The man who made it was arrested, so when people ask me where to get it from I can't tell them. And because my name is very different, when dudes ask for my name they think I'm lying. Then they see the necklace and say, "Oh, you can't be lying."

D

Having a nameplate in NYC is like a rite of passage. I've always strived to be different, and growing up my mom owned a Chinese name chain. At 14 when I got my first summer youth job I finally decided to get my own made! From there on a collection has ensued.

E

In my family, giving jewelry is a significant expression of love and trust, but also growth. The chain length you receive you may need to grow into . . . or you may receive a piece after a moment in your life that you grew from. My 'Sanchez' nameplate came 15 years after my dad gifted me my first plate—it was a white gold double-plated "Mellany" with diamonds & cuts in the M, the swoop, and the heart. He had it made in Bushwick, no doubt. I still have it, but life has made it too precious to wear. To commission my own chain so many years later and in our surname was an homage to him, and to the value I have for our identity. This piece is a solid single plate with the swoop of my dreams—custom-cut features and a row of diamonds on a Cuban link chain.

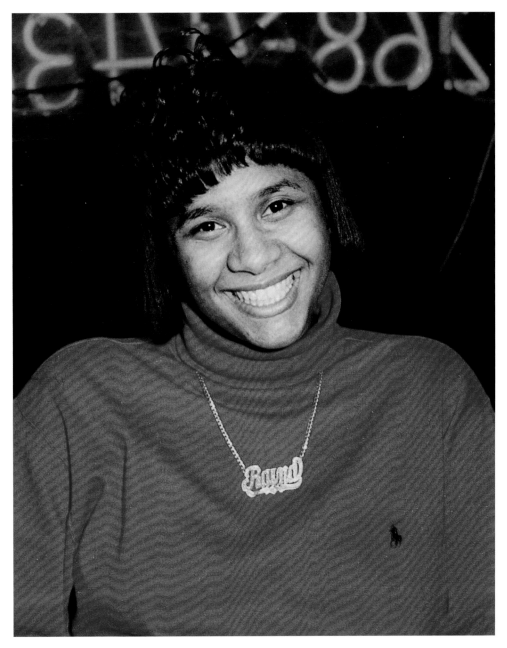

THE NAMEPLATE

Raina Broushet at a hair studio in Manhattan, 1991.

Jaquan had JAQUAN in rhinestones on his waist.

Wait

They couldn't have been rhinestones. Maybe cubic zirconium or Swarovski? Outlining the name Jaquan, a couple inches, maybe six inches below the waist.

We all saw it.

Over time. Week by week, we saw the stones disappear.

<div align="center">

JAQUA

JAQU

JAQ

</div>

He was my first black friend at school. I had a black friend named Dante in preschool but that was different. He was different. Jaquan was the first person to call me an African booty scratcher. He was the first person who told me to listen to 50 Cent. The first person under 10 years old who wore a du-rag and was close enough to actually talk to.

(I only talked to Lil Bow Wow or Lil Romeo in my dreams or through a screen.)

He was the first person to talk to me about an older brother doing bad shit. And, the first person whose Black Life just seemed all out in the open and exposed but also still so far away. His mom worked in the cafeteria and his sister was a few years ahead of us in school. I saw him every morning, first thing in the morning, after my own family. He was there listening to a Walkman, head against the table, resting up before a long day or doing homework. His mother always slipped us a nicer breakfast.

That belt tho.

When the belt lost its allure, Jaquan got an earring. Silver and gold, curving up along his ear, cursively spelled Jaquan. The whole situation was held in place by a chewed-off Dixon Ticonderoga eraser.

That earring.

Every few weeks or so, my mom and I would go to Kings Plaza Mall to pick up CDs, catch a movie, eat pretzels, walk around, stumble into Finish Line, Lane Bryant, or Old Navy. RIP SAM GOODY. The walks between those familiar locations were thrilling. How many times could we walk by the nameplate kiosk? How many times could I see all the options? Red rhinestone belt buckles. Plain silver. Gold.

I don't think I ever even asked my mom for one. If I did, her response had something to do with how strange she found it to parade your real name around. "I'd just get Jay. That's generic," I'd say, and then somehow she was able to keep the conversation at the level theoretical. Always a hypothetical.

I didn't really want that. To be that exposed. Who would see it anyway?

You don't really want that. To be that exposed. Who would see it anyway?

Do I really want that. To be that exposed. Who would see it anyway?

Really frustrating questions.

That's how it was with du-rags too. It had to be a private pleasure. In the house only, for years. I didn't want to be perceived that way. Of course not. We both grew out of that. Or maybe I should say she did. My mom. I really don't know.

I wore du-rags out of the house eventually.

I still haven't owned a nameplate piece, though.

NAMEPLATE STORIES

Azikiwe Mohammed

Knockdown Center
Queens, NY, 2017

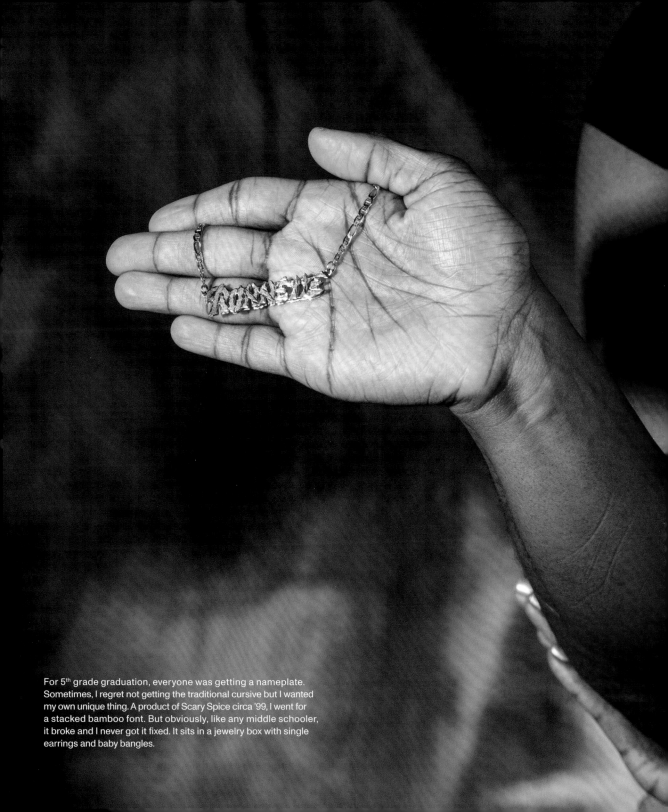

For 5th grade graduation, everyone was getting a nameplate. Sometimes, I regret not getting the traditional cursive but I wanted my own unique thing. A product of Scary Spice circa '99, I went for a stacked bamboo font. But obviously, like any middle schooler, it broke and I never got it fixed. It sits in a jewelry box with single earrings and baby bangles.

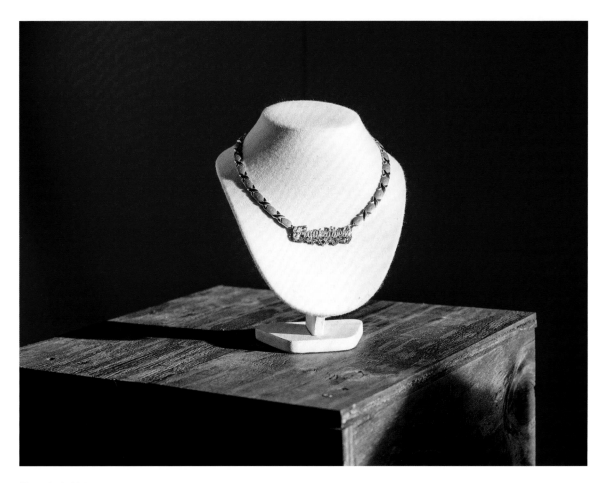

Figuratively, 2017.

THE NAMEPLATE

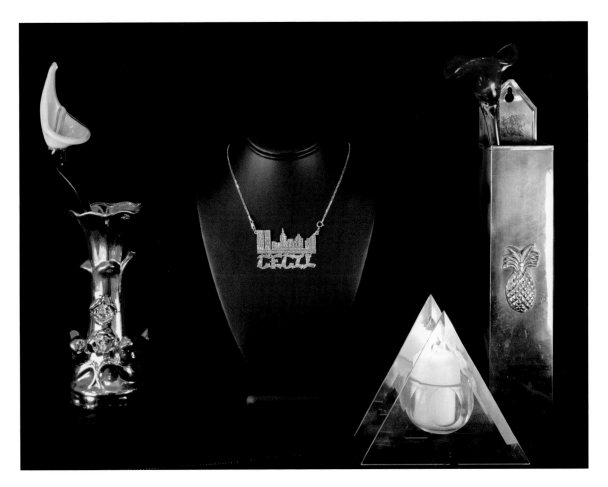

Cecil Robinson, 2017.

AZIKIWE MOHAMMED

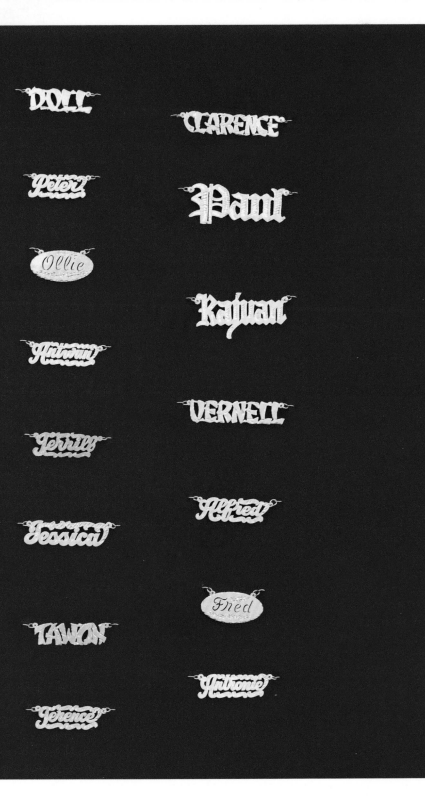

Azikiwe Mohammed, *Unarmed*, 2016; 39 custom-ordered pendants mounted on a red jewelry board, each bearing the name of an unarmed Black person killed by the police in 2016. The style of the nameplate is dictated by the age of the person, and the metal by whether they died in custody or in the street.

Naima Green

Cafe Erzulie
Brooklyn, NY, 2018

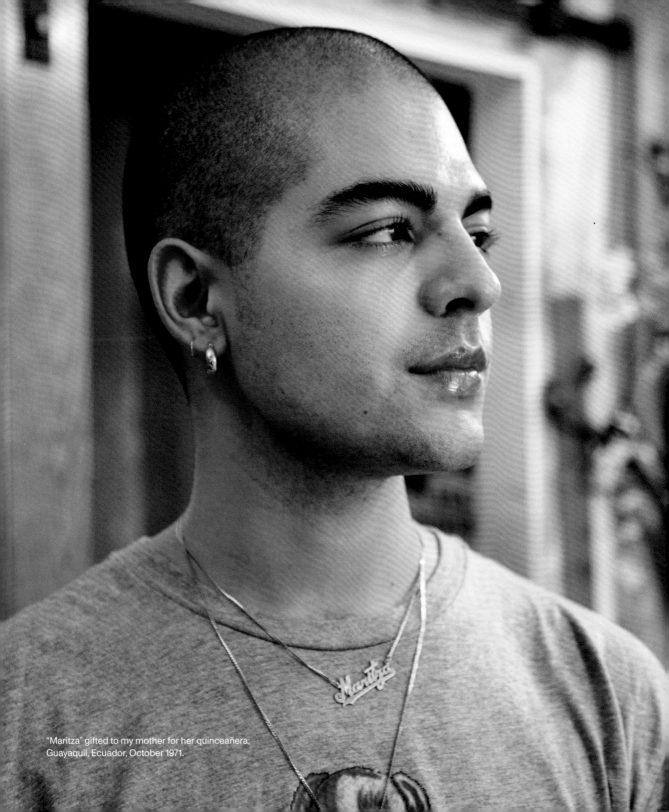

"Maritza" gifted to my mother for her quinceañera;
Guayaquil, Ecuador, October 1971.

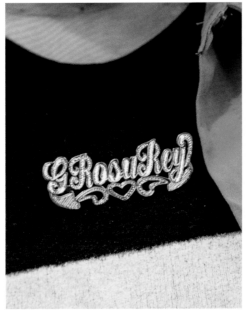

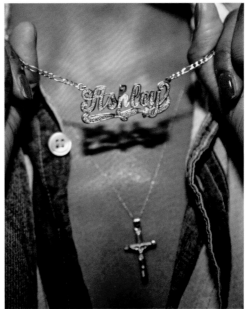

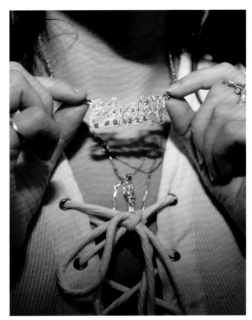

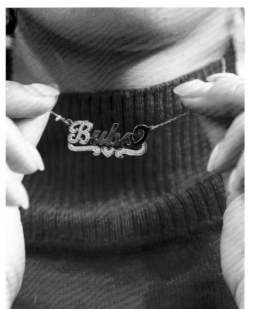

THE NAMEPLATE

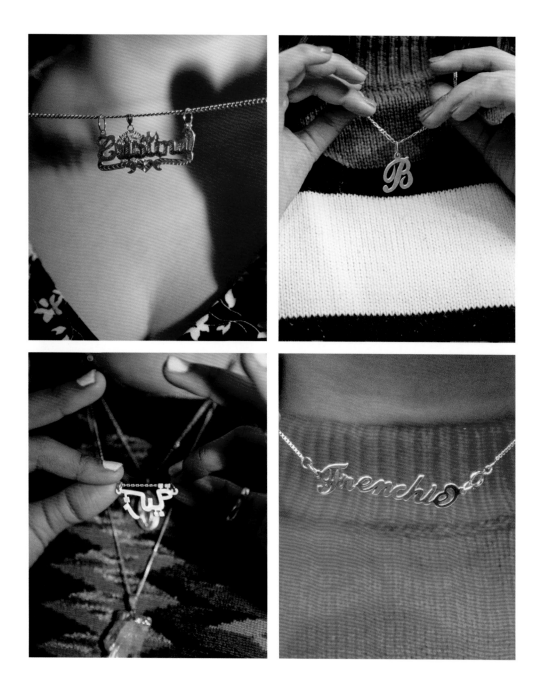

NAIMA GREEN

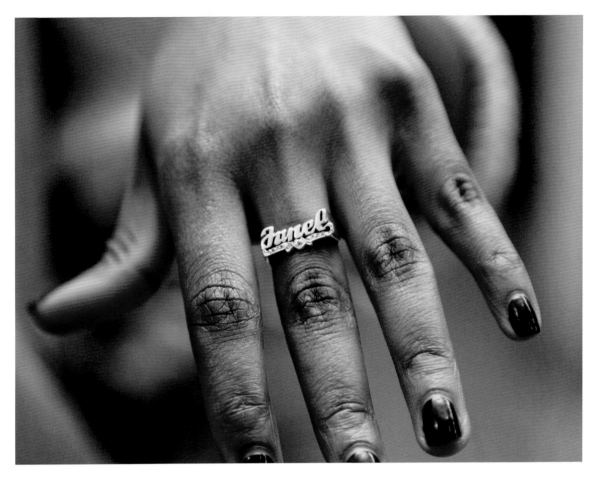

When I was in middle school, my stepdad gifted me this ring. The gold on the back is thinned and cracked, but I finally got it fixed in my 20s.

THE NAMEPLATE

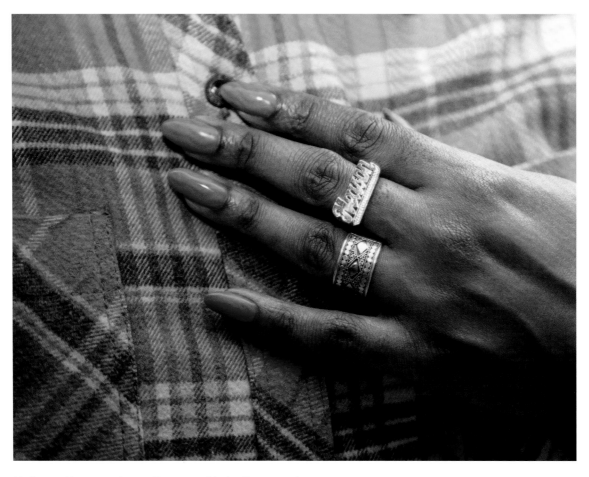

My ring says Neason; my sister and I are some of the last Neasons, and wearing this name is a daily homage to the cities that made me, and the boro I love. It's an expression of love, belonging, and loyalty.

NAIMA GREEN

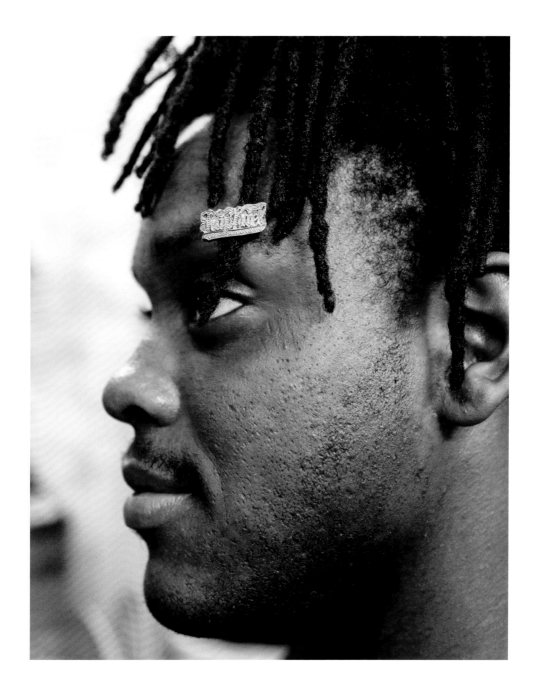

THE NAMEPLATE

My sister bought my nameplate for me when I turned 15 years old, my quinceañera. We went to the flea market in Houston and picked out a design with the birds and heart, just like hers. I'm rarely not wearing my nameplate.

The nameplate was given to me by my grandmother who I was named after. I have other special pieces of jewelry that she gave to me before she passed, but wearing her necklace means so much to me. It becomes even more special each time someone compliments it. I think of it as she's speaking to me.

NAIMA GREEN

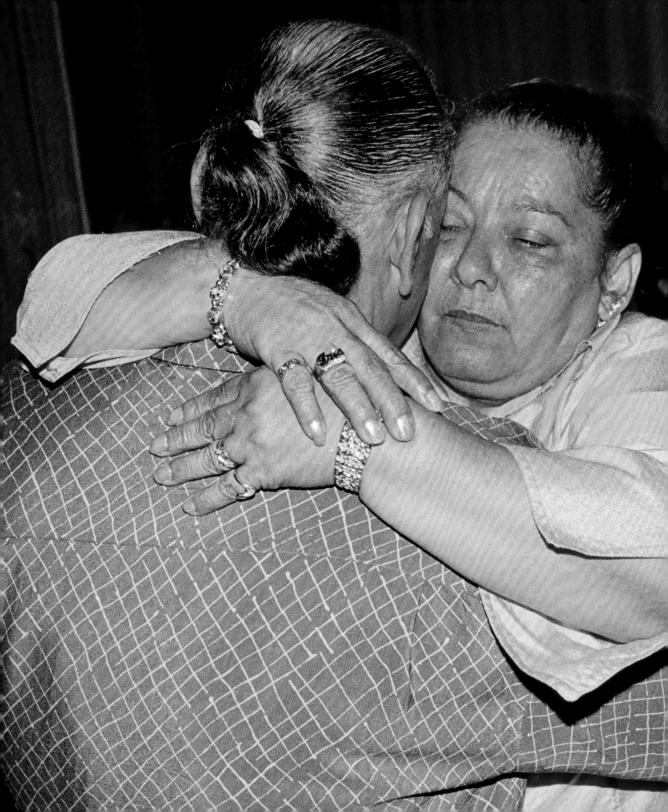

Rafael Rios, *Grandma and Papi Dancing*, from "Family," 2018.

Live from the Colosseum

Eric Darnell Pritchard

that was greater than 14-karat gold, which was itself a luxury on the salary of a postal worker and single mother. The jeweler offered to wrap the ring nicely in a box, but she insisted on wearing it out of the store instead, another lasting symbol of her pride. It was time to show it off as we walked the streets of Jamaica Avenue (aka "The Ave"), a major shopping hub on the southeast side of New York City's borough of Queens, and eventually made the less-than-a-mile walk home.

I have come to think of this walk as the grand march, similar to the ways church folks "style and profile" in their Sunday's best at Black church functions.

Born in Queens in 1980 to a Black American mother and Nigerian father, Melissa McHenry, my best friend since our teens, said of The Ave of our adolescence, "It was everything! It was where everything happened. It's where you could go and get your bootleg CDs. It's where you could go and get your doorknocker earrings. It's where you could go to get to everywhere else in Queens. . . . For me, The Ave is the Grand Central Station of Queens. It's the 42nd Street, the Times Square of Queens."[1]

Fashion historian and curator Rachel A. Fenderson, born in 1984 in Queens to Jamaican immigrant parents, said her favorite thing about The Ave "was the fashions. . . . I loved to see women with their hair looking fly, their nails. These were things that I was looking at because those are things I also wanted to emulate, to see what was the latest thing I could do myself."[2] Fenderson's insights about The Ave are informed by both her personal experience and her scholarship on Jay Jaxon, an African American designer from South Jamaica, Queens, who became a couturier in Paris.

For adolescents, being able to finally go shopping alone on The Ave was a rite of passage into young adulthood. Ask anyone from the neighborhood about the first time they went to The Ave and the stories flow right out. The Ave is replete with memories, where people not only recall how they dressed to go to be seen and shop but also what they bought, and perhaps most important, where they bought it.

ERIC DARNELL PRITCHARD is a writer, teacher, and Black queer feminist alchemist. He is also the endowed Brown Chair in English Literacy and Associate Professor of English at the University of Arkansas and part of the faculty of the historic and prestigious Bread Loaf School of English at Middlebury College. He writes and teaches about literacy and rhetoric and their intersections with fashion, beauty, popular culture, identity, and power. He is the author of *Fashioning Lives: Black Queers and the Politics of Literacy* (Southern Illinois University Press).

"K-I-T-T-Y," I said slowly, spelling each letter as I held the ring in my left hand and slid my right index finger across the smooth surface of its face. The letters, written in cursive, spelled my mother's nickname (or, as she preferred it, her *only* name) in 18-karat gold. The diagonal tail of the *Y,* purposefully elongated under the bottom of the letters journeying back toward the *K,* created the effect of her name being underlined, especially since the line was accented with sparkling diamondettes.

My mother loved jewelry, so it was not uncommon for me to see her wear it, but this is the first time I was ever with her when she bought a piece for herself. This ring is the only piece that I remember her getting that spelled her name, and it was also the only piece of hers

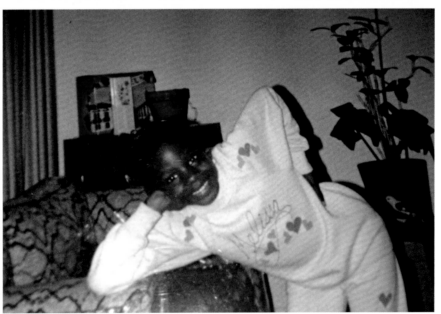

The Jamaica Colosseum Mall in Queens, New York.

All smiles in the living room of her family's apartment in Far Rockaway, Queens, a young Melissa McHenry, age 7, poses exuberantly in a pale yellow, customized sweatsuit gifted to her by her sister—one of several items of clothing and jewelry with her name that she received over the years, much of it purchased at the Jamaica Colosseum Mall and various stores on Jamaica Avenue.

THE NAMEPLATE

Rachel described the popularity and desirability of nameplate jewelry in the nineties and early aughts as akin to "having the latest Jordans. It was the style. And I guess like, also to have notoriety amongst us in Queens. The people who were considered the freshest or the flyest always either had the latest Js, whatever clothing trend, hairstyle, or nails was the latest, or also specifically the nameplate."[3] Her favorite were the nameplates within the bamboo earrings, and though her parents would not buy these for her, she remembers desiring a nameplate "because of community and friendship." She remembers, "All my friends had nameplates—all of them—and I just did not."[4]

If you were from Jamaica and bought a nameplate, The Ave was the place to get it. It is this attentiveness to where one recalls wearing, seeing, desiring, and buying nameplate jewelry that is as insightful as the design of the object itself. In such instances, we are able to glean the web of kinship, a kind of communal memory and practice, that, though not as visible as the name on the nameplate, is no less imprinted on the object. In that sense, the nameplate is a way people not only assert themselves, but assert the people and places that made them, and take them along wherever they go.

Without question, the most iconic shopping center on The Ave is the Jamaica Colosseum Mall, or as it's called by the locals, "The Colosseum." Located on 165th Street, The Colosseum opened in 1984. The mall is configured so that merchants can have mini shops and boutiques along its corridors. In everything from food to fashion, The Colosseum, like much of Queens, Brooklyn, and Harlem, was a mélange of sensations that transported people to various stops in a Black cultural landscape in just one space.

The most memorable part of The Colosseum is the mall's ground floor, which featured dozens of jewelry merchants organized side by side thanks to an open-floor plan. The Colosseum's structure, unbeknownst at the time to me and many of the shoppers of my generation, was built in 1947 as an R.H. Macy's—one of the earliest Macy's opened in NYC's so-called outer boroughs.[5] And though the ground floor, by design, is the very bottom of the building's physical location, it is often at the very top of people's recollection of buying nameplates and other objects featuring their names from necklaces and rings to bracelets and anklets, much of which was still too expensive for many in South Jamaica to afford.

As is so often the case when a particular fashion seems inaccessible on any basis, especially along class lines, people find a way. A unique characteristic of shopping at The Colosseum, as recalled by Rachel, Melissa, and me are the ways people could negotiate the prices of items including jewelry. Additionally, for young people in Queens in the 1990s, an alternative to a gold nameplate was a much more economical metal "dog tag," shorthand for the personnel identification tags often worn by members of the military. At The Colosseum, shoppers could get dog tags customized with their name and just about anything else for a small fraction of the price, thus making nameplates accessible to youth and others priced out of the trend, such as Melissa, who remembers having at least three dog tags:

> The first one was just my name. And then, you know, everybody got a crew. In high school, me and all the newspaper kids at school, we all lived in Queens but different neighborhoods, but had to go through Jamaica Avenue to get home. So, one day we all went to The Colosseum and got dog tags. I can't remember what it said, but it identified us as a crew [laughs]. At some point I also had one that the guy I was dating at the time got for me with our names on it.[6]

Another iteration of the nameplate for those who did not have the means to afford it but were devoted to the aesthetic and its import were objects that could be airbrushed with one's name in the style of the nameplate, such as acrylic fingernails, sneakers, bandanas, du-rags, T-shirts, sweatshirts, denim jeans, and jackets. As a child, for example, Melissa's sister called her "Missy B." Once she went to The Colosseum and got

121

a denim jacket with "Missy B." airbrushed on the back. She also got a yellow sweatsuit that had "Melissa" airbrushed in pink letters on the shirt, and "B." on the leg of the pant. She recalled that the same place that designed the sweatshirts also sold the dog tags and other options for getting one's name and other personalized designs at a cheaper cost than a traditional gold nameplate.

It would not be until she was an adult, however, that Melissa purchased her first piece of nameplate jewelry from The Colosseum, one styled almost exactly like that which belonged to my mother, though with a different name—not Melissa—but "Oshun." Melissa is an initiate into Candomblé, an iteration of traditional West African religion as practiced in Brazil, and she bought the ring as a gift to herself to mark the occasion of her initiation as a daughter of Oshun (o-shoon). One of the many divinities venerated in Candomblé—called Orixá or Orisha (o-ree-sha)—Oshun is associated with dominion over fresh water and is often represented with gold materials or colors, yellow, honey, and femininity, and with energies that, like water, can be malleable but also forceful. The gold ring has "Oshun" written in cursive with the letter *O* encrusted with diamonds. For Melissa, "wearing Oshun's name on my ring was for me to identify myself as her daughter, as her priestess, and as a visible reminder to everyone that I come into contact with that, even if they do not know who Oshun is, that she is there and ever present."[7]

The meaning of the nameplate in people's local fashion and style narratives provides a microhistorical lens onto its significance, one that adds texture to the object's already existing cultural-political-economic luster. In the case of The Colosseum, the stories of its patrons give insight into the ways the nameplate as a trend was appropriated by those for whom the object was inaccessible, who availed themselves of innovative ways to forge their own paths toward the self-affirmation evidenced at the convergence of style and identity.

[1] Melissa McHenry, New York telephone interview, 2021.

[2] Rachel Fenderson, New York telephone interview, 2021.

[3] Ibid.

[4] Ibid.

[5] Joseph Masheck, "Macy's Jamaica (1947): An Unsung Modernist Masterwork in Queens," *Brooklyn Rail* (September 2007): https://brooklynrail.org/2007/9/art/macys.

[6] Melissa McHenry, ibid.

[7] Ibid.

THE NAMEPLATE

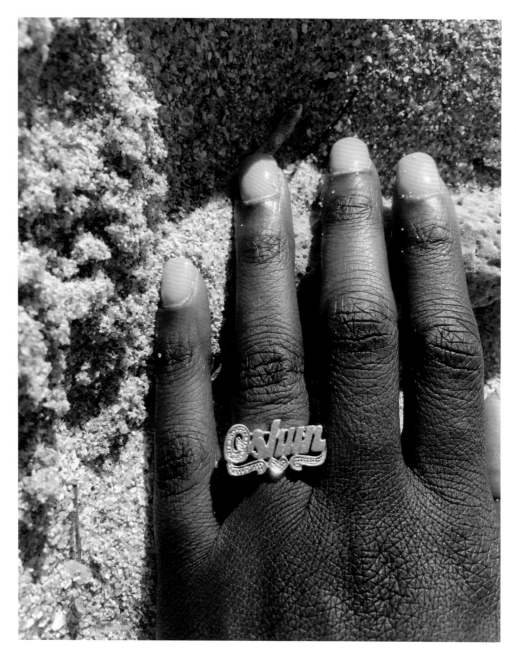

LIVE FROM THE COLOSSEUM

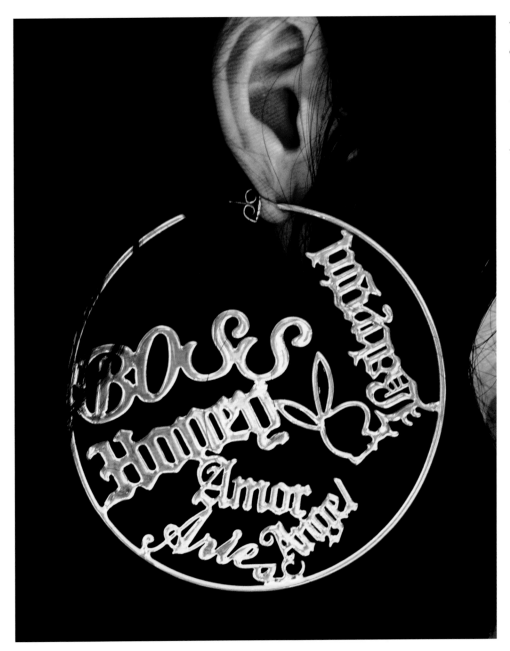

THE NAMEPLATE

Upcycled jumbo hoops made from earrings and pendants by Georgina Treviño, Mexico City.

Wildstyle name rings by Anjuna Bea, Paris.

3-D printed poetry pendant created by a sixth-grade student at Dr. Martin Luther King Academic Middle School for "We Are Here" at Yerba Buena Center for the Arts and the San Francisco Museum of Modern Art, 2019. Image courtesy of Vanessa "DJ AGANA" Espinoza.

LIVE FROM THE COLOSSEUM

Destiny Mata

Playground Coffee Shop
Brooklyn, NY, 2018

Abrons Arts Center
New York, NY, 2019

I was home in LA last week helping my parents pack up my childhood home and I came across some photo albums and decided to take a break from packing and flip thru some cute baby photos of me. Towards the end of this album, I came across this photo. An image of me (about 5 years old) wearing my nameplate necklace (circa 1992). Turns out my Grandma Berta (my dad's mom) sent it to me! Grandma Berta immigrated from Poland to the Bronx in 1963. She is/was a Holocaust Survivor. After the Holocaust, she returned to Poland, married my Grandpa, birthed my dad and survived Communism and Anti-Semitism before immigrating to the US. I wear this necklace every day to remind me of her strength and courage.

THE NAMEPLATE

DESTINY MATA

THE NAMEPLATE

DESTINY MATA

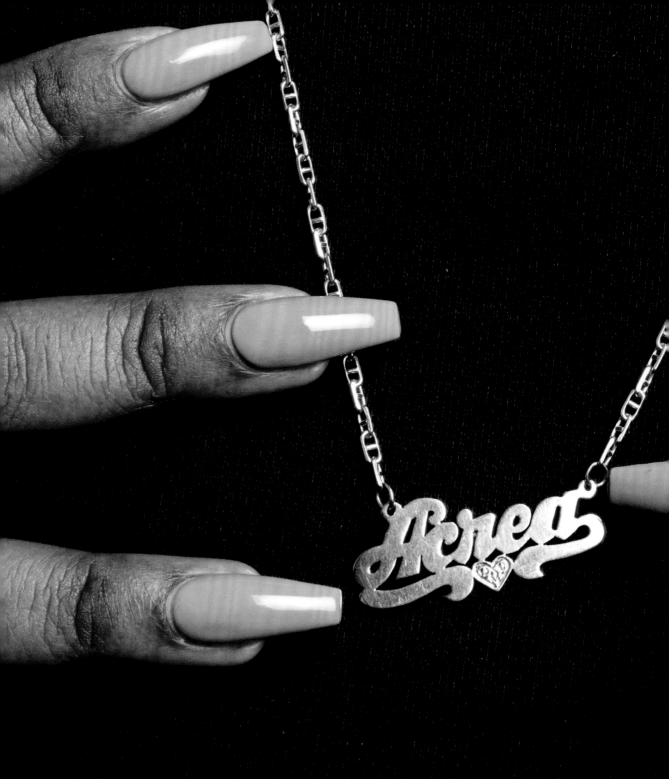

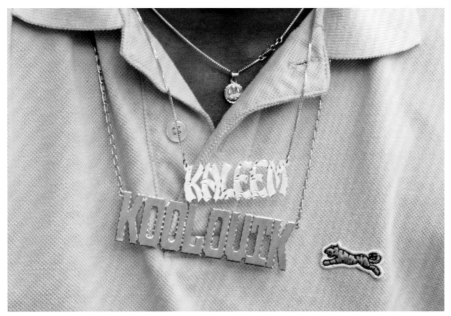

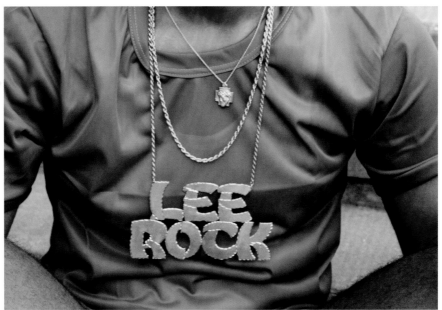

THE NAMEPLATE

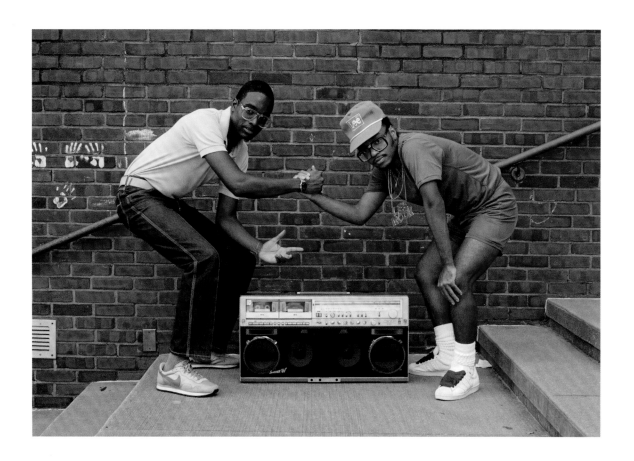

DESTINY MATA

THE NAMEPLATE

For as long as I've been alive, my father (who also named me) gave me the nickname "Cookie." When he passed away from cancer 3 years ago, I vowed to commemorate him every day. My ring is my way of carrying on his last name and legacy. My necklace was a gift from my mother which was also symbolic of our family. It was once stolen from a hotel room and later replaced. I haven't taken the ring or necklace off since then.

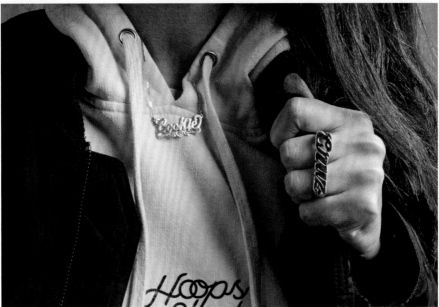

DESTINY MATA

Nahomi Rizzo

Abrons Arts Center
New York, NY, 2019

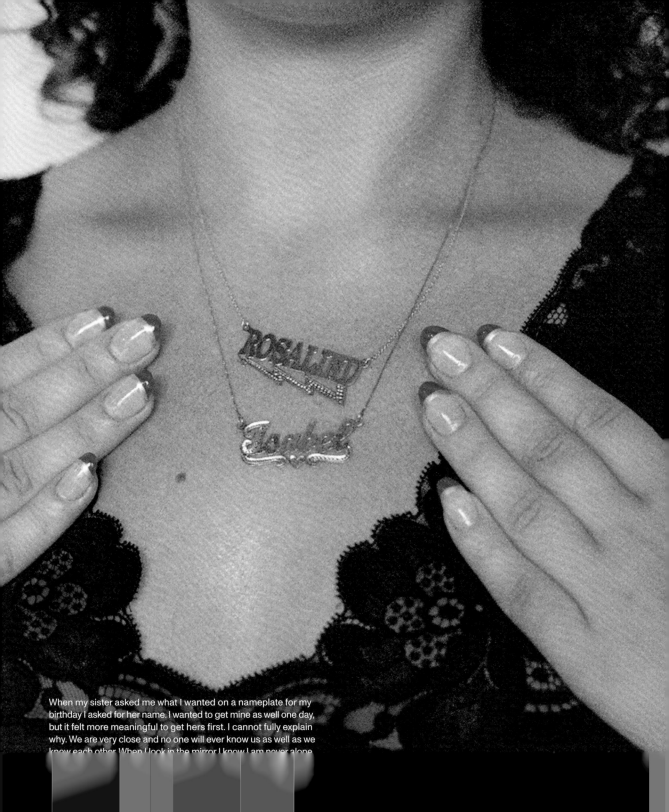

When my sister asked me what I wanted on a nameplate for my birthday I asked for her name. I wanted to get mine as well one day, but it felt more meaningful to get hers first. I cannot fully explain why. We are very close and no one will ever know us as well as we know each other. When I look in the mirror I know I am never alone.

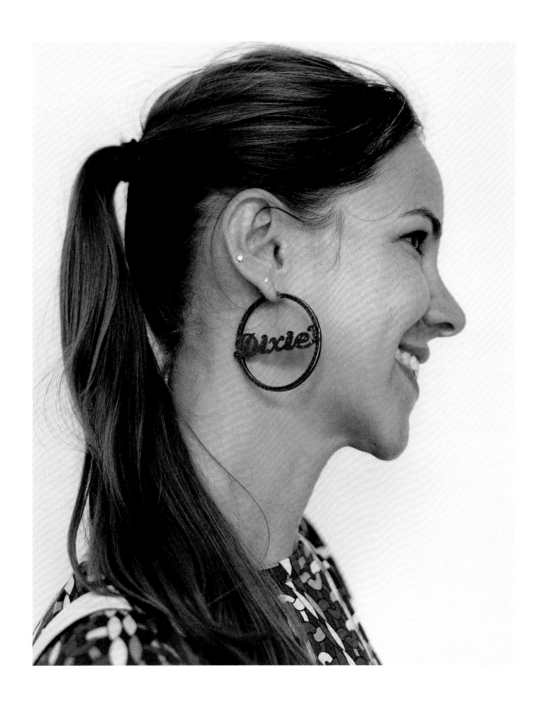

THE NAMEPLATE

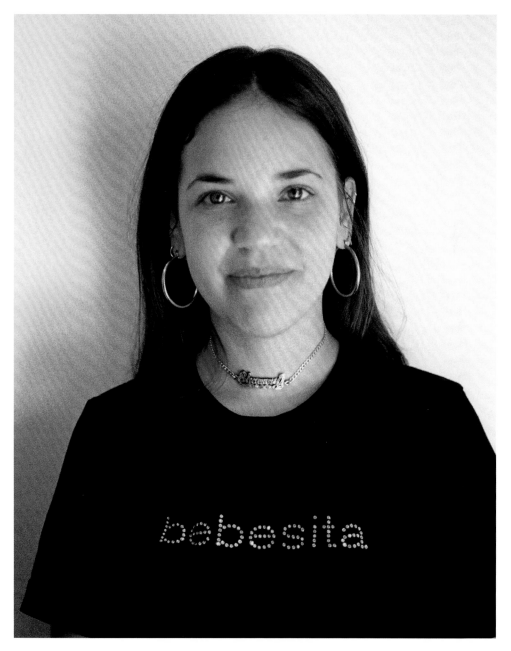

My mom got me my "Shammy" chain as a bracelet for Christmas in 8th grade. I ended up breaking it and getting it done longer to wear as a choker.

NAHOMI RIZZO

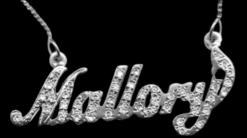
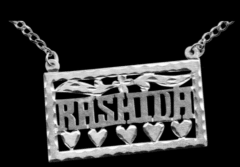
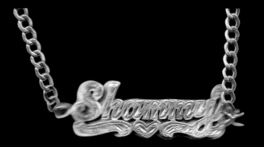

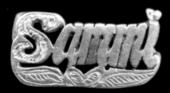

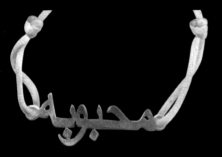

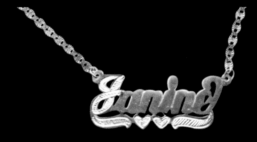

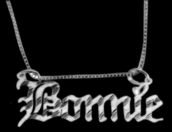

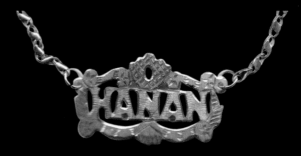
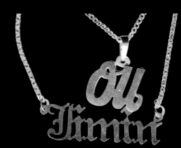

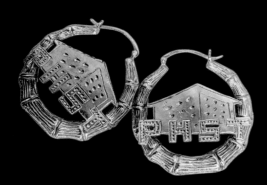

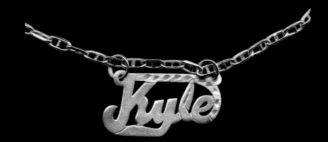

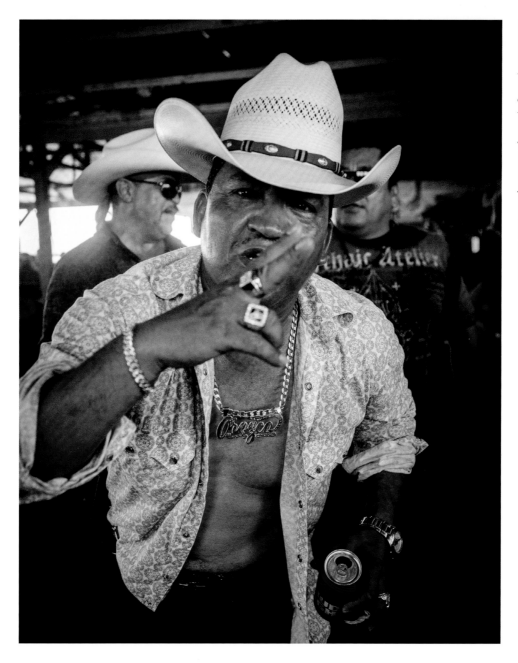

Don Orozco photographed by Arlene Mejorado, San Quilmas.

THE NAMEPLATE

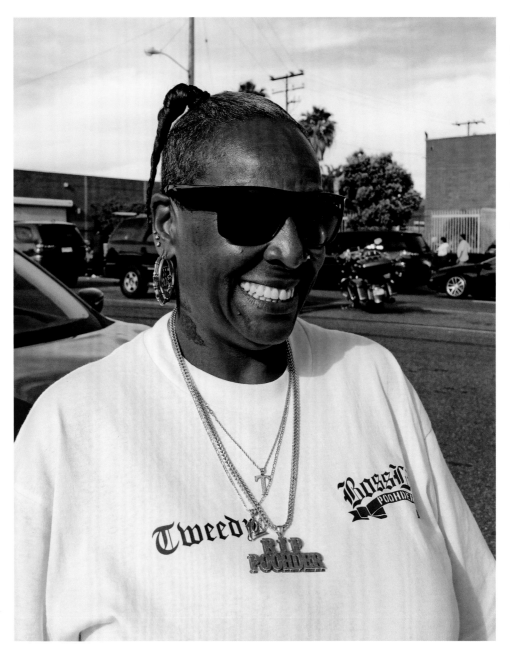

Tweedy photographed by Nichelle Dailey, Los Angeles.

THE NAMEPLATE

Gogy Esparza

Magic 128 Gallery
New York, NY, 2018

Abrons Arts Center
New York, NY, 2019

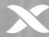

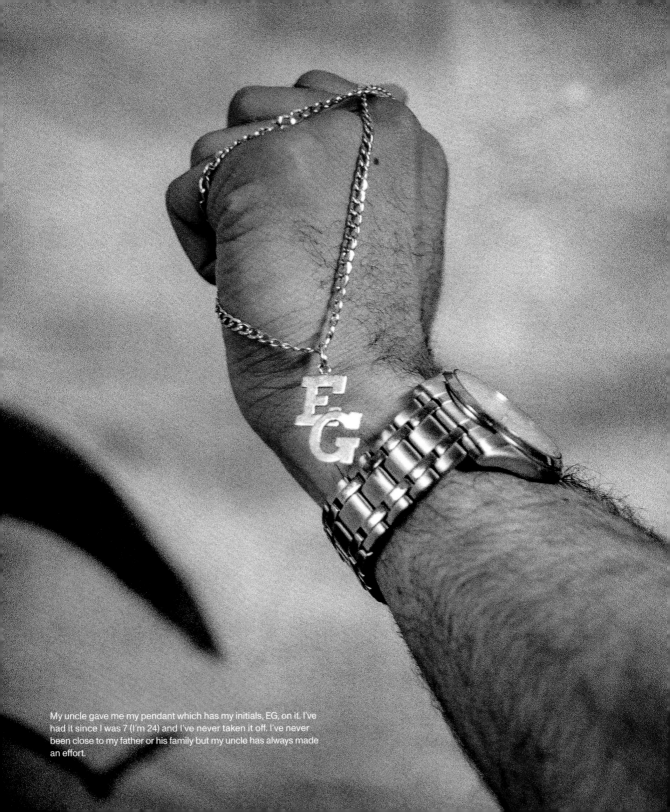

My uncle gave me my pendant which has my initials, EG, on it. I've had it since I was 7 (I'm 24) and I've never taken it off. I've never been close to my father or his family but my uncle has always made an effort.

I went to the jewelry store to get a name ring and was pleasantly surprised to see one with my name in the display case. The salesperson sold the ring to me to me for a discount. It was destiny.

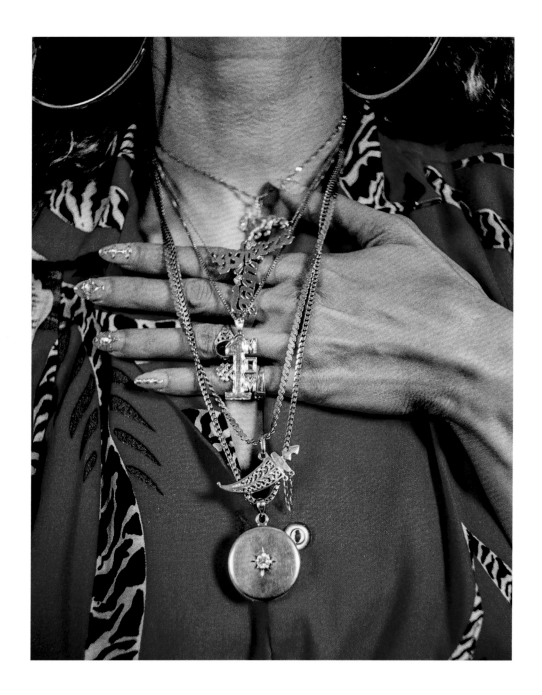

THE NAMEPLATE

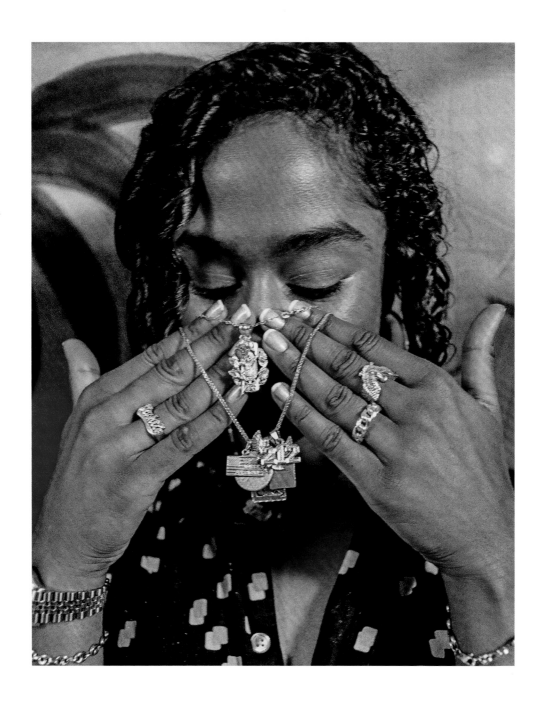

GOGY ESPARZA

An ode to mi mama, my nameplate celebrates Christine Saenz, born in 1957. Planted her placenta with a rose bush in our backyard. I wear her legacy around my neck.

THE NAMEPLATE

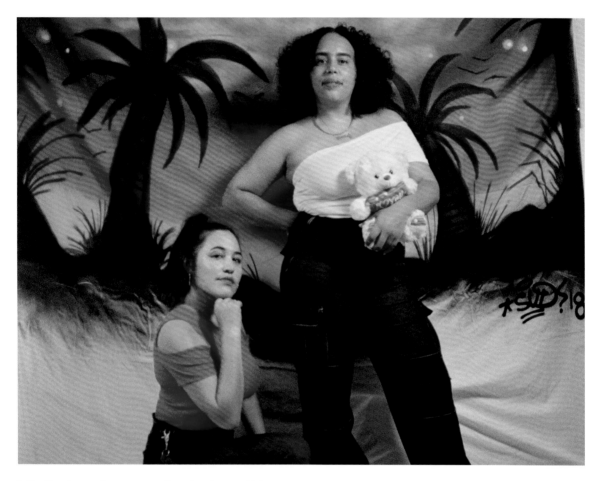

In San Francisco, my hometown, we always bought our gold downtown
at a spot on Powell Street run by fierce API women. I often think about
how so much of our beauty products in the Black Community are
sourced from Asian-owned businesses. From my nails to hair products
to gold—a moment of exchange, shared space and intimacy.

GOGY ESPARZA

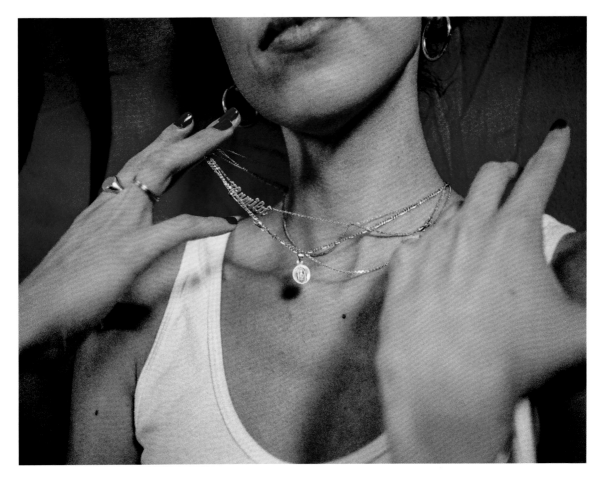

Your project has been very inspiring, and it particularly caught my eye when I read it was including nameplates from all over the world. When I moved to NYC from Mexico City, the parallels between nameplate culture made me feel more at home and even more proud of carrying my nameplates. My mother and my abuelita are from a very small and poor town off of the Pacific Coast of Mexico called Tecpan de Galeana in the state of Guerrero. When I was born, my grandparents got a gold bracelet nameplate with my name for me. Growing up, and even today, some kinds of gold jewelry (specifically nameplates) were considered a tacky "poor man's luxury" by classist and racist members of Mexican society. As a child, people's condescending questions made me feel ashamed of my bracelet. Eventually, I became too self-conscious and stopped wearing it. My mother always kept it safe and gave it to me when I turned 19 and moved to NYC to study dance. NYC name chain culture played a big role in my reappropriation of such an iconic staple in my family. Now I proudly carry the Romero family, Tecpan, and my family's history with me.

THE NAMEPLATE

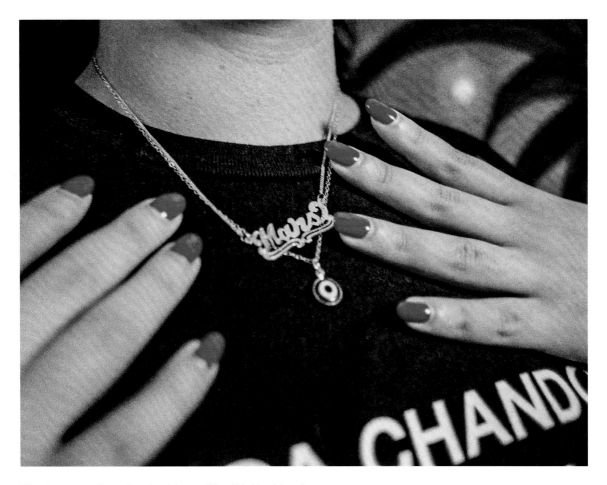

When I was a teen, I was given the nickname "Mars." My friend thought I was out of this world, haha, but really it was given during a time of transition. I recently got this nameplate as a reminder that I am still that bitch, despite cloudy times and moments when I feel like I don't have it all together.

GOGY ESPARZA

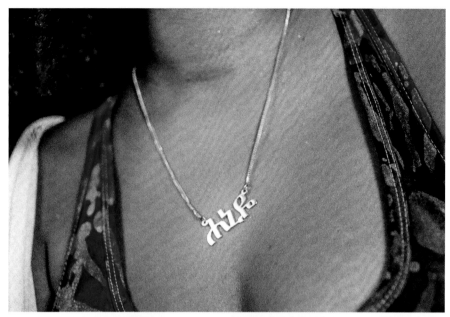

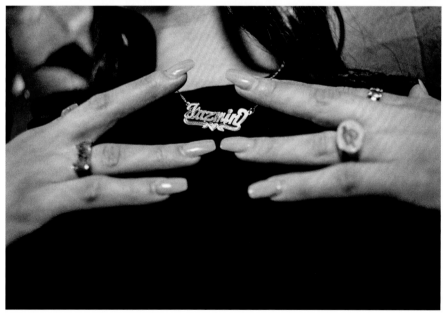

THE NAMEPLATE

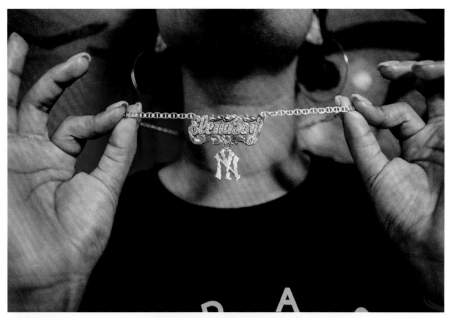

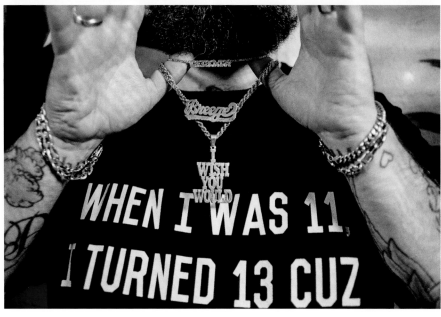

GOGY ESPARZA

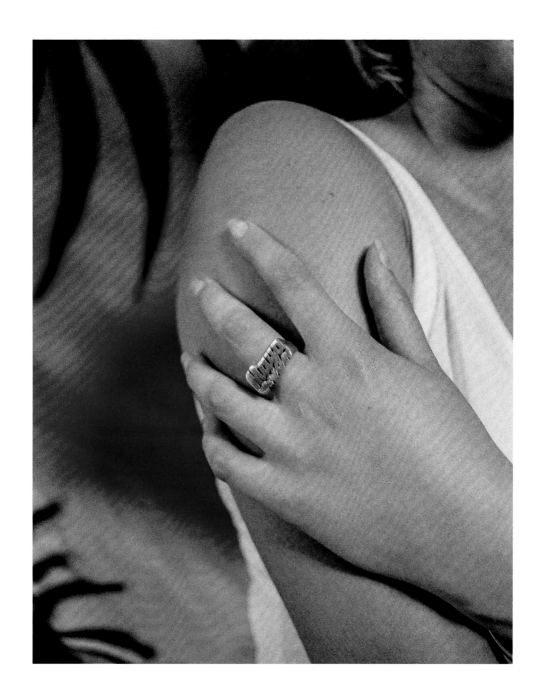

THE NAMEPLATE

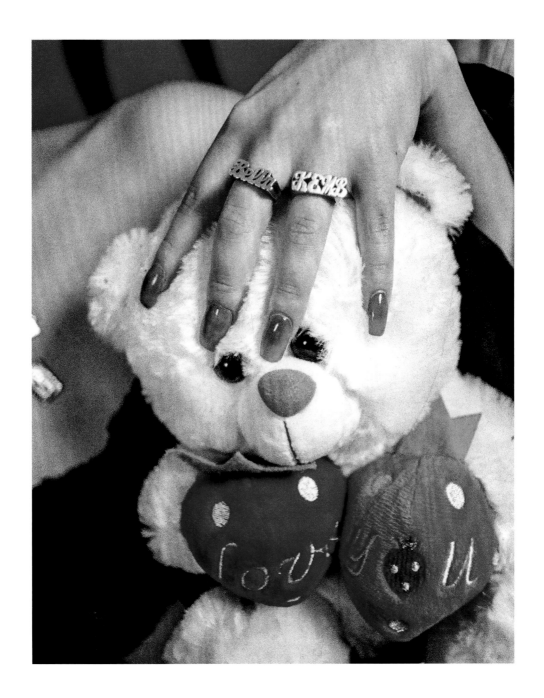

GOGY ESPARZA

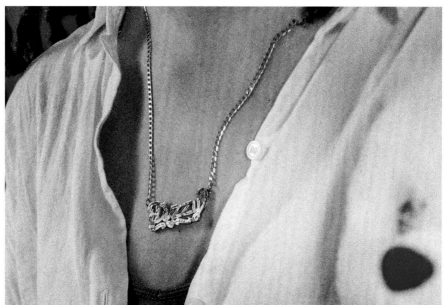

I received my nameplate as a birthday gift when I turned 16. It was my most prized possession. I spelled my name with a Y at the end because I wanted the cursive Y. My nickname is Tizi, but I changed it for the nameplate!!! It's double-plated and has been repaired many times over the years. I still love it as much as I did when I got it 12 years ago.

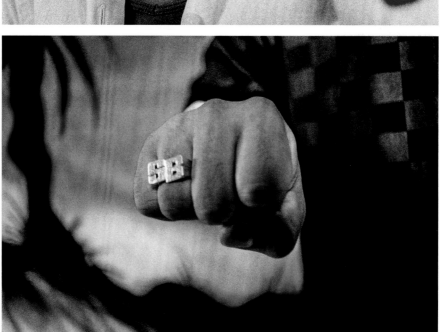

THE NAMEPLATE

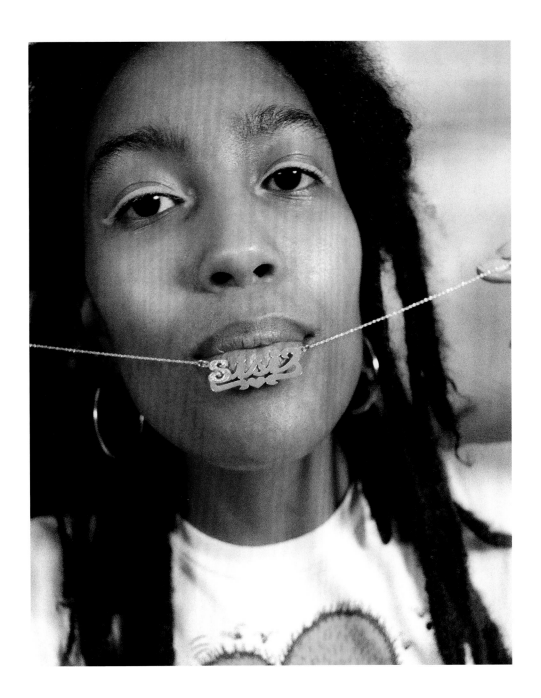

GOGY ESPARZA

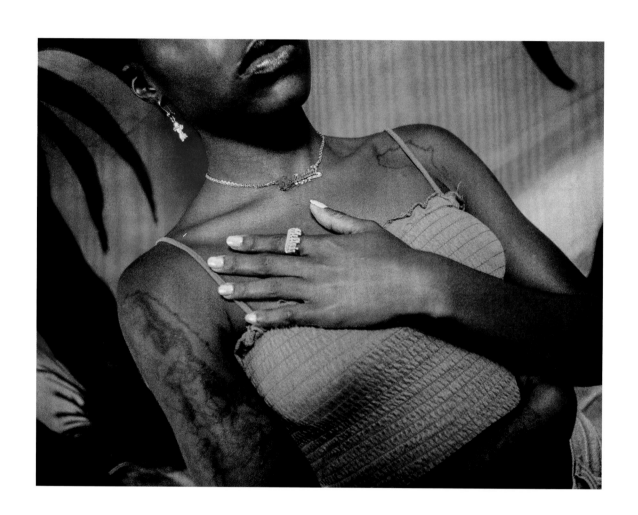

THE NAMEPLATE

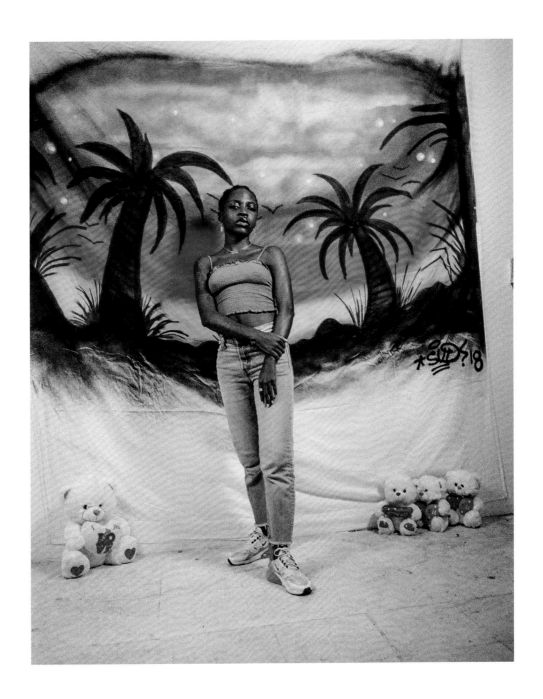

GOGY ESPARZA

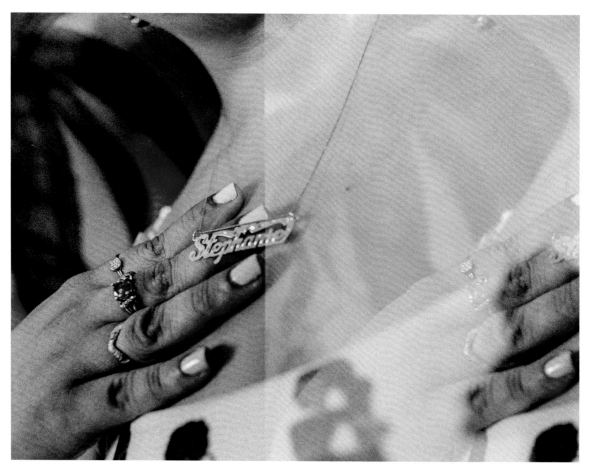

I got my name chain when I was born in 1986. My parents gifted
it to me. It's a token of my existence.

THE NAMEPLATE

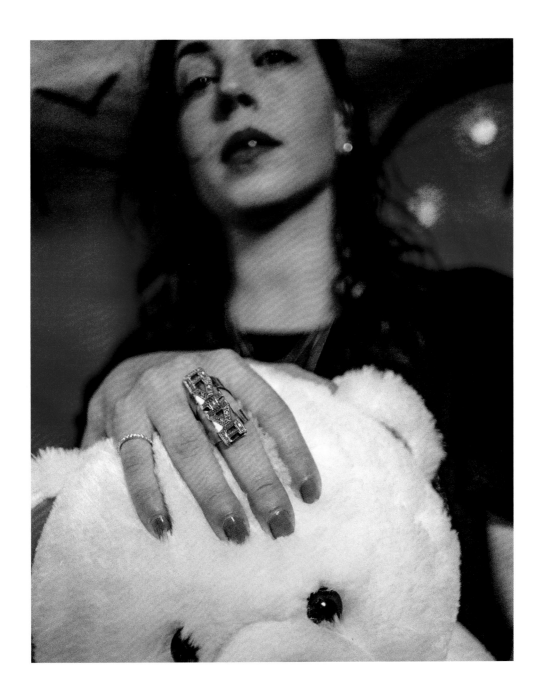

GOGY ESPARZA

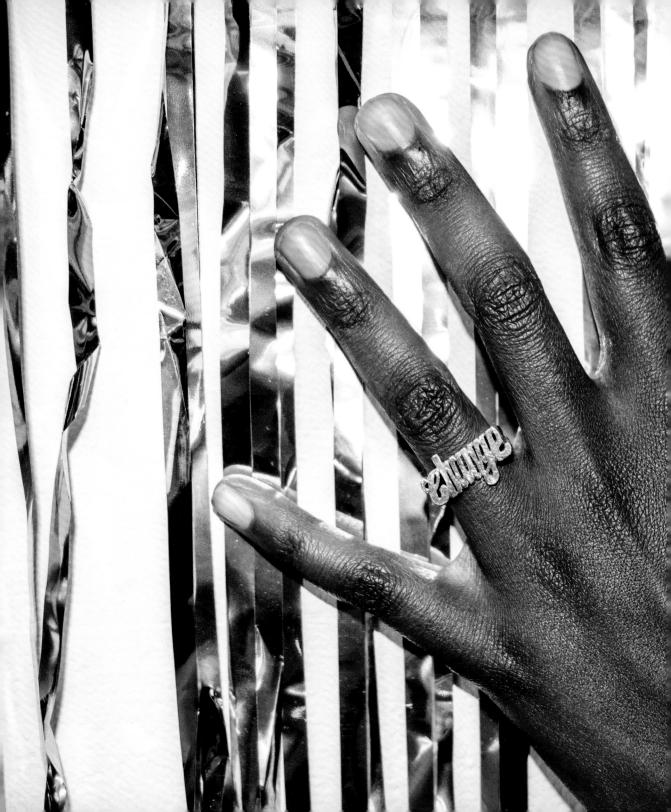

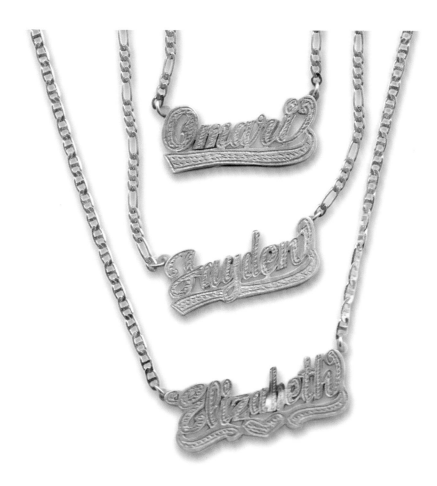

Nameplates have been in my family for as long as I can remember. My mom had two for herself and she purchased one for my three sisters and me. When I lost mine, she was a little upset. So was I. I had it since I was 8! When my mom passed away, I decided to purchase my own nameplate, and nameplates for my sons, to remember her good taste in jewelry.

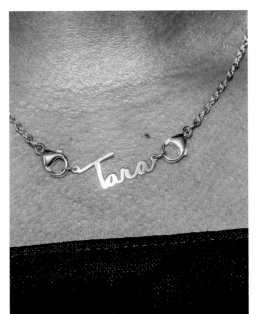
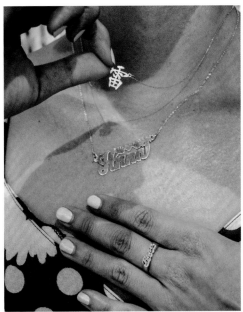
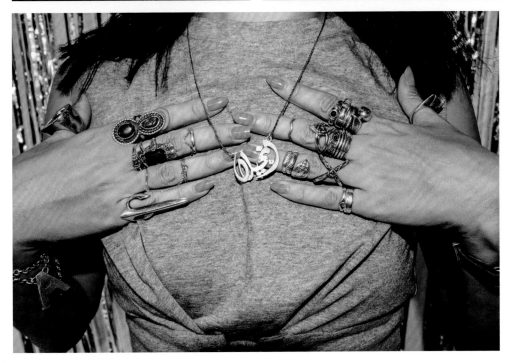

GOGY ESPARZA

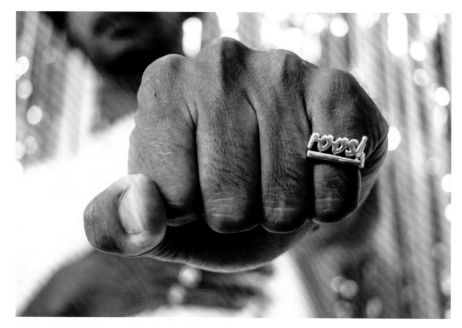

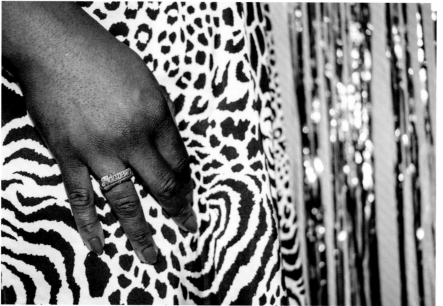

I hail from Manhattan and grew up downtown. Nothing makes me feel more LES than my nameplate jewelry that I got from Delancey Street. My middle name "Ndapewa" is Oshiwambo from Namibia, meaning "I'm given."

THE NAMEPLATE

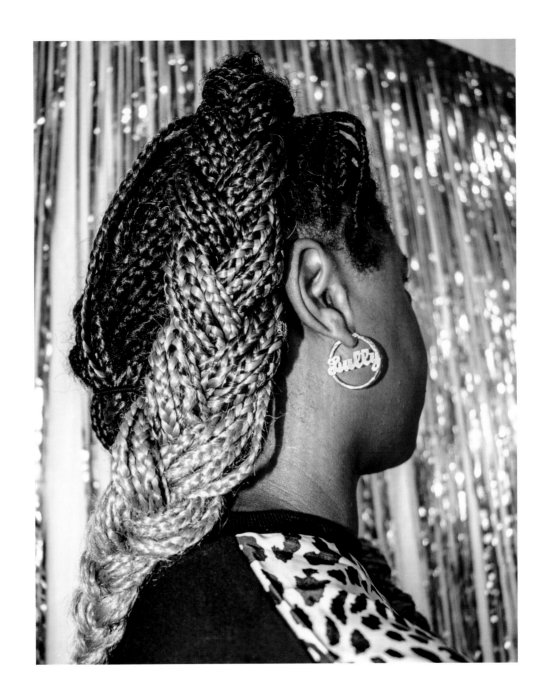

GOGY ESPARZA

Gold for Gold

*Claudia
"Claw Money"
Gold*

CLAUDIA GOLD, who for years was known simply as "Claw Money," is a pioneering graffiti writer, artist, curator, stylist, costume designer, fashion editor, historian, marketing and branding expert, author, agitator, mentor, and arbiter of downtown New York City culture. She lives and works in NYC.

What can be said about the nameplate that hasn't already been? It's an affirmation and assertion of identity from a time before there were infinite ways to do so with relative ease; before your carefully curated image could be transmitted through the web to an infinite audience. A nameplate was a tangible signifier that let anyone who saw you know not only your name but also who you were, your experience, and your origin.

I first began to notice nameplates as a teen in the mid-eighties. I noticed young women wearing their first names proudly—setting their look ablaze with yellow gold shimmering around their faces. All kinds of women. Black girls from Brooklyn, Bronx Latinas, Italian girls from Queens; the nameplate became ubiquitous on the streets of New York. But it wasn't just a staple for girls and women. Men embraced the trend, often rejecting the signature script in favor of a bolder font. This all took place within a rich context of individual expression and promotion, not just of names but of crews, neighborhoods, ethnicities, zodiac signs, and more.

I remember sorely wanting one of my own and, rooting through my jewelry box, finding a silver necklace that said *Claudia* in English, Arabic, and Hebrew that my mother got me in Egypt when I was eight—it wasn't exactly right. I looked at my *Claudia* script pin and at a small gold pendant with a *C* on it. I was getting warmer but was still disappointed. This was not the same boldly embellished golden script emblazoned in my mind.

A couple of years later, in the early nineties, when I first started working and had some disposable income, I started frequenting jewelry and pawnshops. While I was on a serious budget but dying to be fly, my gold habit kicked off. A block from where I tended bar, on 12th Street and Avenue A, there was a shop I always returned to. I would look at everything displayed in the windows and fantasize about how I might maybe get a ship's wheel with my name across it, or perhaps a giant pendant with a personalized bunny and my name in script beneath. I always dreamed of magically finding a necklace that already said *Claudia,* which I hoped would defray the cost of customization, but, of course, I never did. And I also wanted it to be created just for me. Mine. So, I told my then-boyfriend how badly I wanted a nameplate and he delivered, sort of. A week on, I received a tiny, white gold, diamond-encrusted graffiti block letter necklace that said *CLAW.* Cute, but this wasn't it either. I was grateful, but surprised he didn't get me what I wanted, being that he was from Corona, Queens, and knew that I was desperately trying to leave my St. Marks Place silver behind. I was writing a lot of graffiti, and I never wore that necklace as my tag; that abbreviation was far more likely to betray my anonymity. It put me in danger, I said. But truly, it just wasn't right!

I remember obsessing over it to my girlfriends, telling them, "my name is Claudia Gold—how am I wearing silver and how do I actually get this necklace?" Lo and behold, my friend Pam gifted me a perfect yellow gold

Claudia script nameplate necklace for my birthday soon after. All was right in the world.

This simple and sweet necklace from Pam set off a quest to assert myself on my body as I was now asserting myself in public spaces. I was already using graffiti to send messages, and I knew I could similarly do that on my own person, but in a much more subtle and intimate way. So I did. I began to make huge nameplates with my crews on them. I then used my street symbol—which is my name turned into an icon of an actual claw—to make jewelry, which basically sparked my idea to start my own brand. Combining the golden symbol so beautifully packaged around my neck with the rough, spray-painted iconography of street corners and gates resulted in a clothing and lifestyle brand that is now twenty years strong.

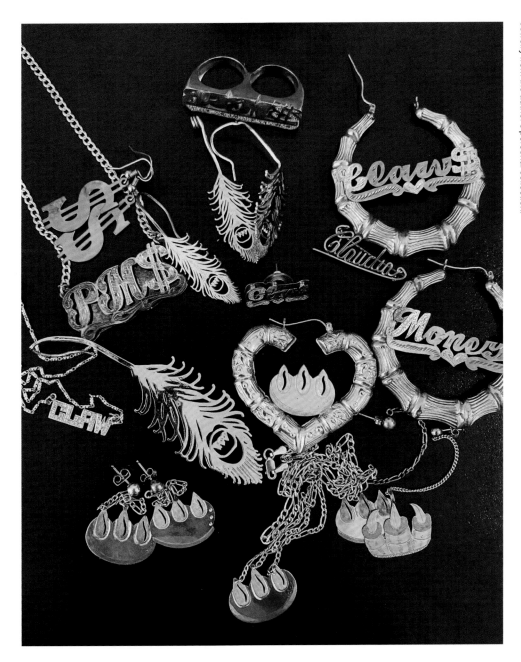

GOLD FOR GOLD

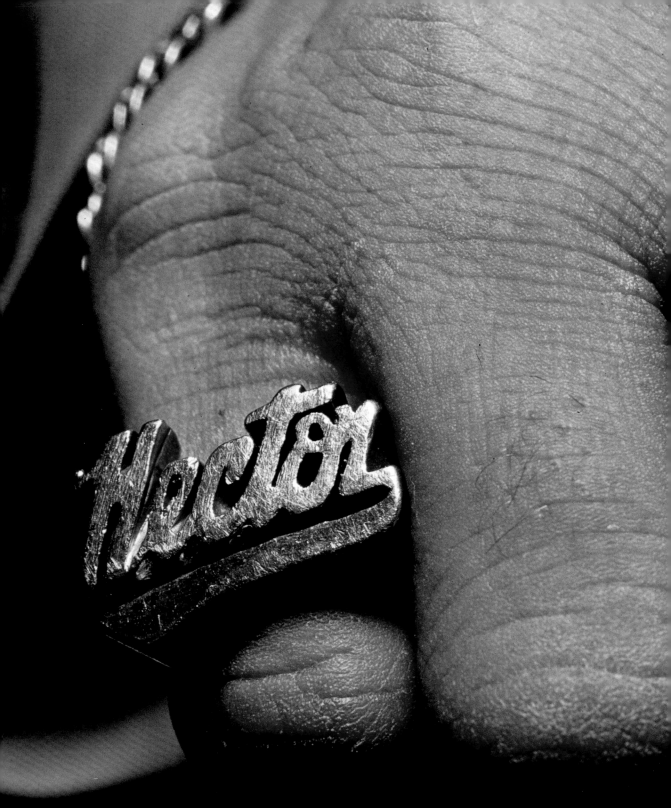

Mia Penaloza

Hester Street Fair, Girl Power Day
New York, NY, 2019

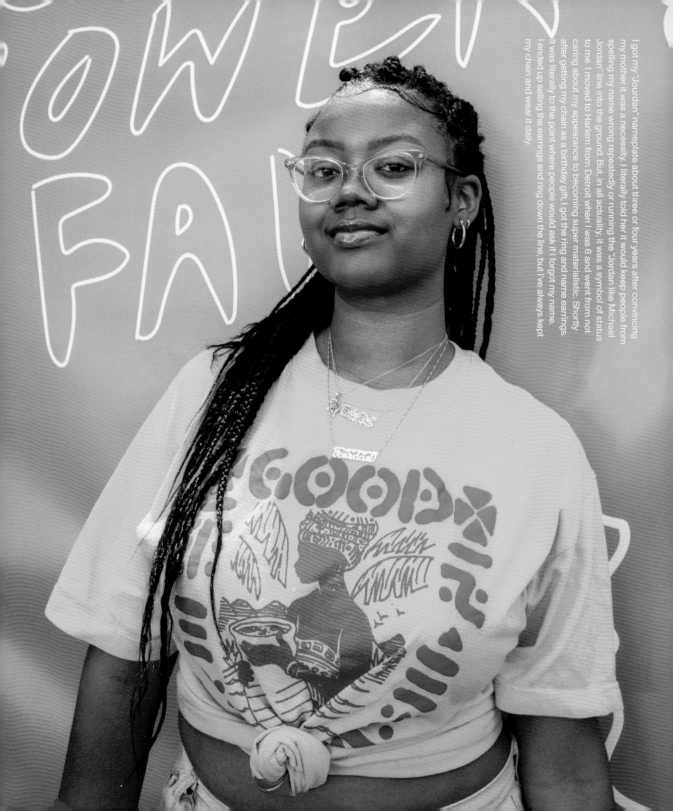

I got my "Jourdan" nameplate about three or four years after convincing my mother it was a necessity. I literally told her it would keep people from spelling my name wrong repeatedly or running the "Jordan like Michael Jordan" line into the ground. But, in all actuality, it was a symbol of status to me. I moved to Harlem from Detroit when I was 6 and went from not caring about my appearance to becoming super materialistic. Shortly after getting my chain as a birthday gift, I got the ring and name earrings. It was literally to the point where people would ask if I forgot my name. I ended up selling the earrings and ring down the line, but I've always kept my chain and wear it daily.

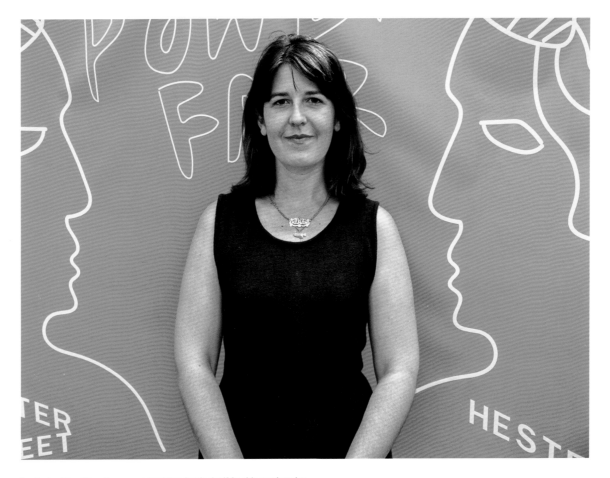

Iraqis don't traditionally wear nameplates, but in the '90s, this one jeweler in Baghdad started making them so my Bibi (grandma) had one made for me and for my sister. She brought them as gifts when she came to visit us in the States, which is also why they're written in English rather than Arabic, so we would fit in better.

I only started wearing mine again a few years ago and when I wear it now I feel more in-your-face and confident. I'm proud of my name because it reflects my family and my background.

THE NAMEPLATE

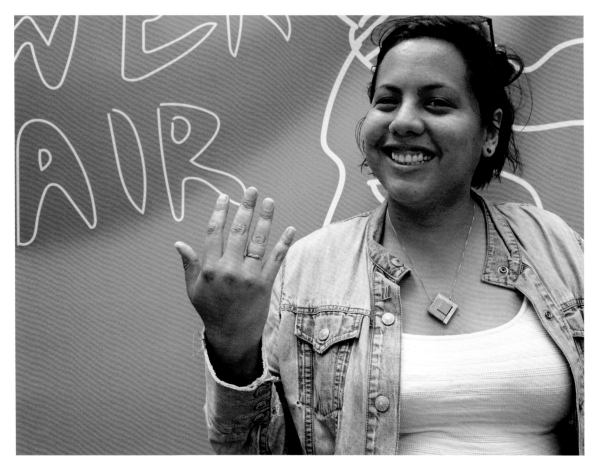

My amor ring was my grandmother's. She wore it, along with its matching English version saying "love" every day. On a literally random day, I was admiring the ring for the 10,000th time in my life. She took it off, handed it to me, and said "it's yours." The ring is over 55 years old.

MIA PENALOZA

THE NAMEPLATE

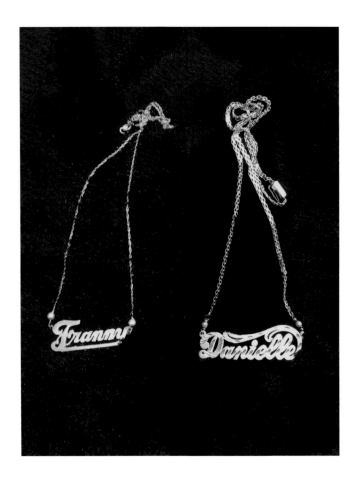

My mom hated her first nameplate, which read "Frances." Known as Fran, my mom was supposed to be named after her mother, Francesca, who died in 1964 in a Brooklyn hospital within days of her birth. Nonna Francesca immigrated in 1955 from Cinisi, Sicily, a small village near Palermo. Lacking any English and being deeply traumatized, my Nonno couldn't advocate for the proper name on her birth certificate, and so they Americanized my mother's name without consent.

Her stepmother, my Nonna Elena, was a gold queen who gave nameplates as gifts to the ragazzi in the family. She replaced the original "Frances" necklace she got for my teenaged mom with one that said "Franny." She would eventually have her name legally changed from Frances to Francine.

Nonna Elena was once a nun and always a seamstress, born in New York City and raised in Cerignola, Italy, before coming back and marrying my Nonno. Like my other two grandparents, she spoke no English, but did her best to help my mom raise her two "scootch" kids—"scootch" is Italian American slang that means pain in the ass.

Before she passed in 1995, Nonna Elena encouraged my mom to get me a nameplate that read "Danielle" in a vintage and gaudy style that reminded me of her rope chains and elaborate Madonna medallions that she wore daily. She understood me in ways I couldn't understand myself just yet, probably best illustrated by the nameplate's design and her indulging my baby goth desire to be Morticia Addams for Halloween, making me a polyester velvet and lace dress from scratch.

While Nonna Elena might have been celebrating names in gold to honor a Catholic tradition similar to birthdays, name day, my mom says that nameplates and bold gold were a Brooklyn and NYC institution across cultures in her high school years—everyone wore them to show pride in their identity.

MIA PENALOZA

You Will
Know Our Names

April Walker

Got the hottest girl in the game wearing my chain.

– JAY-Z

APRIL WALKER is a fashion game-changer and culture-maker who inspired a lane, helping to create a multibillion-dollar industry—coined as streetwear today—through her brand, Walker Wear. As the first woman in this lane, she was also one of the first to secure celebrity endorsements from icons like Tupac and The Notorious B.I.G., along with opening distribution doors and commanding millions in sales. The Walker Wear lifestyle brand still thrives today and is included in exhibitions internationally. Walker, still at the helm of her brand, is an author, a wellness advocate, and an educator who contributes to the Streetwear Essentials online course at Parsons.

My first nameplate experience was a name belt that I owned in junior high school. I was part of a select few, which gave me automatic cool points, and then, in '86, my most memorable experience to date was being gifted with a Gucci link full diamond script nameplate necklace emblazoned with "April." It was a bit over the top, but in a good way. I was elated and nervous at the same time because I knew it would draw a lot of attention in a dangerous way. My Spidey senses kicked in, and I rarely rocked it.

As the eighties evolved, nameplates had become the best fashion accessory of an entire subculture.

They gave you a chance to rep your own brand while simultaneously flaunting to the masses that you were a proud outlier. If memory serves me correctly, Panamanian nameplates created the groundswell. They were beautiful, 24-karat with a copper gold aesthetic and a special script. One of the first people I saw wearing that style was my best friend, Jennifer, who had one in high school. The problem was it was an impossible purchase unless you knew someone in Panama who could bring one back for you. They were highly aspirational because of this scarcity factor. It wasn't long after that I started seeing more gold nameplates in my high school, and then they caught fire. Once, my sister and I went to a Fresh Fest concert at Madison Square Garden and someone snatched her nameplate chain off her neck inside the concert. It was a hot-ticket item in high demand.

By now, you've probably connected the dots and realize that Carrie Bradshaw from *Sex and the City* didn't create the trend or popularize the nameplate necklace, but white America and the press outlets did a great job at whitewashing its history. Nothing is recognized until whiteness has declared and appropriated it, and usually that comes after doing the drive-bys in our hoods. There are creators, imitators, and facilitators, but that story is never told correctly.

While the gatekeepers still empower structures that actively spin narratives and allow creative looting and pillaging without repercussions, there will always be those of us who forge new paths and look for solutions while rocking our nameplates and amplifying our stories.

In the seventies, New York City felt like a war zone and the government was our enemy. The socio-economic challenges were overwhelming for many, especially if you weren't white. Buzzwords like "inclusivity" were still taboo. Think post–civil rights, the Vietnam War, and the Watergate scandal. It was going down. If you didn't live in a certain zip code, then you were considered a "nonfactor." We were trapped in a system that was not only neglectful but also disrespectful.

YOU WILL KNOW OUR NAMES

As that young, Black/brown (i.e., Blexican) girl growing up, I can attest firsthand to the lack of resources and support, as well as to the shame game society projected upon us for the lack of opportunities available. There was intentionality in making us feel insignificant.

Fortunately, there was also a culture brewing called Hip Hop. Born out of the Bronx, it ushered in this "survive and thrive" spirit, in spite of the deck being stacked against us. The music was unapologetic and amplified the voices of the unheard, and melodically, the rhymes became the CNN for hoods across America. This energy and force-multiplier created contagious behavior that unleashed unbridled self-expression with various creative tentacles, including graffiti, break dancing, rhyming, deejaying, and fashion.

The streets became the runways and gave us a chance to blaze our own trails. Defiant and unapologetically in your face, we were determined to do things differently. Just as the music was telling a story, the fashion reverberated in the same way. We were disrupting norms and reimagining style, rocking frayed jeans and bleached denim, bell-bottoms, tube tops with permanent creases, custom airbrushing, phat shoelaces and shell-toes, and we can't forget nameplates. Speaking of nameplates, it's arguable that graffiti tags were the first ones, even before the physical adornments arrived. Whether it was written on the train or adorned on our necks, the message was clear, and it was one that demanded respect. It was an assertion of branding ourselves while amplifying our essence. "You will not miss us. You will know our names. We are not invisible."

As the late Dale Carnegie once said, "A person's name is to that person, the sweetest, most important sound in any language," and I believe that still rings true today.

YOU WILL KNOW OUR NAMES

Arlene Mejorado

Slauson Swap Meet
and Alameda Swap Meet
Los Angeles, CA, 2019

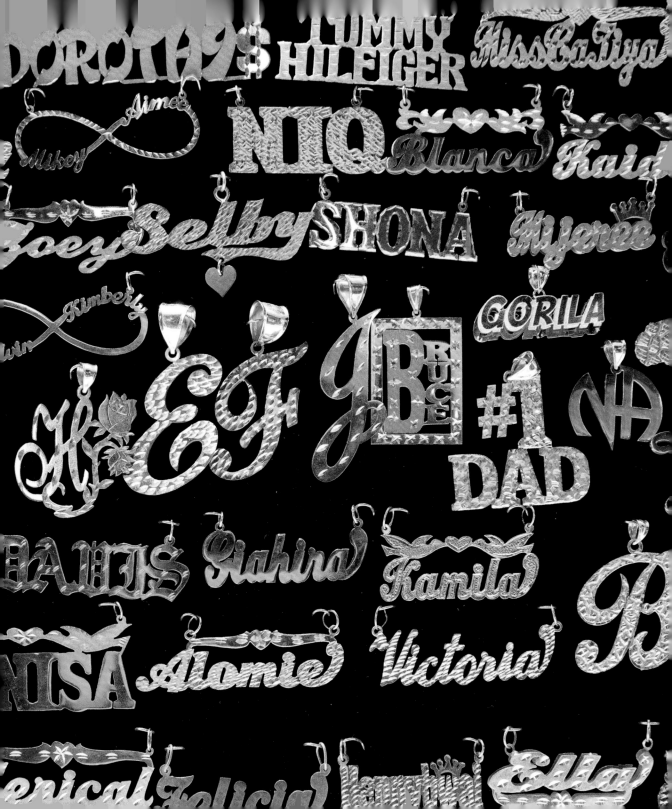

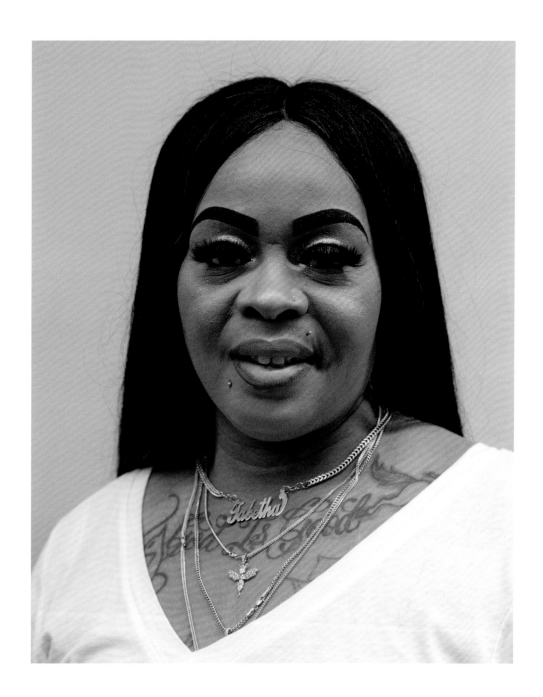

THE NAMEPLATE

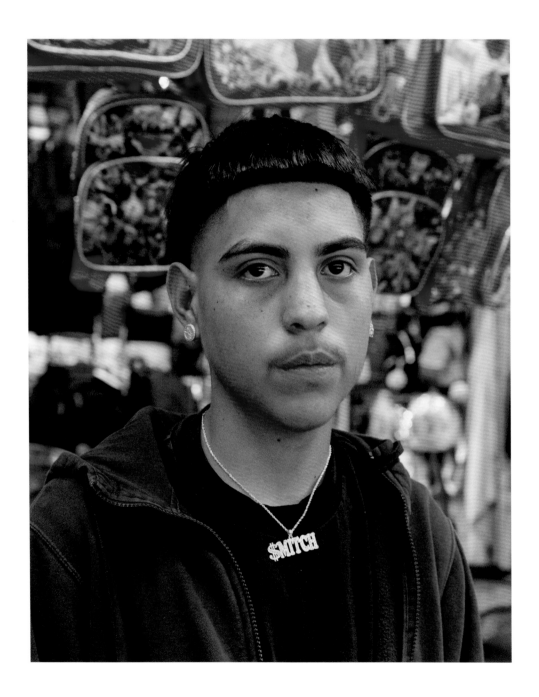

ARLENE MEJORADO

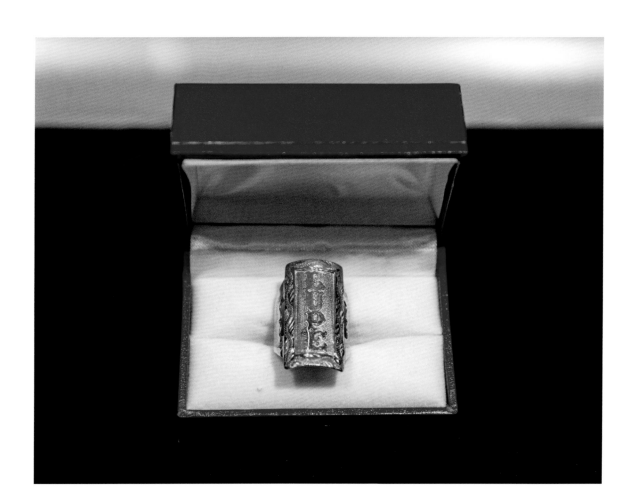

THE NAMEPLATE

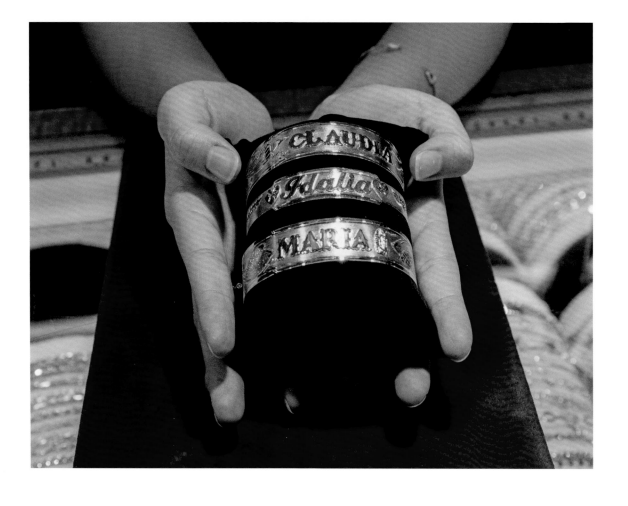

ARLENE MEJORADO

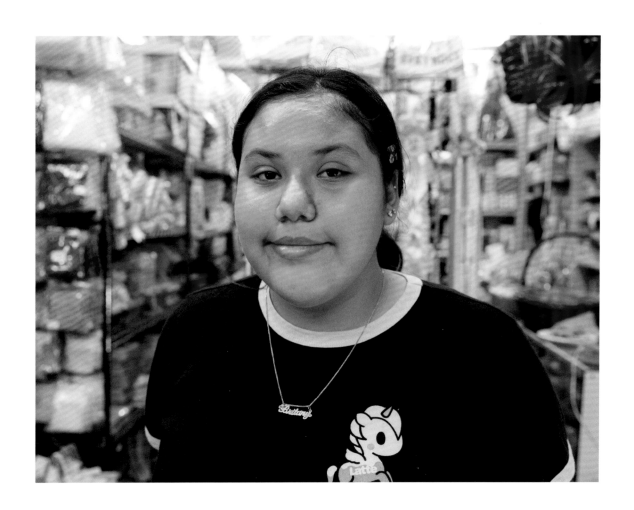

THE NAMEPLATE

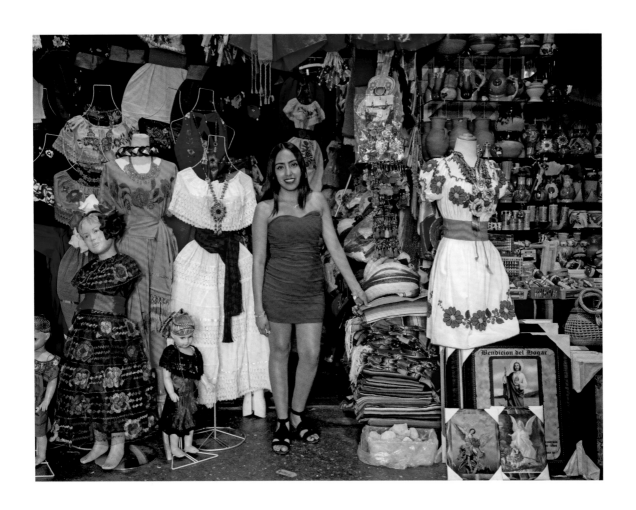

ARLENE MEJORADO

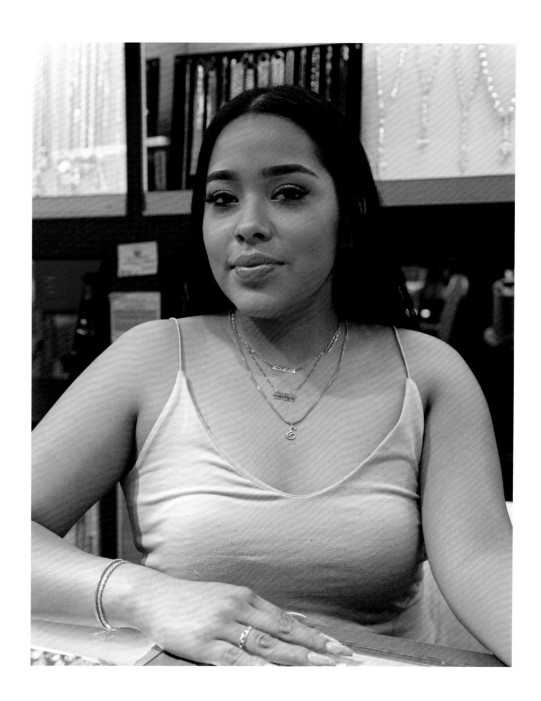

THE NAMEPLATE

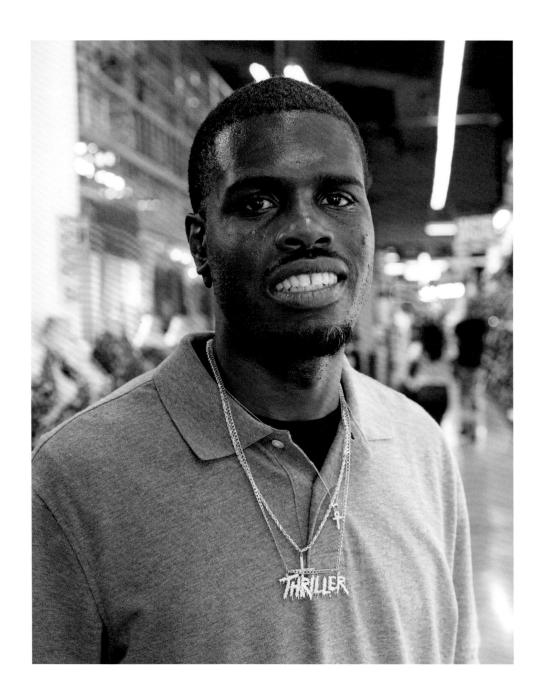

ARLENE MEJORADO

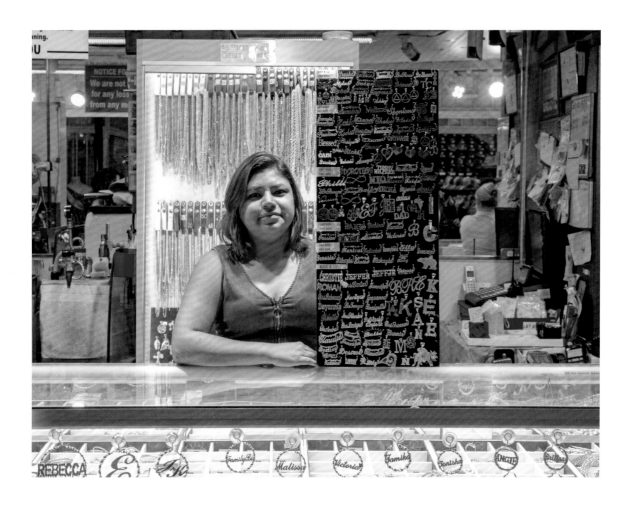

THE NAMEPLATE

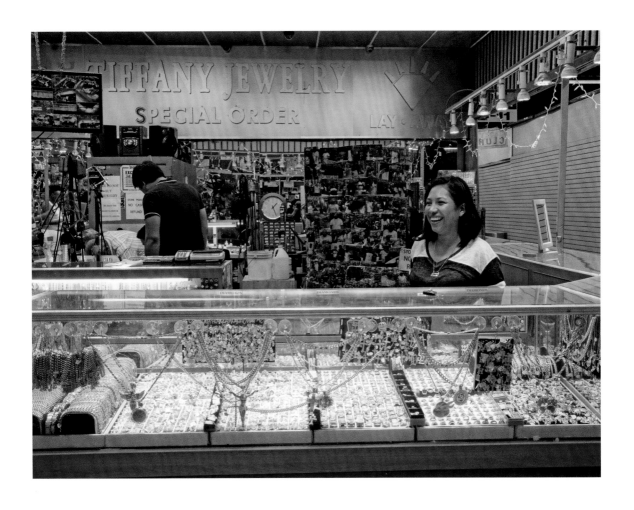

ARLENE MEJORADO

Nichelle Dailey

In Collaboration with Bella Doña
Echo Park, Los Angeles, CA, 2019

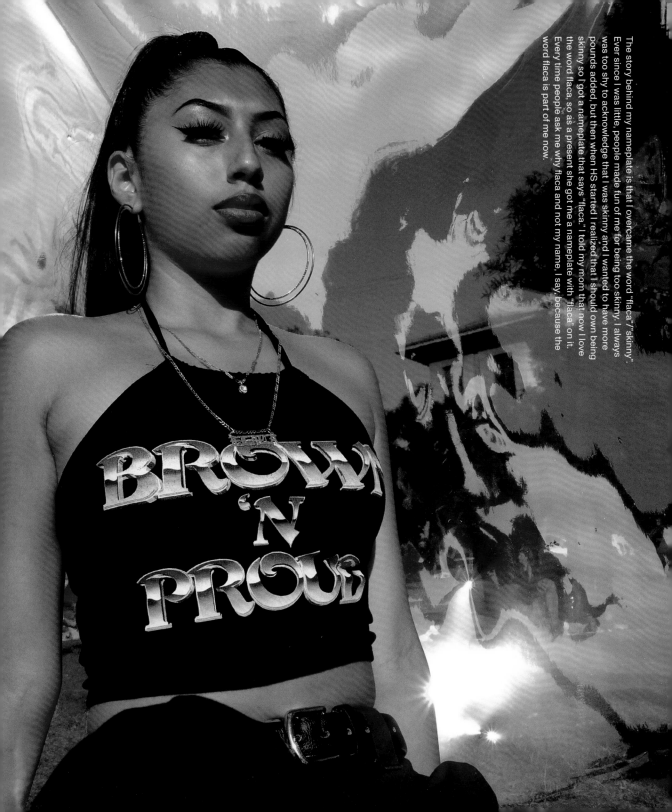

The story behind my nameplate is that I overcame the word "flaca"/"skinny". Ever since I was little, people made fun of me for being too skinny. I always was too shy to acknowledge that I was skinny and I wanted to have more pounds added, but then when HS started I realized that I should own being skinny so I got a nameplate that says "flaca." I told my mom that now I love the word flaca, so as a present she got me a nameplate with "flaca" on it. Every time people ask me why flaca and not my name, I say because the word flaca is part of me now.

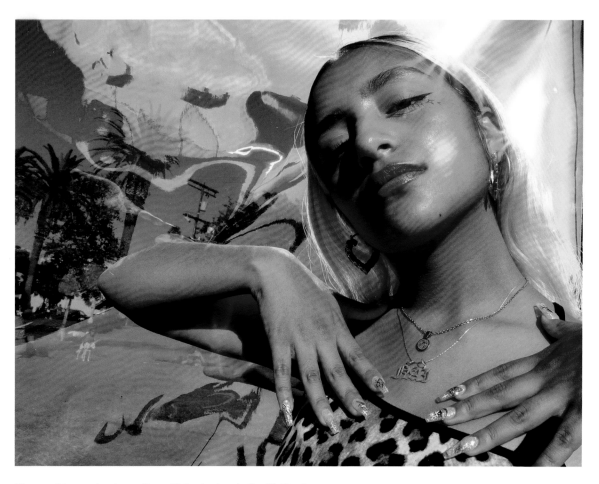

My nameplate was given to me after my high school graduation. My friend was learning to create nameplates from his father, who owns a jewelry stand in the Slauson Swap Meet. He ended up making me a nameplate that said "Nai," which is what my close family and friends call me.

THE NAMEPLATE

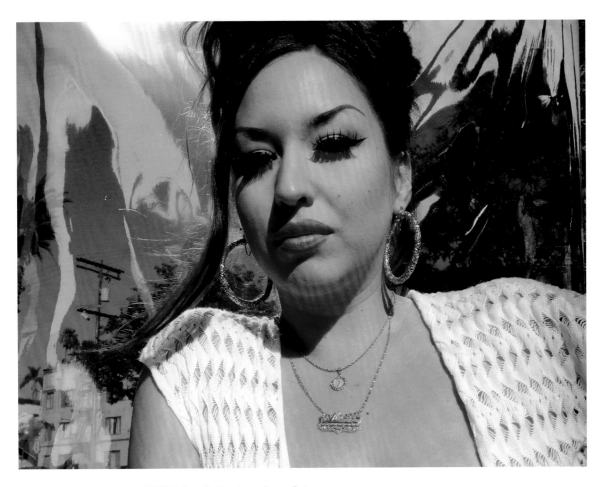

My nameplate was a very special birthday gift given to me by my first love. Coincidentally, it fell apart as our relationship did. I've since had it repurposed but still wear it as a reminder of resilience through all of life and love's tribulations.

NICHELLE DAILEY

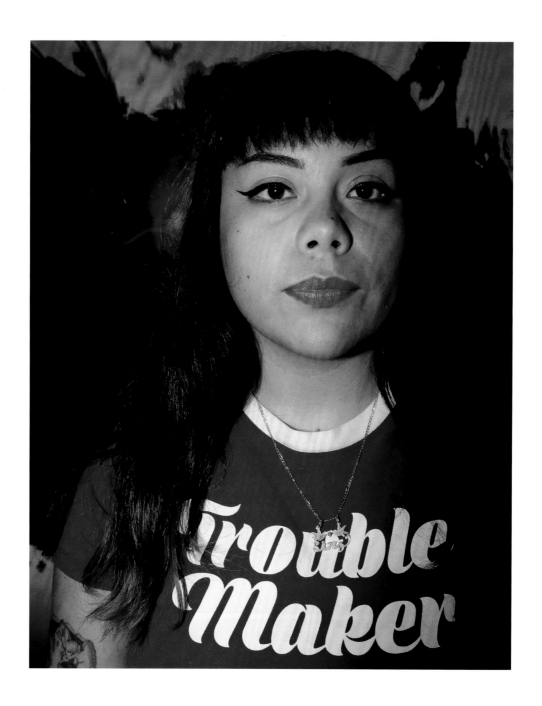

THE NAMEPLATE

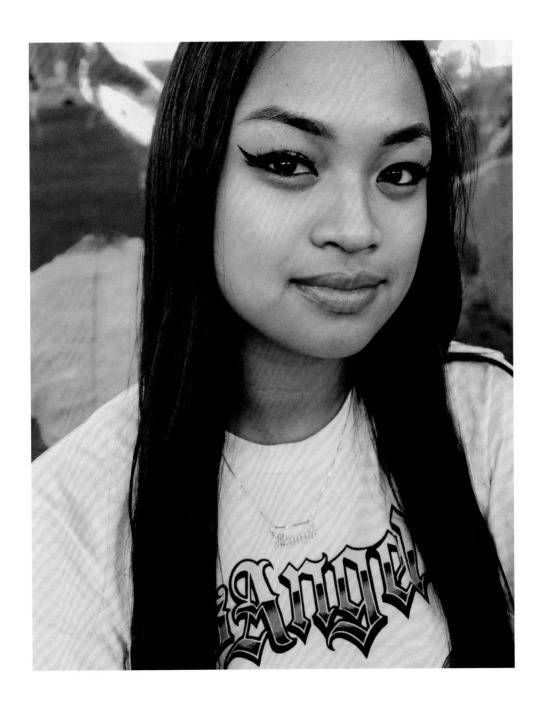

NICHELLE DAILEY

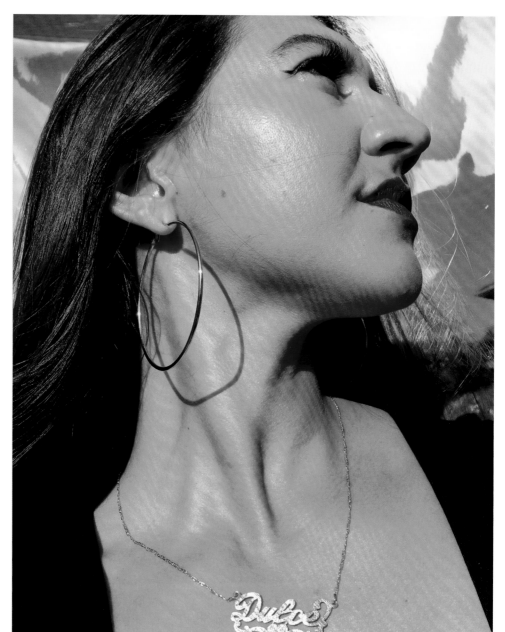

After saving up my Christmas money, birthday money, work money, and good report card money, my parents finally took me to the Fort Lauderdale Swap Meet to order my nameplate. I didn't have enough for the chain, so I took the small, delicate chain I had from my first communion. I wore it every day and in every school picture. I eventually stopped wearing it, but when I moved to Los Angeles, some new friends were wearing theirs proudly ... and out came mine again. It makes me proud of my name and my culture.

THE NAMEPLATE

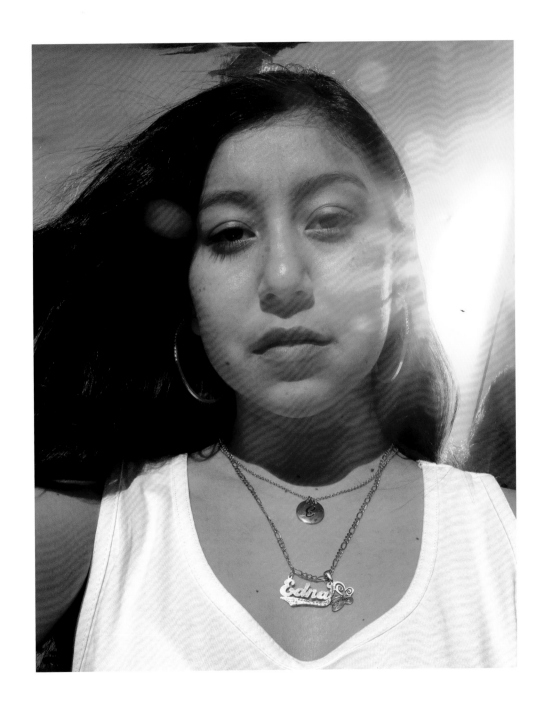

NICHELLE DAILEY

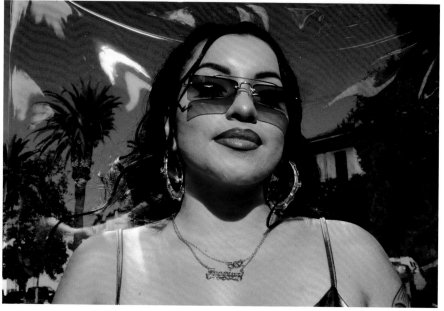

THE NAMEPLATE

NICHELLE DAILEY

Rite of Passage: Nameplates and Coming of Age

LaLa Romero

—As told to Isabel Attyah Flower and Marcel Rosa-Salas, 2021.

LALA ROMERO is a singer and co-founder of the lifestyle brand Bella Doña. She lives in Los Angeles, CA.

Growing up, I always felt like a nameplate was a rite of passage. If you accomplished something and leveled up a step in your life, you might get this badge of honor, this medal. My earliest memories of nameplates were seeing the girlfriends of my older cousins and the older women in my family wearing them, and me feeling like, "when will it be my turn?"

I'm from Van Nuys, California—it's the 818, it's in the Valley. I grew up in an apartment complex that was very Black, Latino, and Asian American, and I think that when you grow up with not very much, you take extra good care of the little things and you show out in a different way, whether it's through your sneakers or even the way you iron your clothes. You take care of your white T-shirts. That's how you assert who you are. I always felt a nameplate was a way to show off your fly, to let people know like, "I'm here, this is who I am, this is what I do. Maybe you can or can't pronounce my name, or maybe this is the only name that you get to know, because this might be a nickname, this might be an aka, but this is the me that I choose to present to the world." My family is Chicano (Apache, Navajo, Mexican, and white) and I also have nieces who are Filipino, Black, and Latina. Our identities can be really complicated, but the commonalities of the nameplate bring us together. These objects are heirlooms: a precious metal with the most personal thing you have—your name.

On my block of ten apartment buildings, every single one was packed with families with intergenerational living situations. In our house, sometimes my grandpa was living with us, sometimes my *tías* were there, too. Everything you imagine LA looked like in the nineties, my block was just like that. I was in middle school at that time and car shows were popping, but I was still too young to go. I wanted to use Aqua Net and lip liner, but I had to sneak to do it when I was already at school. It was all still very aspirational, but I got to watch through the older sisters of the girls in the building. I have a cousin who is seven years older than me, and all his girlfriends had their hair gelled, their lips lined, their acrylic nails, and their nameplates. Everybody had a nameplate. And if it wasn't a nameplate necklace, it was a belt, even just with your initial. Every little opportunity you could get to assert, "this is who I am, this is where I'm from, this is what I rep," you would take it. It was also something shared cross-culturally. On Saticoy, the street where I grew up, we were all from very similar socioeconomic backgrounds, and despite our ethnic and cultural diversity, the styles and aesthetics I've described were not perceived as specific to one group. I was lucky to grow up in a family that was also very conscious of the roots of Hip Hop, so that legacy informed my perspective, too.

The first nameplate I ever got—not my current one, but my starter one—I had to buy for myself. I always worked, even in high school. Big up to Macy's that gave me a job while I was still in tenth and eleventh grade. At first I could only afford the pendant, and I had to wait to get the chain. Luckily, you could do layaway at the swap meets, so you'd lock in what you were going to get and then make your payments on it.

When I first started doing music and got my publishing deal, I was like, "What am I gonna buy myself?"

And it wasn't even that kind of money, but every rapper gets a chain, so I wanted to level up my nameplate. I got my *pave* double-plated pendant and it cost like five hundred bucks—that's still a lot of money! It was a big deal for me. The fact that I was able to do that for myself, to treat myself, was very significant. When you have to work to earn something, you treat it very differently than if it was gifted.

Growing up, I didn't have a quinceañera, which was how a lot of girls got jewelry when they turned fifteen. I associated nameplates with coming-of-age events and religious ceremonies, especially in a Latina's life. A lot of babies get their first little gold bracelet with their name on it when they're baptized, or for their first Communion, then their confirmation or quinceañera. When I notice that someone close to me doesn't have a nameplate, often I will get them one for a birthday or something like that. It feels very special to be part of the moment when someone receives a nameplate. Even if you don't wear it, even if you hang it on your mirror in your bedroom, you just gotta have it.

When I started doing shows at circuit tours for Art Laboe and *Lowrider* magazine, I also had a ring made. I was like, "What if we took a bamboo nameplate earring and added a ring to the back?" because I wanted my name to be visible when I was holding the microphone. And it was still small! I was doing venues with like ten thousand people. Nobody was seeing this little thing! But I wanted to represent, and I wanted to feel connected to home, even when I was traveling through different states and cities. No matter where I was, I was always reminded of the little swap meet that I got her from.

I had another nameplate, too, because for music my handle for everything was LASadGirl@hotmail.com. My *LaSadgirl* nameplate was huge, and it was gorgeous. But then I decided to do a giveaway for fans and my management at the time was like, "Oh, you should give away the chain" because girls would always ask me about it. To this day, I still regret doing that giveaway.

If I post on Instagram, "Who won that nameplate?" I might be able to find her, even though this happened close to fifteen years ago.

I still have a relationship with the jeweler who did my first nameplate, and my double plate. Almost all of my jewelry is from the same spot. It's important to know the jeweler and their work—the cuts, the fonts, the details. When you find someone you like, you stick with them. When I was growing up, there were more swap meets. Swap meets were the one place you could get everything—your sneakers, your jewelry, your cellphone, your incense. You could probably get a tattoo, a piercing, airbrushing, colored contact lenses. A lot of the smaller ones don't exist anymore, so I think people tend to get their jewelry at Slauson or downtown.

To me, the single-plated etched gold pendant is LA's signature nameplate style. That's what I initially had. The Old English or Gothic font is also very LA and very Chicago, as Chicago is also very Chicano. That script is synonymous with Chicano aesthetics. In Chicano culture and on the West Coast, we have a subculture around lowriders. If you have a lowrider and you're in a car club, you have a plaque that sits in the back. The plaques look exactly like a nameplate. I think that if you're a woman who grew up in or around car culture, your nameplate is your version of a plaque, because cars are often owned by men. They are the men of the family's heirloom, and a car typically gets passed down to a boy, even if there's a girl who could receive it. I've always wondered about the relationship between plaques, nameplates, and the women who support the culture and who the cars are often named after. The women are usually sitting shotgun. They are the muse for the car. And, just like for a nameplate, you gotta earn your plaque; you don't just get a lowrider and plaque up. There are a lot of steps to earn that. It's a big deal to represent who we are and where we are from.

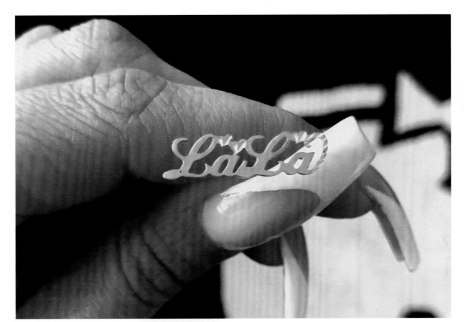

Jewelry from the author's personal collection.

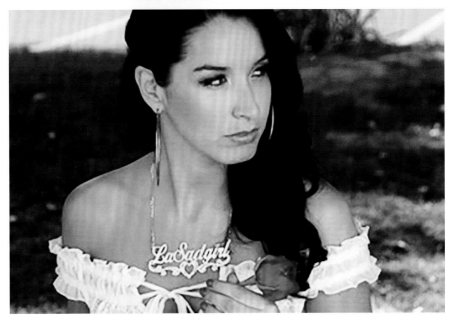

RITE OF PASSAGE

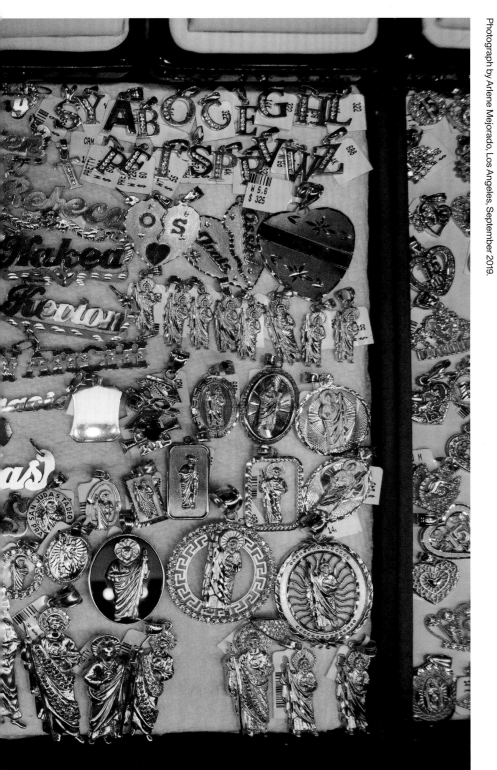

Photograph by Arlene Mejorado, Los Angeles, September 2019.

Adria Marin and Celeste Umaña

Las Fotos Project
Los Angeles, CA, 2019

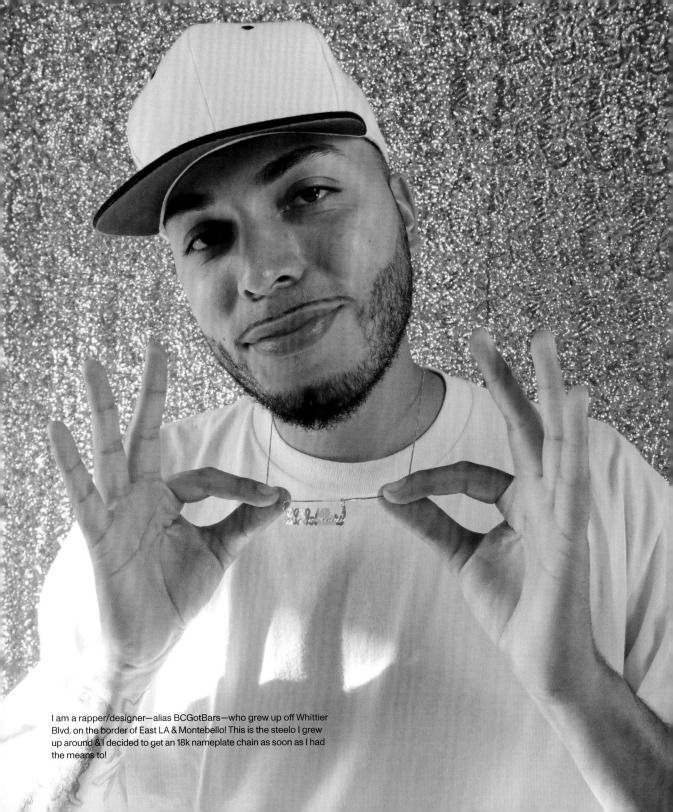

I am a rapper/designer—alias BCGotBars—who grew up off Whittier Blvd. on the border of East LA & Montebello! This is the steelo I grew up around & I decided to get an 18k nameplate chain as soon as I had the means to!

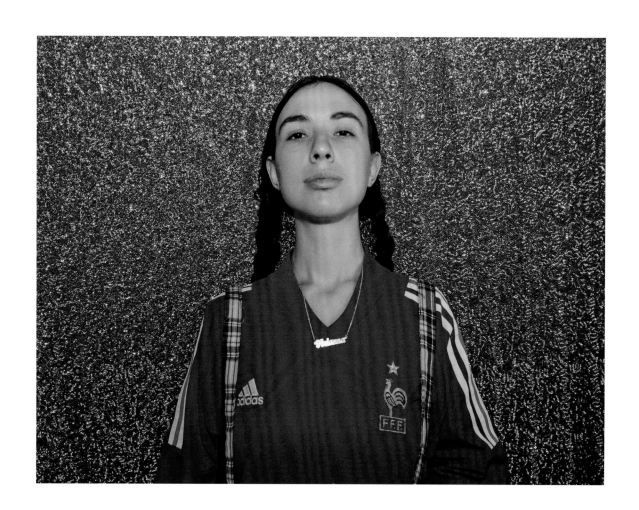

THE NAMEPLATE

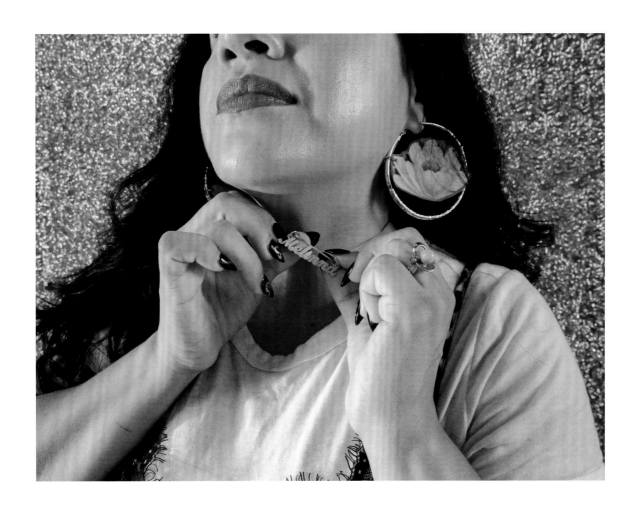

ADRIA MARIN AND CELESTE UMAÑA

Troy Montes

Houston, TX, 2019

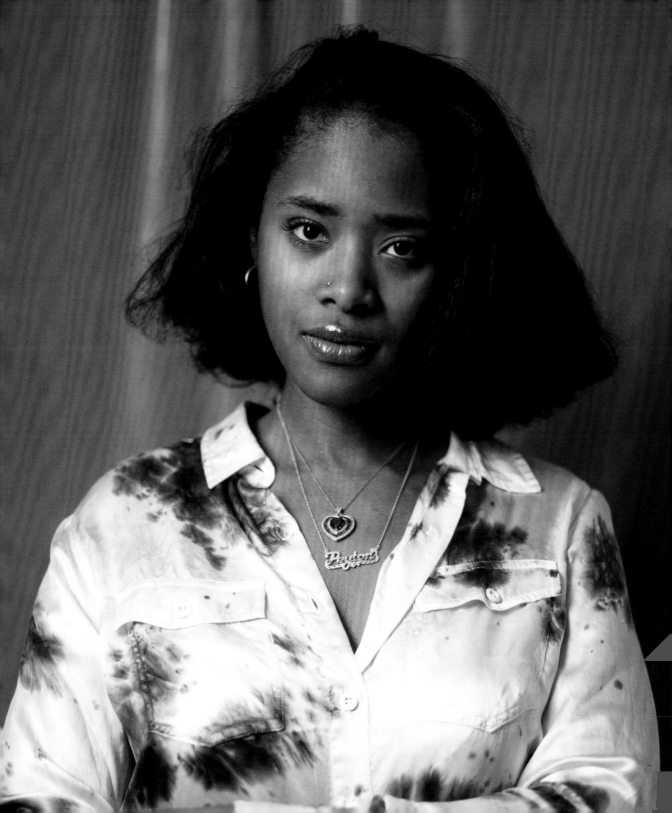

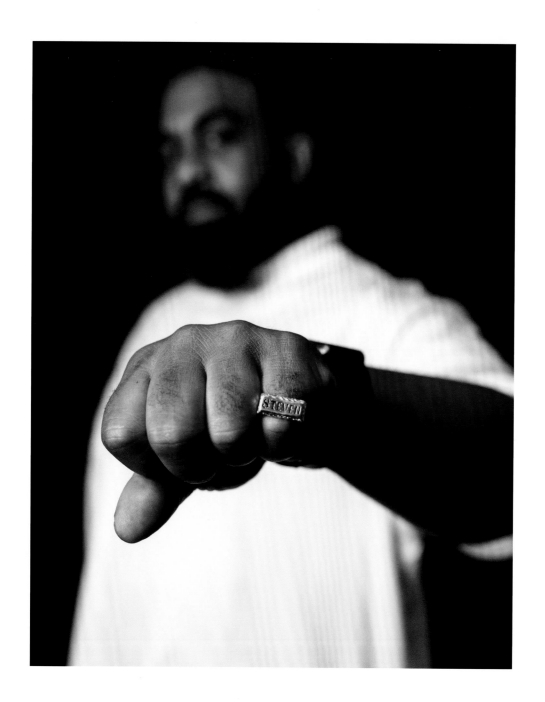

THE NAMEPLATE

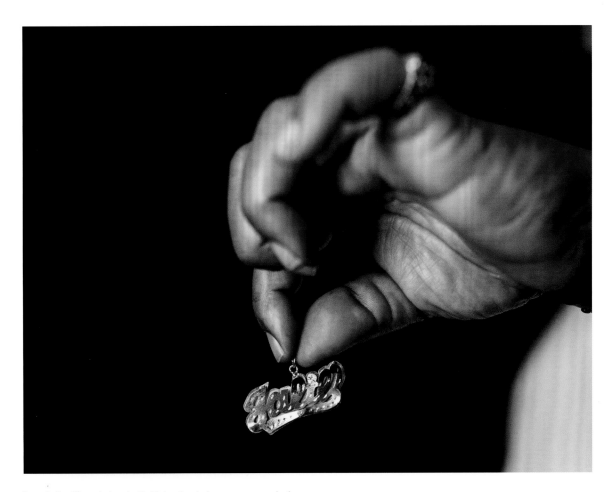

I was in the 8th grade headed to high school when my mom and other church members went to Philadelphia. My mother has bought gold for years. Back home she had her gold custom made, so I seen and already had a chain. If you been to Philadelphia or New York back then they had streets with nothing but gold shops on both sides of the street. I've never seen so much gold on one block. We went in one shop and this guy was cutting names into rings. Well, the rest is history, I had to have that ring. She says, "We gonna look around" but I say, "No, Mom, I want that one." I'll be 49 this year and I still have my ring . . . Thank you.

TROY MONTES

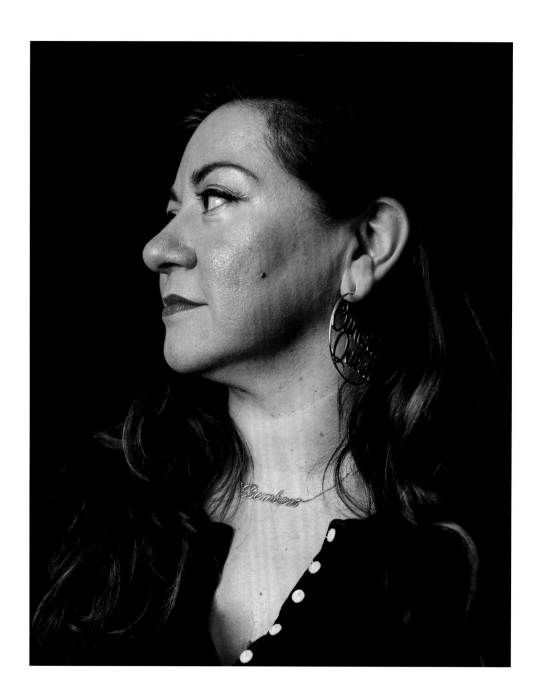

THE NAMEPLATE

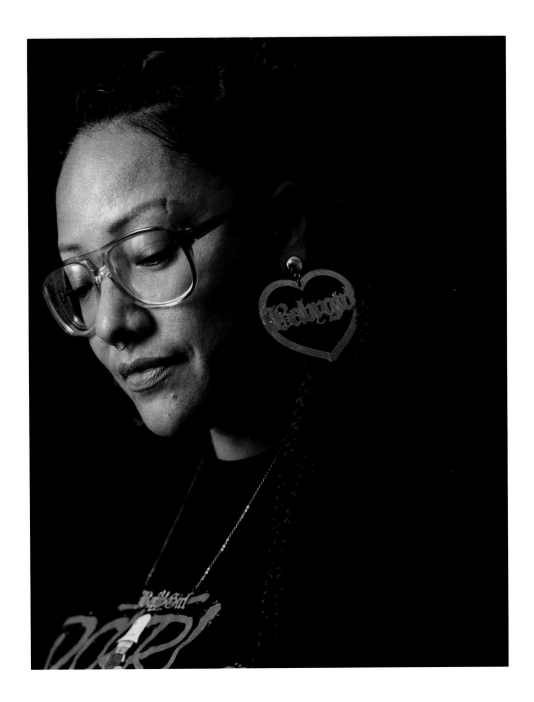

227 TROY MONTES

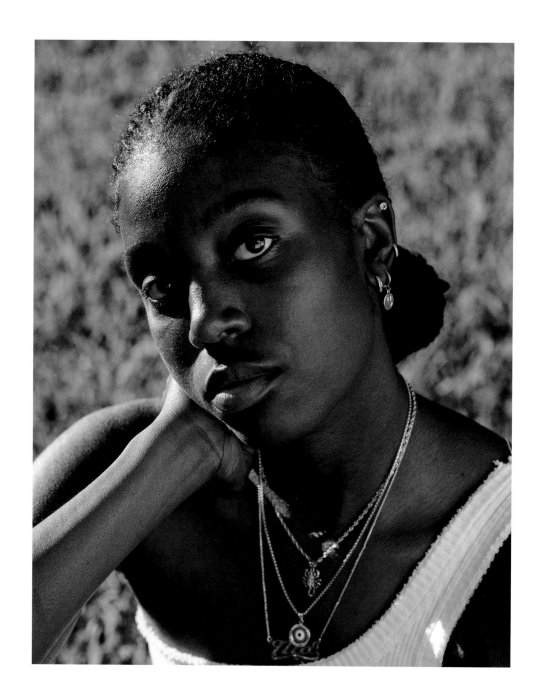

THE NAMEPLATE

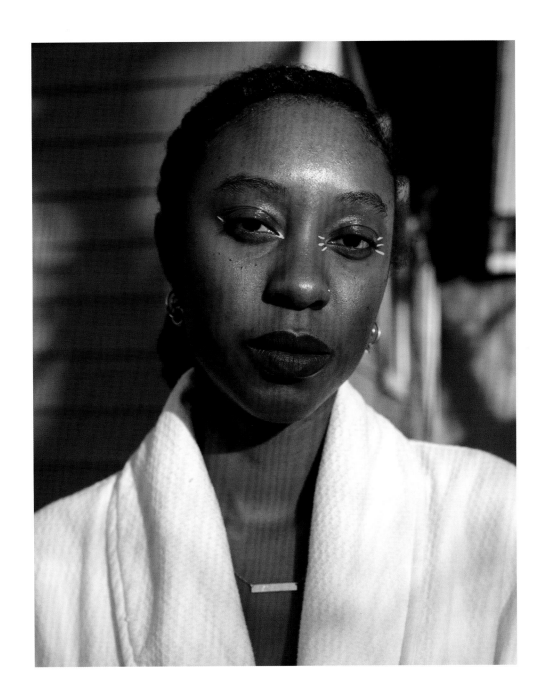

TROY MONTES

Laura Ciriaco

Longwood Art Gallery
Hostos Community College
Bronx, NY, 2020

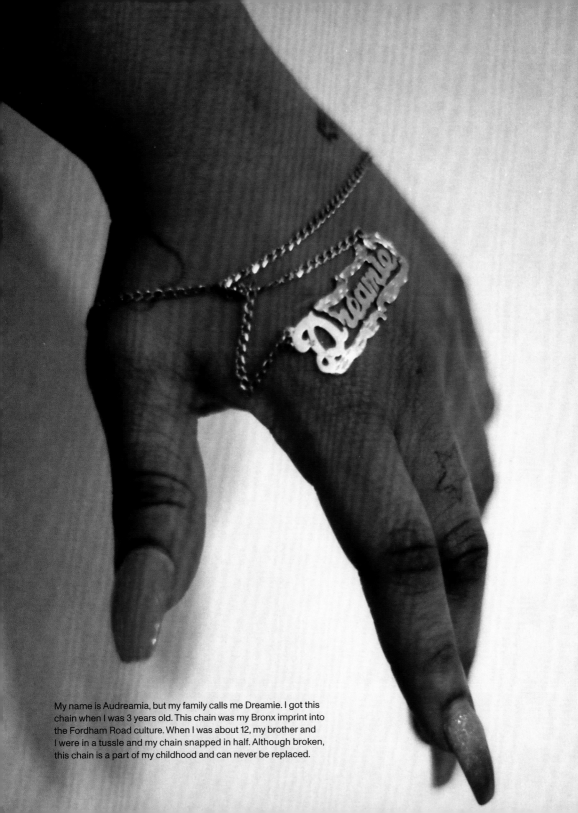

My name is Audreamia, but my family calls me Dreamie. I got this
chain when I was 3 years old. This chain was my Bronx imprint into
the Fordham Road culture. When I was about 12, my brother and
I were in a tussle and my chain snapped in half. Although broken,
this chain is a part of my childhood and can never be replaced.

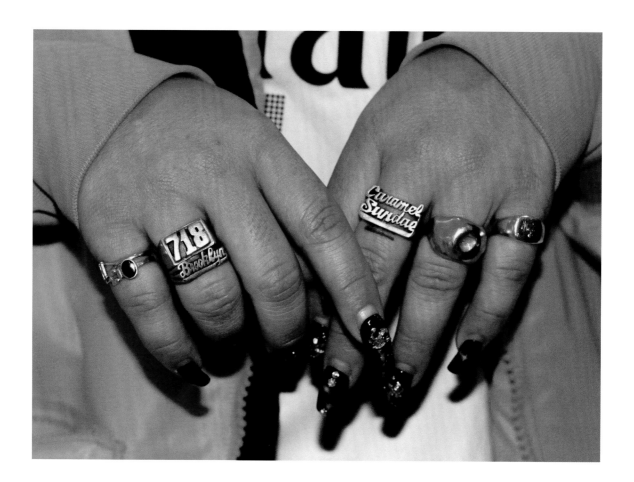

THE NAMEPLATE

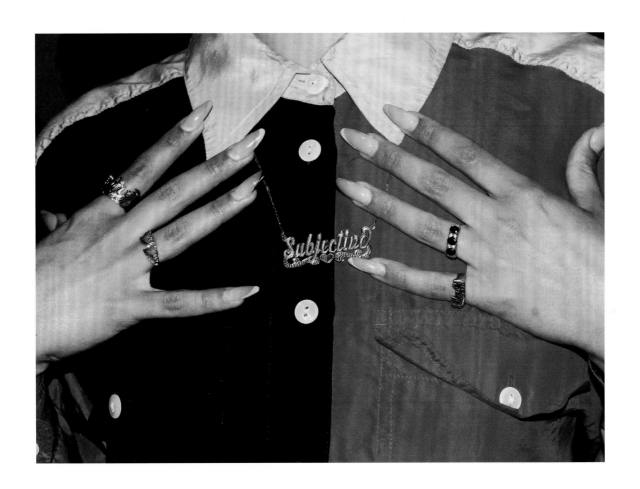

LAURA CIRIACO

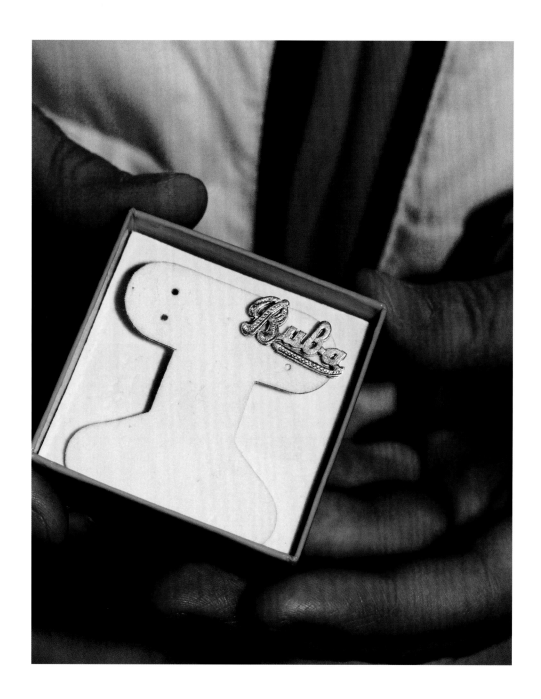

THE NAMEPLATE

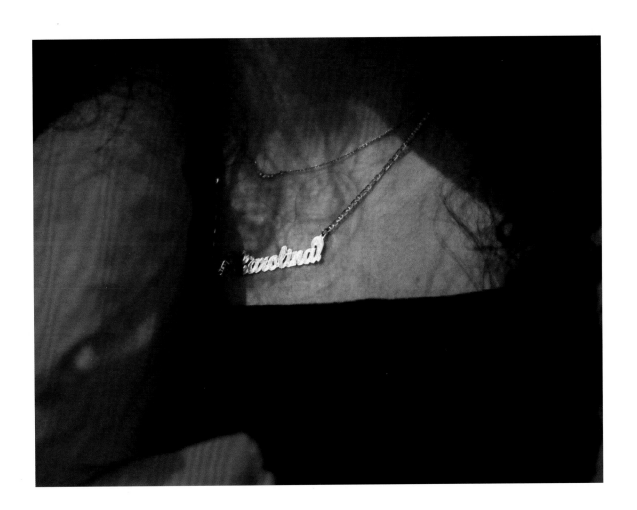

LAURA CIRIACO

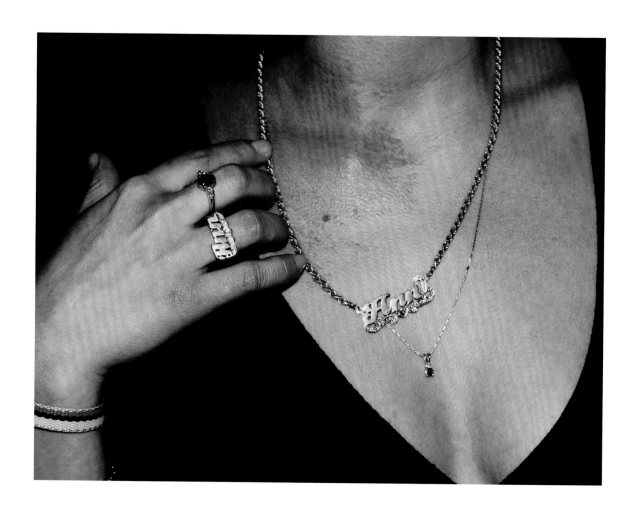

THE NAMEPLATE

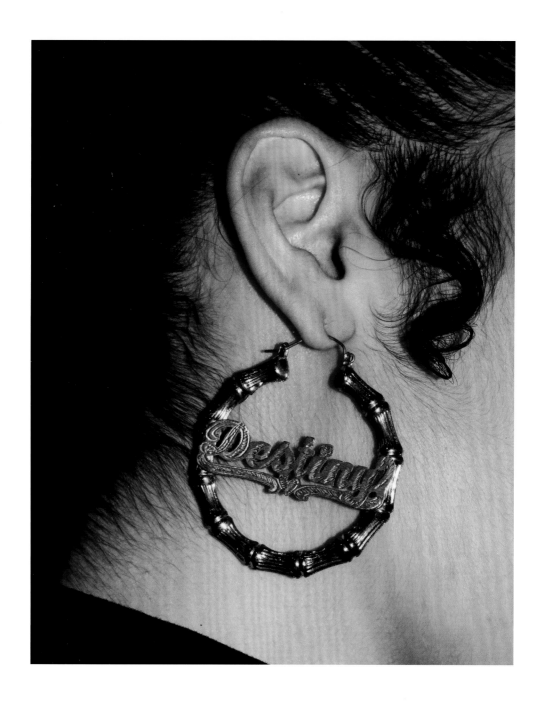

LAURA CIRIACO

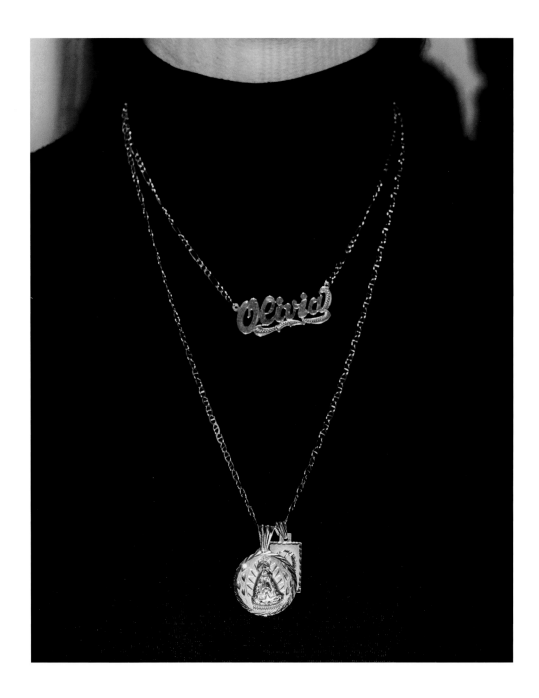

THE NAMEPLATE

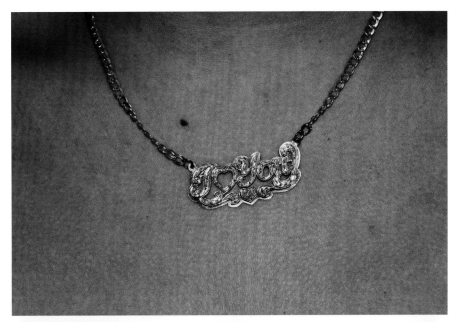

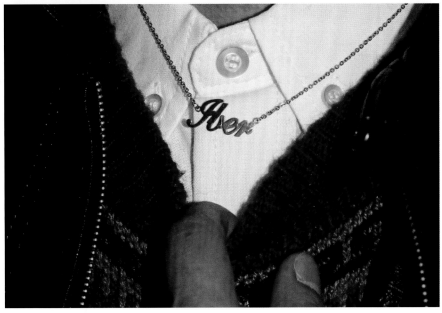

LAURA CIRIACO

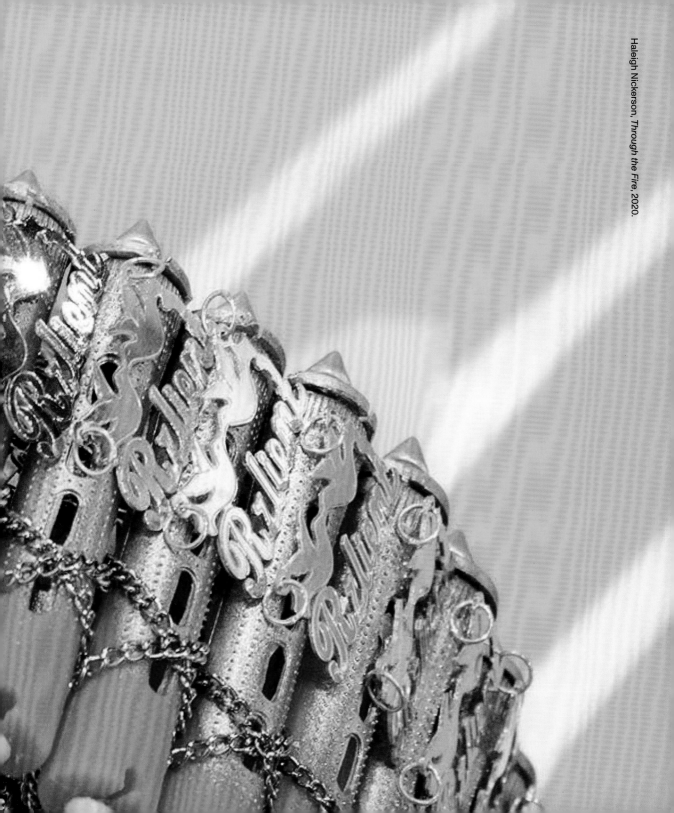

Diana Lozano, *Baby Love Angel Forever and Always*, 2018, foam, Aqua-Resin, rope, metal hardware, resin clay, vinyl paint, and flocking.

THE NAMEPLATE

Pedro Baez, CC Ordep, 2019, oil on canvas.

LAURA CIRIACO

Our Bodies Are Art: Nameplate Love Alchemy

Jillian Hernandez

me from the evil eye. In so doing, she turned an error into a subject worthy of gold and protection. Recognition and care are the nameplate's work. A love alchemy.

The alchemical operation involves turning a so-called base metal into gold. It's a metaphysical endeavor whose underlying aim is transmutation. In its affirmation of the name as a signifier of both kinship and belonging in an American racial grammar of misnaming and ungendering,[1] the nameplate transforms. It turns colonized flesh into willful bodies and racialized categories into artful genders. The nameplate is a performative object whose stage is skin surface and whose affect is love. A gift to oneself or others, it proclaims: You belong, we recognize you.

For a racialized subject to belong to oneself and one's loved ones is a crime in the United States racial economy.

Belonging is as complicated as love is. But colonized peoples understand love to be imbricated with methods of survival and beyond that, transformation. This means turning white oppression into the aesthetics of excess that declare abundance for those who are forced to navigate austerity. Gold reclaims minerals stolen from ancestral lands. Implicated in continued exploitation through the Nikes and mass-produced brands we rock, we are not innocent. Perhaps our politics are an open acknowledgment of the messiness as a starting point to new, needed transformations of global capital. And who would better understand and lay claim to such politics than those of us whose very bodies and styles have been circulated as commodities beyond our control, without love, recognition, or remuneration?

Beyond marking racialized subjects *as* valuable, perhaps the nameplate as a practice transforms value itself. As a performative object, the nameplate enacts love alchemy.

The transformational significance of the nameplate has been thrown into stark relief during the Trump era, which saw heightened levels of racism elaborated as anti-Black, anti-immigrant, anti-Asian, and anti-trans violence. In response to this moment, contemporary

JILLIAN HERNANDEZ is a scholar, curator, and community arts educator. Her areas of expertise include contemporary art and visual culture, girlhood, and Black and Latinx gender and sexual politics. She is the author of *Aesthetics of Excess: The Art and Politics of Black and Latina Embodiment* (Duke University Press) and is faculty at the Center for Gender, Sexualities, and Women's Studies Research at the University of Florida.

When I think of nameplate jewelry, I think of all of the mistakes that riddle my birth certificate. My name is spelled Jillian instead of my mother's intended name for me, Jilli*anne*, and her birthplace is documented as Cuba, not Puerto Rico. I imagine that for the hospital professional who was entering this information, my working-class, eighteen-year-old Nuyorican mother and her child were errors of a sort. Subjects unworthy of recognition, let alone reproduction. But my mother did what colonized people have turned into an art: make meaning and community out of/despite dehumanizing conditions. Turn errors into art.

She embraced the misspelled name, and it became the one inscribed on the nameplate I was given as an infant, with a dangling black azabache to protect

OUR BODIES ARE ART

artists of color have turned to the nameplate as creative gestures.

For example, a five-foot sculpture of a nameplate bearing the word "illegal" was included in Latinx artist Yvette Mayorga's 2017 multimedia installation *High Maintenance*. The immersive pink space staged an investigation of Latinx immigrant life through a visual language of consumption and excess. The paintings included in the installation appear as if they are fashioned from piped cake frosting. Their pastel colors, compositions, and architectural references index the eighteenth-century French rococo style, but images of Jeeps, Nike sneakers, and gold link chains insert the contemporary. The dreams of happiness that appear in these canonical art historical rococo references—such as *The Swing* (1767) and *The Progress of Love: The Meeting* (1771–72) by Jean-Honoré Fragonard—are disturbed by the nightmares of Latinx experience, as the dark-skinned figures depicted in the paintings are continually confronted by ICE (Immigration and Customs Enforcement) and militarized police. By including an oversize nameplate in the tableau, Mayorga enacts love alchemy by signifying "illegal" as an avowal of the border crosser as a radical outlaw who faces violence for freedom.

Placing one's body on the line for freedom is also a Black feminist practice, and the critical importance of naming was underscored during the Trump era amid heightened anti-Black police violence. As the Black Lives Matter movement has gained traction throughout the United States, the mainstream discourse on race and policing continues to center Black men, thus spawning the #SayHerName campaign in 2014, which aims to raise awareness of Black women's and girls' experiences with police violence.

In response, artist Kenya (Robinson) created a custom *Breonna* nameplate following the murder of Breonna Taylor at the hands of police in 2020. In viewing adornment as a form of valuing the self, and also of protecting the self from a hostile social environment, (Robinson) turned to the nameplate as a way to process her feelings of depression, anger, and loss at the continued devaluation of Black women's lives.[2] In turning Breonna's name into gold and wearing it, she performs a loving kinship that recognizes and values Black femmes and brings that energy forth into the world.

The nameplate criminalizes.
The nameplate agitates.
The nameplate values the unprotected
and transforms value itself in the process.
The nameplate claims a humanity rooted
in relation and love.
The nameplate affirms beauty and
survivance as our legacy.
Our bodies are art.

[1] Here I am referencing Hortense J. Spillers's ground-shifting essay in feminist and Black studies, "Mama's Baby, Papa's Maybe: An American Grammar Book," *Diacritics*, vol. 17, no. 2 (1987): 64-81.

[2] The artist discusses her process of creating the nameplate in the panel discussion "Femme Figurations in Contemporary Art," hosted by Lux Art Institute, April 6, 2021.

OUR BODIES ARE ART

THE NAMEPLATE

Selfie with "Breonna" nameplate by artist Kenya (Robinson).

Yvette Mayorga, *Nameplate*, 2017, acrylic on wood.

OUR BODIES ARE ART

Acknowledgments

We would like to acknowledge the people who have been instrumental to the creation of this book.

First and foremost, we extend our deepest gratitude to all of the participants who contributed their nameplate stories and images. Your collaboration is what made this possible.

Kyle Richardson, our designer, understood this project's creative essence from the very beginning and has translated that into the beautiful book we have today.

Many thanks are due to the photographers we commissioned to take portraits at our events, the artists who contributed images from their archives, and the thinkers who lent their words to these pages: Azikiwe Mohammed, Naima Green, Gogy Esparza, Destiny Mata, Nahomi Rizzo, Mia Penaloza, Arlene Mejorado, Nichelle Dailey, Troy Montes, Laura Ciriaco, Adria Marin, Celeste Umaña, Christelle de Castro, Jamel Shabazz, Polo Silk and the FAB5LEGACY Archive, Rafael Rios, Eva G. Woolridge, Kelly Shami, Georgina Treviño, Aviva Klein, Diana Lozano, Eina Ahluwalia, Haleigh Nickerson, Pedro Baez, Vanessa "DJ Agana" Espinoza, Lee Marshall, Maria Liebana, Garret Morris of RMS Titanic Inc., Big Bubb, Ilya Shaulov, Anjuna Bea, Emily Manwaring, Gizelle Hernandez, Tasheka Arceneaux-Sutton, Rawiya Kameir, Professor Q, Eric Darnell Pritchard, April Walker, Claudia "Claw Money" Gold, LaLa Romero, and Jillian Hernandez.

Special thanks to the people we partnered with on our events, including Mark Luxama from Cafe Erzulie, Zenat Begum from Playground Coffee Shop, Ali Rosa-Salas from Abrons Arts Center, Janine Ciccone from Hester Street Fair, Alyssa Garcia, Eric Ibarra, and Lucia Torres from Las Fotos Project, LaLa Romero from Bella Doña, Grace Zuñiga from Sawyer Yards, Theresa Escobedo from MECA, Elizabeth Cruces and Roberto Tejada from the University of Houston, and Kiara Ventura. Shoutout to Sonny Noladiv, Jory Shareff, Michael Thomas, Jr., Rosalind Flower, Shahiem Melendez, SMURFOUDIRTY, Ron Baker, Hasan Insane, Deemehlow, Sienna Fekete, Barbara Calderón, and Naya Samuel for their many forms of generosity.

Jewelry stores and the people who work at them are a vital primary source for our understanding of nameplates. We're especially indebted to Ali, the manager at Bargain Bazaar Jewelers in Brooklyn, New York, whose support made the store a home base for our work. We'd like to thank Oswaldo Serrano, one of Bargain Bazaar's jewelers, for allowing us to document his craftsmanship process. We also extend our appreciation to Sal at Palm Jewelry in Brooklyn, and to the jewelry vendors we visited at Slauson Super Mall and Alameda Swap Meet in Los Angeles, California, King Best Mall and KNG Jewelry Center in Houston, Texas, Royal Hawaiian Heritage Jewelry in Honolulu, Hawaii, and the countless other shops we have stopped by over the past seven years.

Along the way, we've been very fortunate to connect with people who supported furthering this book: Yeiry Guevara, Anita Herrera, Bella Neyman & JB Jones of New York City Jewelry Week, Lizania Cruz, Amanda Reid, Megan Reid, Wally Ludel, Maggie Levine, Samantha Johnson, Jenny Sanchez, and Nicole Lee.

And finally, much gratitude to our literary agent, Monika Woods, and the team at Clarkson Potter: Gabrielle Van Tassel and Sahara Clement, our editors; production editor Mark McCauslin; production supervisor Kim Tyner; and designers Robert Diaz and Mia Johnson.

This book has been a collective effort from inception to finish, and no part of this project would have been possible without the community of people who shared their time, care, and faith to bring this idea to life.

This Is The End Of Us, from the series "Nameplate Poetry" by Kelly Shami.

OUR NAMEPLATE STORIES

MARCEL ROSA-SALAS

I grew up in Brooklyn, right across from a jewelry store owned by a portly Italian American man everyone in the neighborhood called Casale. There was one that remains emblazoned in my memory: a pendant that spelled out the name "Maria" in a bubbly diamond-encrusted cursive. It was one of the first objects that I consciously remember perceiving to be beautiful. I have a twin sister and have spent most of my life being called by the wrong name. The idea of wearing my name for others to see was appealing for the dual function it offered: a stylish accessory that was both decadent and practical. I got my first nameplate at age ten after writing my mom a letter explaining that I deserved one for being a good student.

ISABEL ATTYAH FLOWER

I was born in Washington, DC, and grew up in the nineties, moving between small cities and suburbs in Pennsylvania and New Jersey where nameplates were a constant and prized staple among my peers. As a kid who was never really "from" anywhere, and with parents of different heritages and racial backgrounds, I loved that nameplates carried a sense of community and a shared visual language that grounded my sense of self as I grappled with figuring out who I was. I remember waiting to be old enough to order a costume necklace from one of the "same-day pickup" kiosks that lined the atrium of my local mall.

KYLE RICHARDSON

I am pretty sure I got my first nameplate for my kindergarten graduation—six years old!—from my grandfather in Puerto Rico. I hated my name "Kyle" for many years, but just as I've grown into my chain, I've grown to love my name.

OUR NAMEPLATE STORIES

Marcel at her 5th-grade graduation in Brooklyn, 2002.

November 19, 2001

Dear Mom,

Please excuse me for not telling this directly to you. I am kind of embarrassed.

Since I was five, I have always wanted a name plate. Unfourtuneatley, I wasn't responsible enough. Every year, I hoped you would remember I wanted it. I hoped it would be under the Christmas tree; but each year it wasn't.

Now that I am in the fifth grade and definately responsible for this necklace I think I deserve it.

You also have to remember I did work my "butt" off on all of the city wide and New York state tests (for my own good of course.)

Please read this letter over and think about it. I will be forever thankful.

Love,
Moose

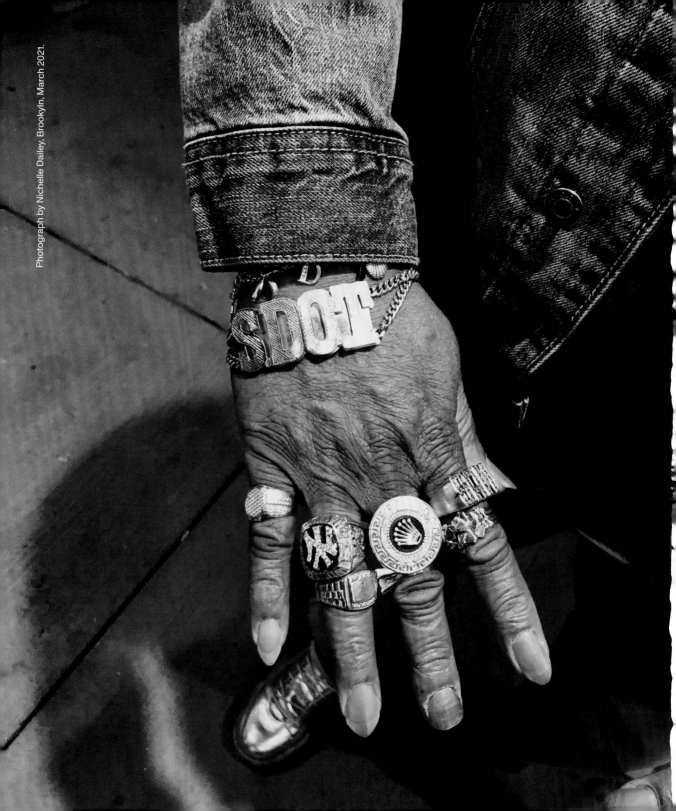